archaeology of elegance

archaeology of elegance ▪ 1980–2000 ▪ 20 years of fashion photography

. marion de beaupré . stéphane baumet . ulf poschardt . rizzoli

archaeology of elegance . text by ulf poschardt

grew up in the 1980s and 1990s, describe their lives largely as photos and layouts in magazines of their choice. Their biography – as their first video clip shows – is a melancholy recollection of the glamour and rebellious codes of those two decades. When plundering the archive, they discovered the antecedents for their own sensitivities, collected them almost deliberately, and brought them respectfully up to date. And the trip to the archive is rewarding musically, too, as their cover version of Kraftwerk's *The Model* shows. The song was originally released in 1978 – at the time pre-empting the age of the magazine and cold sounds, the model as its icon.

Although Kraftwerk's music – unlike that of Zoot Woman – seems futuristic, this acoustic futurism is relativized by historical quotes from film. While the musicians themselves appear in their spaceship-like studio and like inhabitants of the future, the models are shown in black-and-white of sections cropped from the weekly news. In other words, the music attempts to seize the future, while those images which focus on fashion look back into the past. Respect for the practical skills of fashion compelled Kraftwerk to take this step, whereas in the Zoot Woman video acoustic and visual signals function in harmony. Models and musicians are guests and inhabitants of the same 'harmonious landscape', or 'syntaxcape', as British media philosopher Kodwo Eshun calls them.

Kraftwerk and Zoot Woman both take the stage as archaeologists of elegance. Both look back on how elegant they longed to be as adolescents. The syntaxcape of the archive offers the historical plasma in which they construct continuities and avoid discontinuities. To this extent, today's fashion photography is more a story of similarities than

of differences – not in the sense of discernibly different aesthetic approaches but of lineages that constantly crisscross and interconnect. The Zoot Woman video represents one of those points in contemporary culture where all four important force-fields of the last twenty years inter-lock: Punk, Glamour, High-Tech futurism and Art.

The history of fashion photography is also a history of the media in which the photos appear, above all print magazines, whose editorials took stock of the potential symbiosis between fashion and photography. The early 1980s marked a new beginning in magazine journalism. In the wake of punk and New Wave both in England and in the United States a new form of fashion journalism grew up which defined itself more by stance than by labels. The codes had a strong cultural and social force: fashion photography came charging out of its usually decidedly bour-geois closet and into the rough everyday world which had set out to influence style and elegance as strongly as the catwalks in Paris, Milan and New York. Not much later, this new style – infused with what used to be called 'ugly' – entered the domain of the prêt-à-porter: young designers such as Alaia and Montana, Stephen Sprouse and Vivienne Westwood made it clear that the old definition of fashion had come to an end.

Wherever definitions come to an end, the media and arts have work to do. Fashion photography found itself on the front line. Once the old had been overthrown, the restless desire for the new swiftly created the basic formations for a new visual identity that went beyond the brash fanzines and provocative album covers. Kraftwerk probably had to sam-ple historical fashion photography in their video for *The Model* if only because at that time there was no fashion which would have functioned

in the context of futuristic pop music. Fashion photography and the media in which such photos were published thus clearly obeyed an inevitable logic.

Surveying the last twenty years means focusing on an aesthetic upheaval: fashion photography liberated itself from its immaturity, in part its own fault, and found the courage to accept a new pictorial complexity and variety which during the 1990s increasingly perforated the boundaries of art. Towards the end of the twentieth century, some fashion photographers had become celebrated artists, and art had in part become the fan and imitator of fashion photography, as shown in the works of Karen Kilimnik or Vanessa Beecroft.

Who pointed fashion photography in a new direction when and why? 'Redundant photographs', as Vilém Flusser calls them, are – as ever – not of interest.[1] All the photographers represented here search for still unexplored possibilities, for hitherto unseen pictures, and most of all for a visualization of attitudes, for attitudes are the most precious commodity of an internalized style and grace. At the end of the twentieth century, almost every haute couturier could be quoted on how attitude took priority over what was worn – and in this sense attitude has become the common currency of fashion photography. Pictures salvage those moments when attitude preserves itself by means of sheer intensity. Capturing these moments of intensity constitutes one pole of fashion photography – that is, authenticity in the traditional meaning of the word, namely the emphasis on the realistic, documentary gesture of the photographic medium.

Thanks to technical advances over the last two decades, the belief that pictures were apparently real, already shaken, was shattered fur-

[1] Vilém Flusser, 'Für eine Philosophie der Fotografie', in Hubertus v. Amelunxen (ed.), *Theorie der Fotografie IV, 1980–1995*, München 2000, p. 57 ff.

ther. For this reason, at the opposing pole to authenticity, we see artificially created gestures and attitudes emerge. They interpret what Jeff Wall has termed 'artificial realism': a contemporary concept that integrates the idea of artistic creation and agency into a more complex form of depicting objects. Produced with the assistance of computers or with surreal backdrops arranged in the studios, the purportedly inauthentic, fictitious pole of fashion photography approximates art and its virtual worlds. The belief in reality is just as apparently naive as the belief in total artificiality. The authentic as posed – for example in punk's 'great Rock 'n' Roll swindle' dreamed up as a marketing ploy by ex-situationists – prompted only a few photographers to become more pious and truth-loving, whereas most allowed for a deliberate lack of focus when depicting apparent authenticity and forced naturalness. The fictionalists, on the other hand, consider their monstrous fantasies to be an authentic description of a reality constructed by floods of images. However, a second nature emerges from the simulation of reality, one that finds a realism of its own in the works of Guy Bourdin right through to David LaChapelle.

Art directors and stylists feel their way into the most different of pictorial world in order to bring out the force of complex visual photographic codes. Countless new or advanced pictorial languages arise, and a new grammar allows more linguistic possibilities than ever before. The boom years of the 1980s and 1990s, with the increasing market for luxury goods and the attendant advertising, certainly encouraged variety. The new refinement of fashion photography was a direct result of the coupling of prosperous liberalism with an aestheticization of everyday life in almost all Western industrial nations.

The archeology of elegance aims to expose as many strata as possible. It attempts to identify semantic depth and flexibility. This is the reason for dividing the work of those twenty years into four key categories: Glamour, Punk, High-Tech and Futurism, and Art. Glamour, which arose in the 1980s, runs like a red thread through the entire history of fashion and fashion photography. Its modern, postmodern and nostalgic variants display the most luxuriant and shimmering variety of the last twenty years. In punk, the images pulsate with the rebellious energies of 1977 and the classic Sex, Drugs and Rock 'n' Roll fantasies, couching them in the finest nuances of Trash, Anti-Glamour and a devastating, authentic sort of poetry. At the turn of the new millennium, High-Tech and Futurism have been not only the all-defining motif of fashion photography, but have prompted changes in the production technology itself: new digital processing techniques have stood the aesthetics of images on their head. This marks the caesura of fashion photography in the age of multimedia networking. The fourth concept – Art – brings together all those pictures whose free, untrammelled staging and intellectual thrust have moved into the domain of the visual arts or have even stemmed directly from it. Art designed for consumption has changed into autonomous art that is both independent and innovative, and this change has set the entire culture alight.

Photographers are sometimes represented in more than one section. Viewers will draw their own distinctions and create their own typologies. What all the photographs have in common is an extremely sharp point, highly emotional, precise, and outstanding reflections of the spirit of their time and the mind of their maker – and telling us more about our world, its dramas and beauties than we had been aware of before. It is a

way to travel into the immediate past by picture, to an era that cries out to be rediscovered.

The idea of fashion as a kind of second skin or armour impressively alludes to human happiness and pain without trying to get beyond the surface to explain it psychologically. Attitude and disposition are both especially influenced by the sub-cultures on which fashion photography has focused.

2 Arthur Rimbaud, 'Adieu', *Une saison en enfer,* 1873

Contemporaneity defines a community of those who understand their time, respond to it aesthetically and thus represent it. This body-related form of self-expression as the representation of the now, in keeping with Rimbaud's demand that we be absolutely modern,[2] can be seen as a leitmotif throughout fashion photography. Once established, innovation comes to a halt. In this way, the last two decades of fashion photography also document the history of different attitudes and their success or failure. Fashion photography popularizes attitudes – even where it purports to be purposely elitist. It thus propagates an image of its time that has to be asserted in the face of other concepts and notions of time. Fashion photography's greatest success is to express the force with which to define our age. Fashion photography's power is that it can define what the here and now means. In line with the general sentiment of the day, this can on the whole be an intuitive and contradictory matter – in other words, it embraces far more than those elites who, as the self-appointed fashion world, are in the throes of infighting.

In an age of self-design, photography has renounced the innocence connected with merely being decorative. Floods of images come

glamour

graphs of Herb Ritts, Steven Meisel and Patrick Demarchelier desire is given a new guise. In Chloe's loft, the model model in *Glamorama*, there are any number of picture books by Matthew Rolston, Annie Leibovitz and Herb Ritts. The models are themselves accomplices and friends of the apparatus of reification. This is a sign of the desire for alienation.

In the neo-cool, glamour-celebrating TV series *Miami Vice* the double life of policeman and fake criminal Sunny Crockett ends in retrograde amnesia and the loss of all identity: his lifestyle, with its mint-coloured jackets, white Ferraris, bright yachts and postmodern villas of South Beach Miami, has diluted the traces of identity. The TV episodes (also complicit with fashion photography and commercials) seem to be the truly endless preparation for a state of loss of individual identity: the placement of ever more luxury and an ever greater number of consumer goods seems like an exercize in self-dissolution.

Glamorous fashion photography is the shadow of the alien Ego which an increasing number of people bear within them as desire. The wish no longer to have to be an ego but to dissolve into a staged scene, to don an alien identity – this also reveals the lack of political alternatives in the closing decades of the twentieth century. Glamorous fashion photography entails the search for the greatest possible beauty. As a modern phenomenon, glamour opts for the false rather than the true, for transition rather than truth, for the occasional rather than the durable.[6]

The implied emptiness in a world of luxurious opulence is only rarely alluded to in the pictures: their basic affirmative structure does not allow it. Nevertheless, the opulence of the setting functions as a proactive prophylactic, blocking even the suspicion of emptiness behind the surface and trappings. The star models and celebrities in the pictures, whose

[6] See Michel Onfray, *Libération*, Supplément 'Mode', summer 2001, p. 63.

aura of fame unleashes power, are managed and used like labels. Faces are the currency of the media society that is not interested in the reality of the masks, but only seeks a guaranteed impression that there are personalities concealed behind the masks.

Films and Hollywood are themselves quoted in order to imbue the faces, these empty facades, with the impact of great stories: Lindbergh's bike gang and the Russ Meyer sample used by Max Vadukul are intended to instil the empty faces of the models with certainty by virtue of the image of readily tangible film references. Lindbergh entered new territory with his narrative stories, above all the now famous story with Helena Christensen and the extra-terrestrial. These stories did not leave things at the level of quotation, but themselves constructed stories in order to emphasize that fashion photography can of course even create storyboards for blockbuster films by means of a photo sequence in a magazine accompanied by editorial copy. Specifically, the self-empowerment of fashion photography is shown precisely when it abandons quotation and redefines pictorial stories. The connections to video clips are as obvious as those to new Hollywood movies which, in the course of the 1980s and 1990s, have increasingly taken their cue from commercials and images from fashion photography.

Boredom becomes super-sexy. The equanimity with which the privileged regard their own lives is celebrated as an ability not to participate, and that permits all forms of beauty. No one in the photographs actually does anything, wishes to do anything, can do anything. The frozen gestures, even when they are part of the script, indicate the point of zero action at which the figures become statuesque. Robert Mapplethorpe's women are columns rather than statues; their bodies seem to be drawn

more immortal. Its hubris works for it and against reality. Taking leave of the world is the last hope left for a vision that entails transfiguration as the elimination of the real. Dialectically speaking, this of course also means initially that reality has to be present as the platform of rejection. In the end, glamour occurs and represents reality in the presence of the absent – the renewed triumph of the real over its rejecter and yet the first step towards forgetting it for good. The better you look, the more you see.

glamour

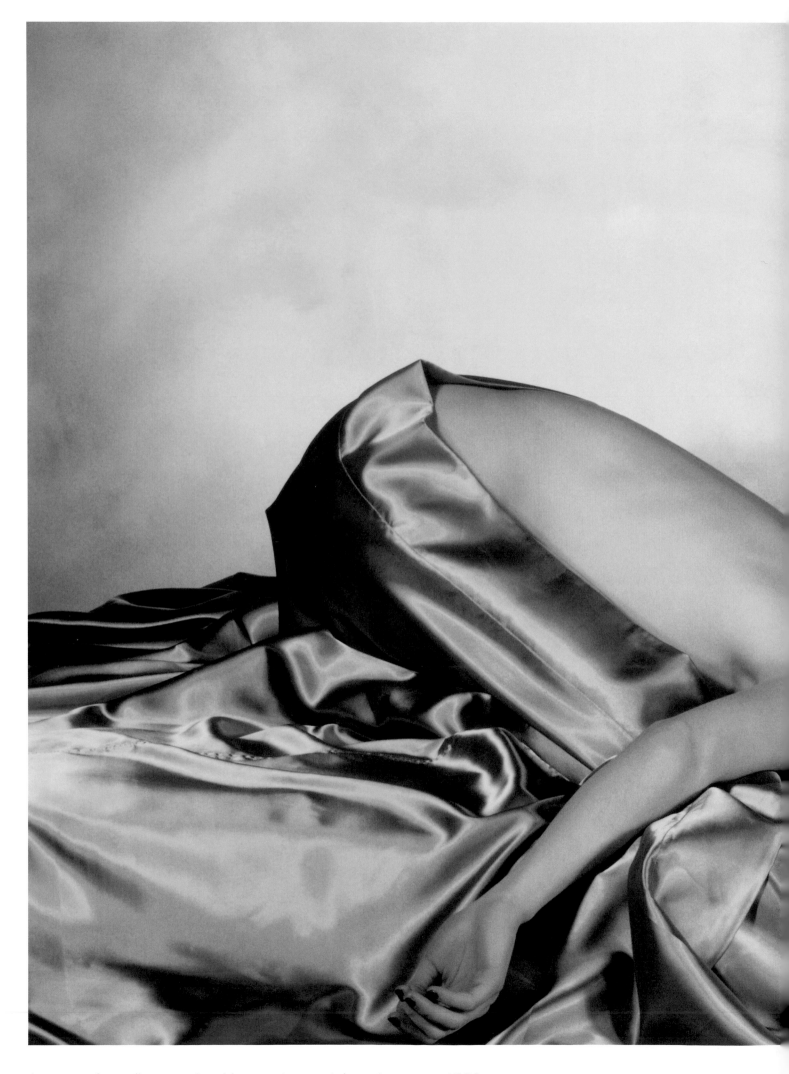

1 ▪ guy bourdin ▪ calendrier pentax ▪ tokyo, japan ▪ 1980

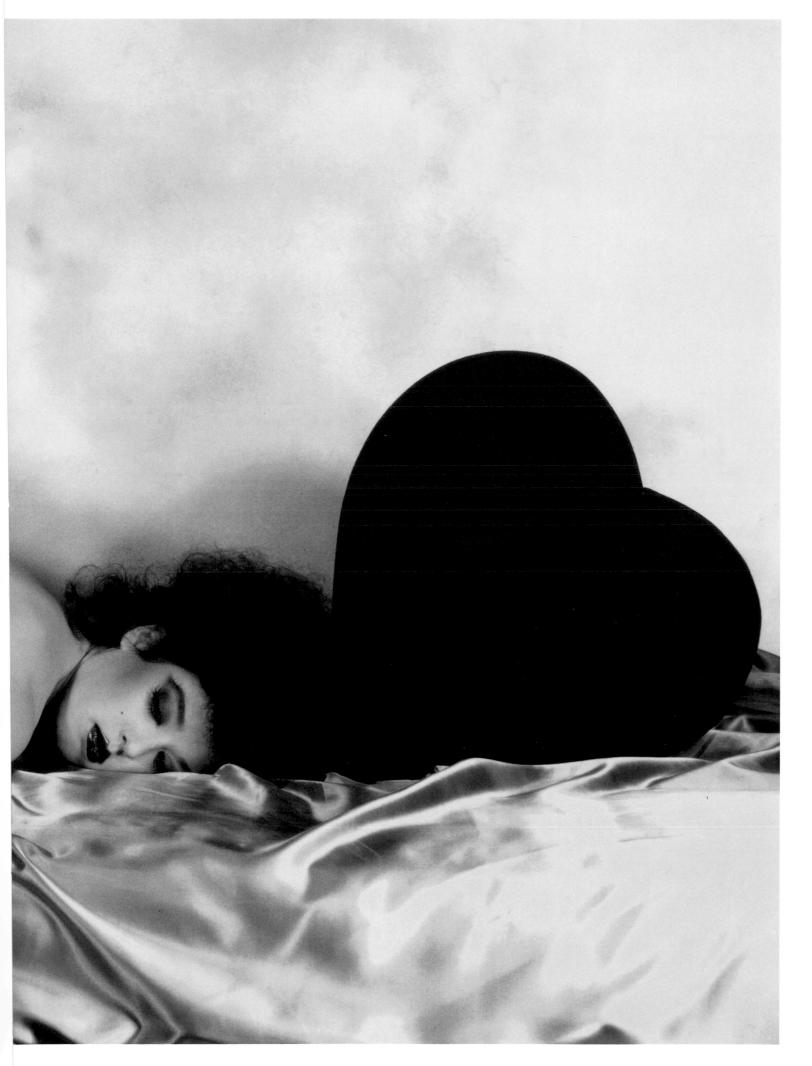

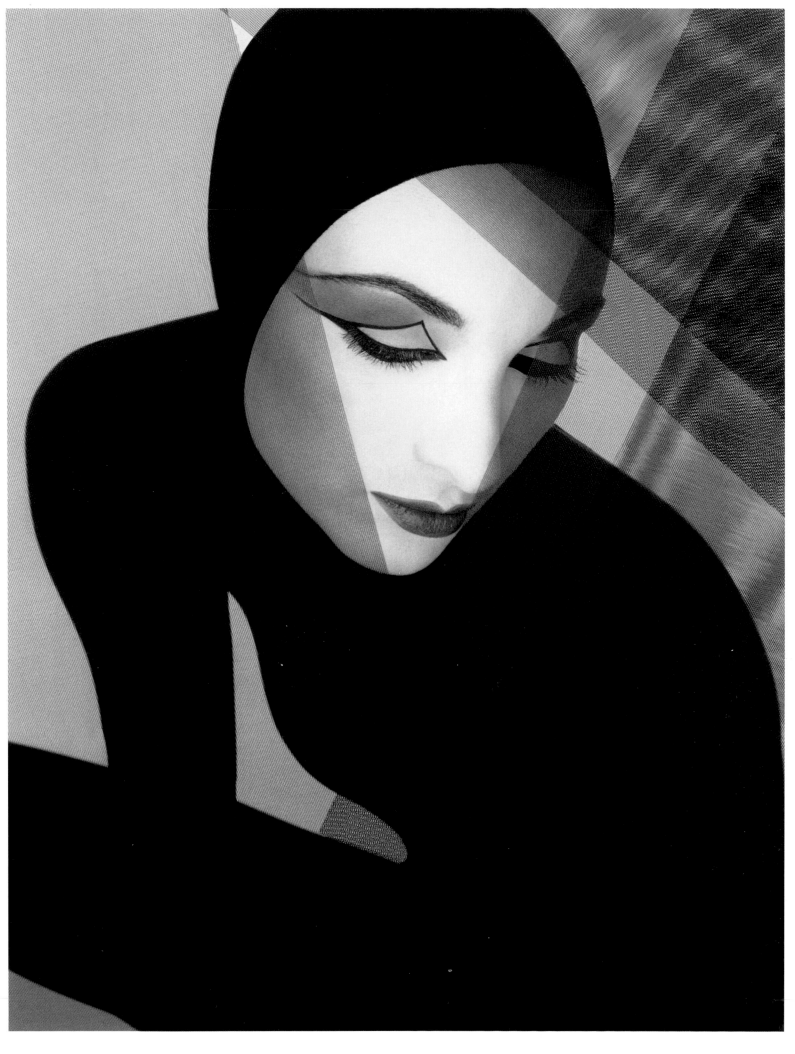

6 ▪ serge lutens ▪ ombre lumière, tulles découpés, elena ▪ 1995

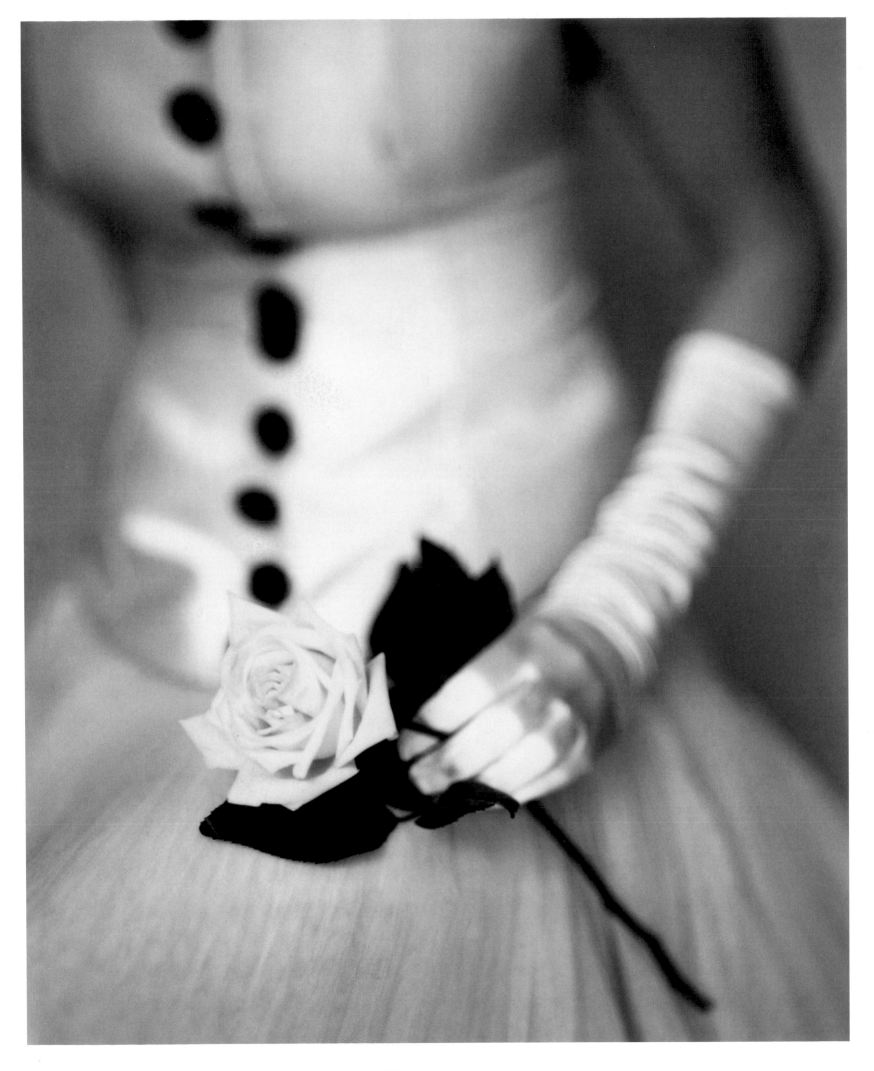

7 . paolo roversi . olga, paris . vogue uk . 1994

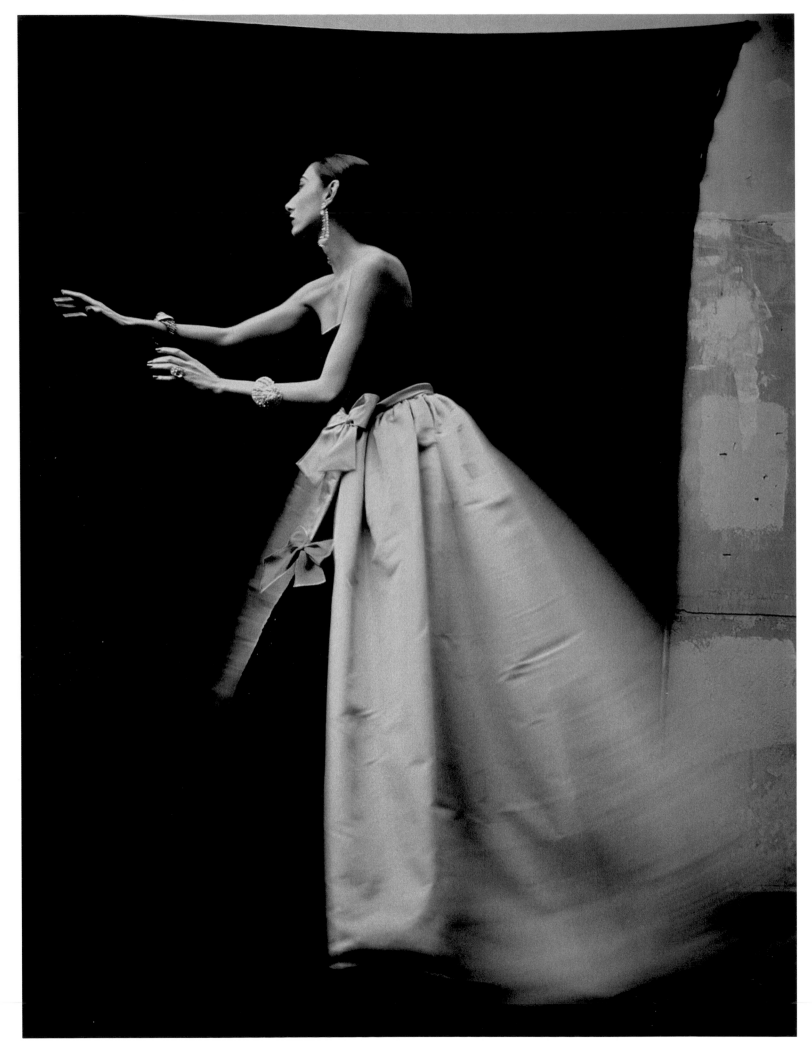

10 . david seidner . ahn duong, yves saint laurent . 1986

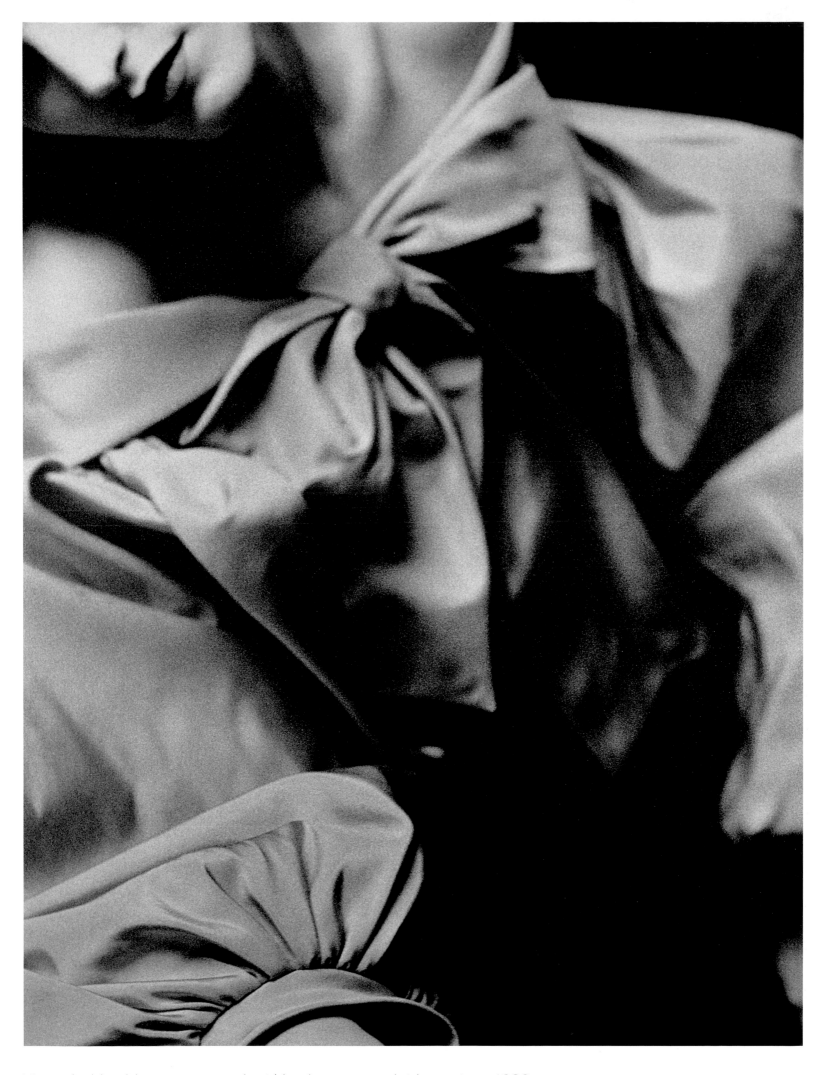

11 . david seidner . anne rohart/domino, yves saint laurent . 1983

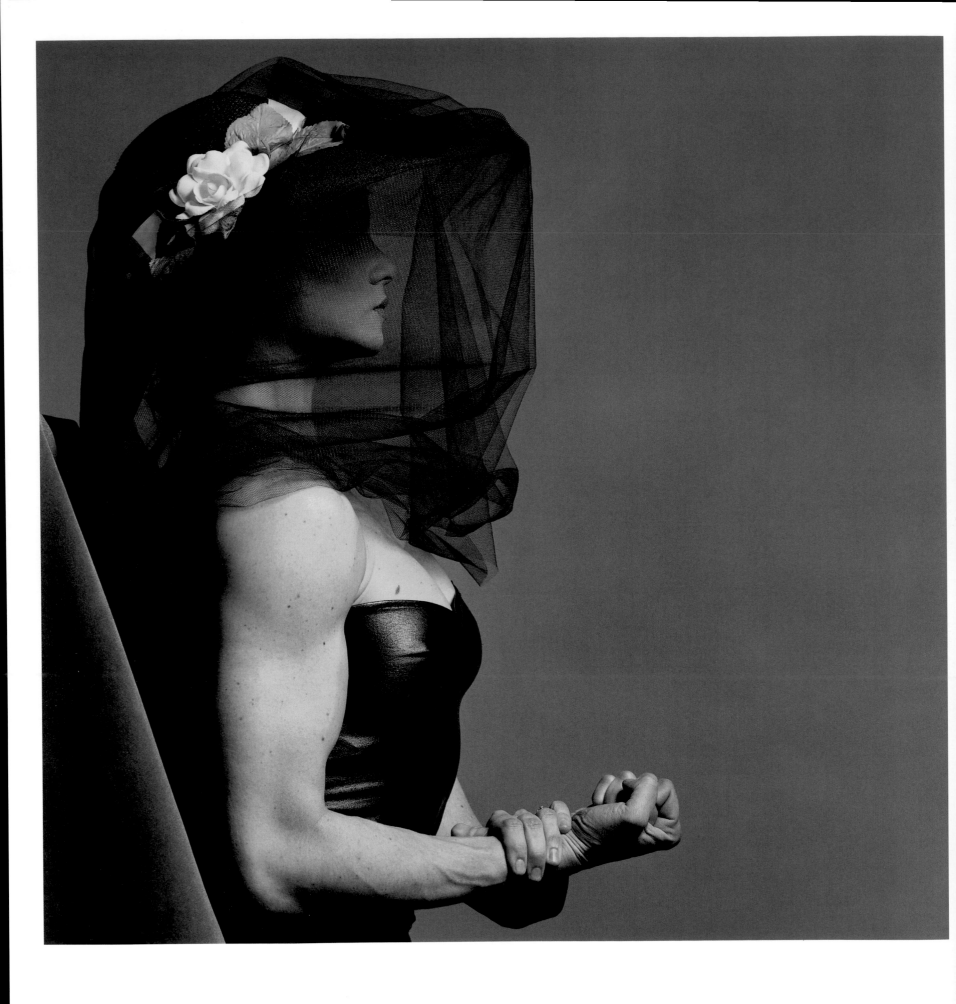

12 . robert mapplethorpe . lisa lyon . 1982

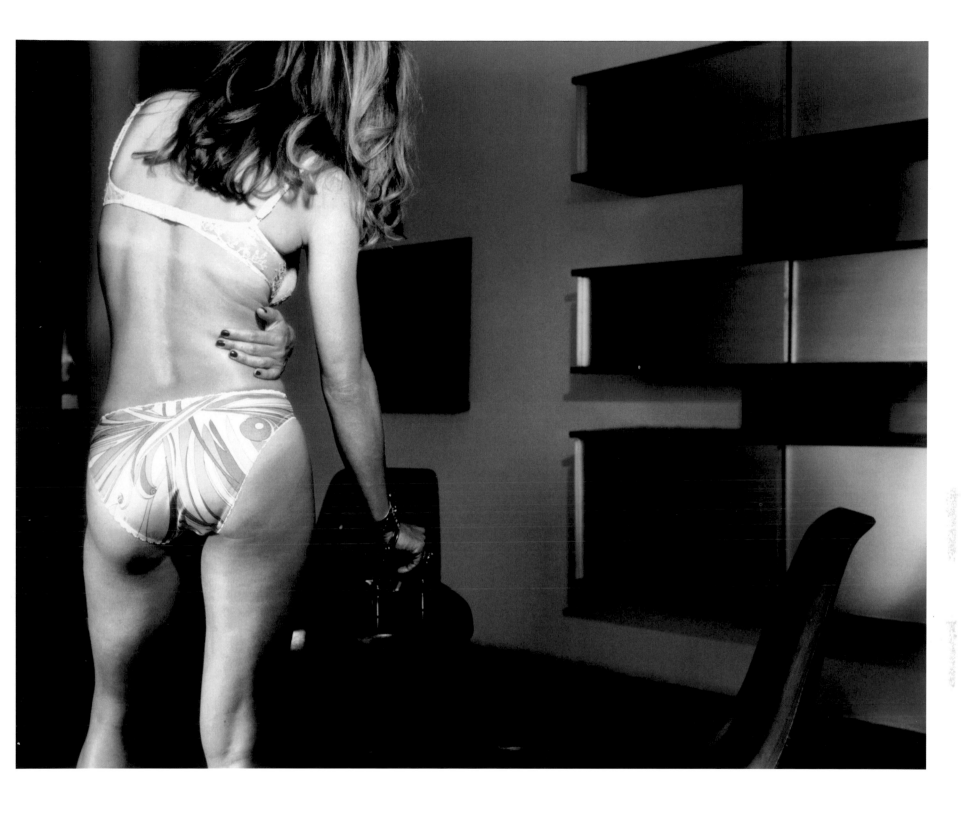

13 . bettina rheims . le dos de cordula, new york . english nova magazine . 2000

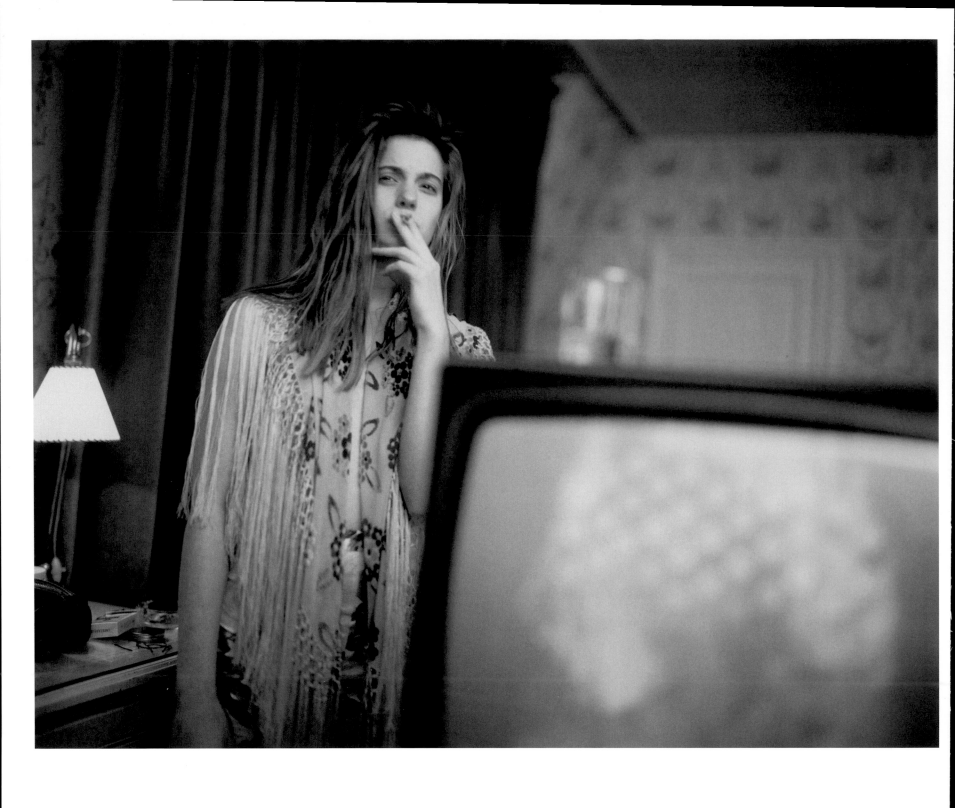

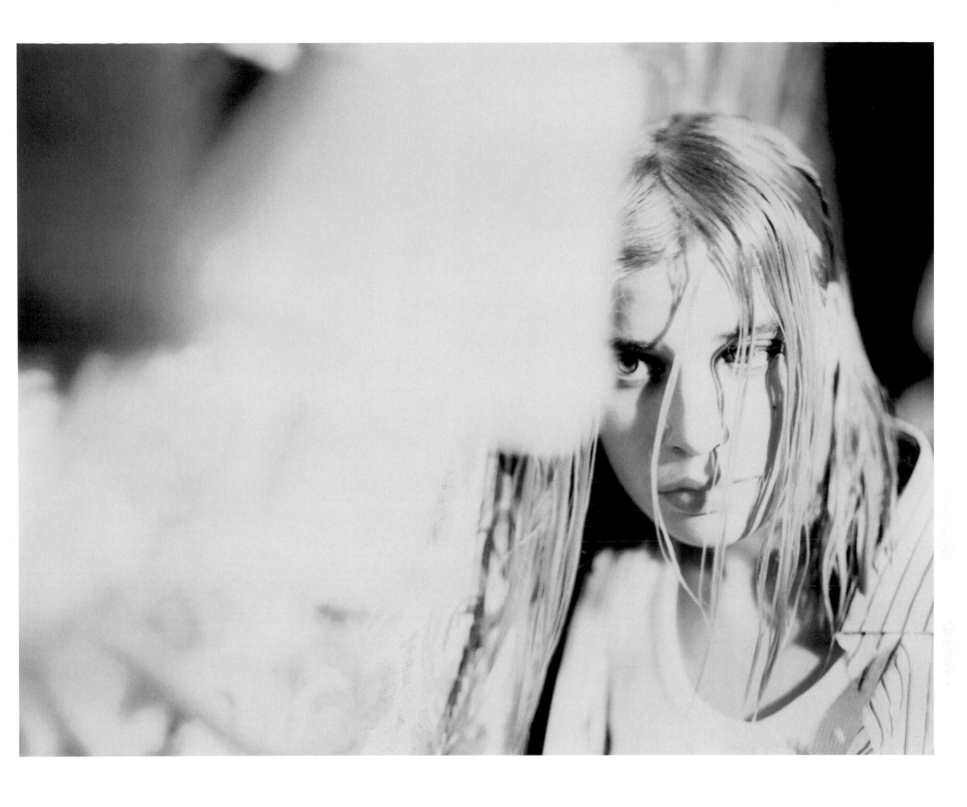

15 . jean-françois lepage . claudia . lei . 1985

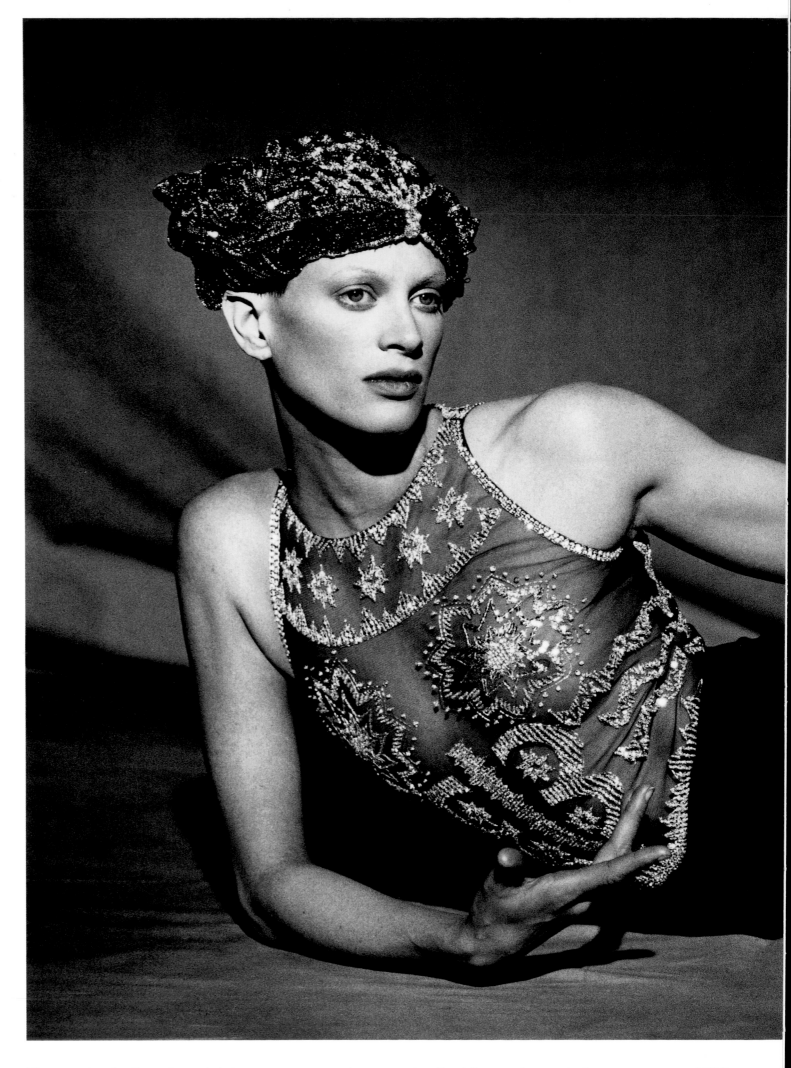

18 . peter lindbergh . kristen mcmenamy, homage to diaghilev . harper's bazaar, usa . 1992

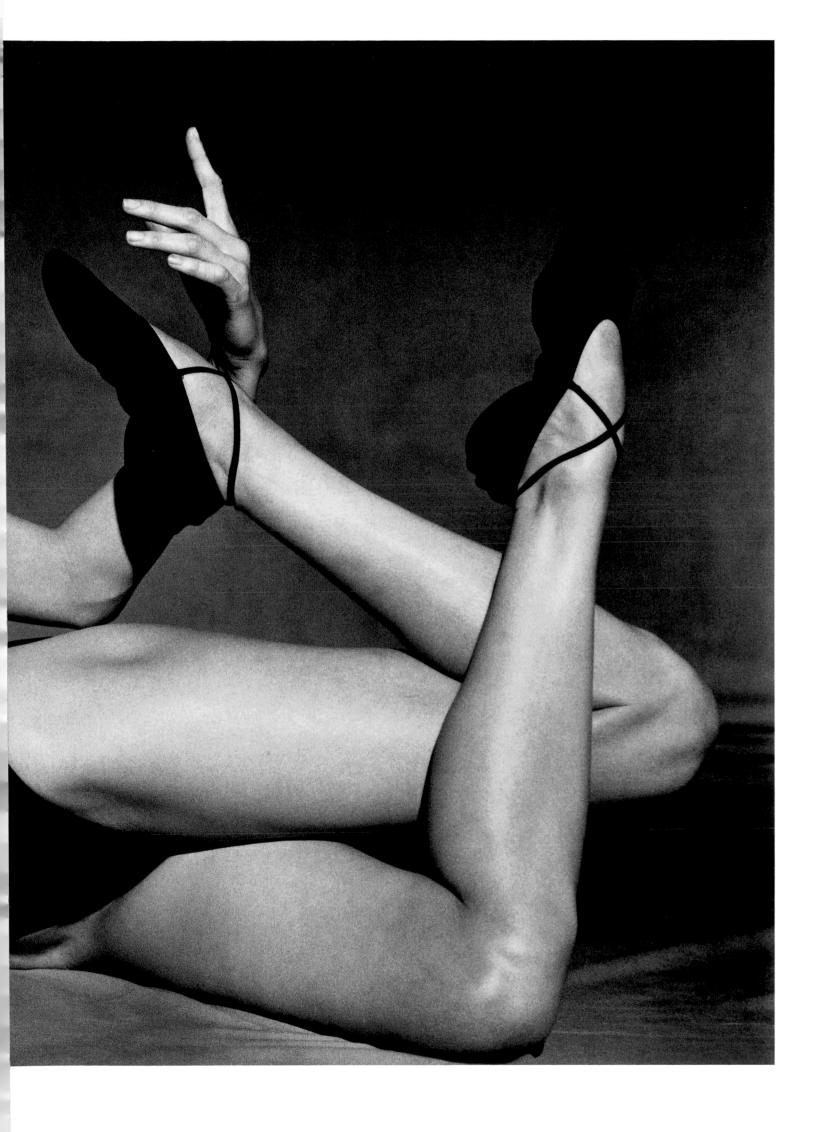

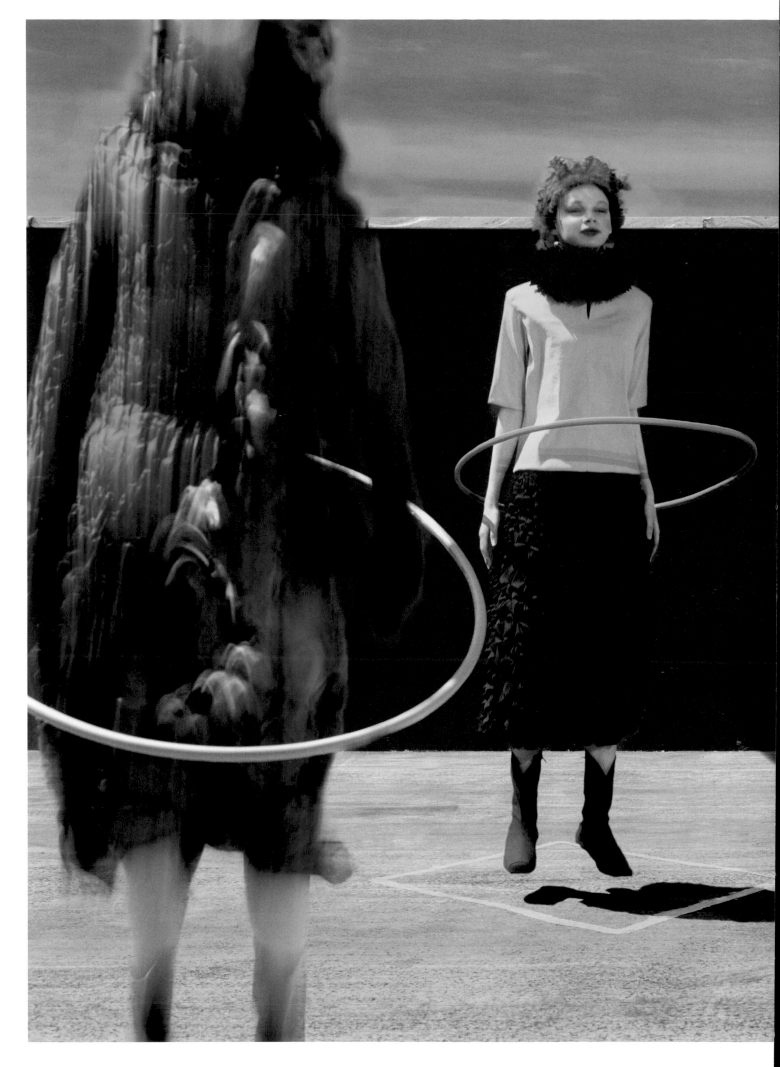

21 . thierry van biesen . houps! . elle japan . 2001

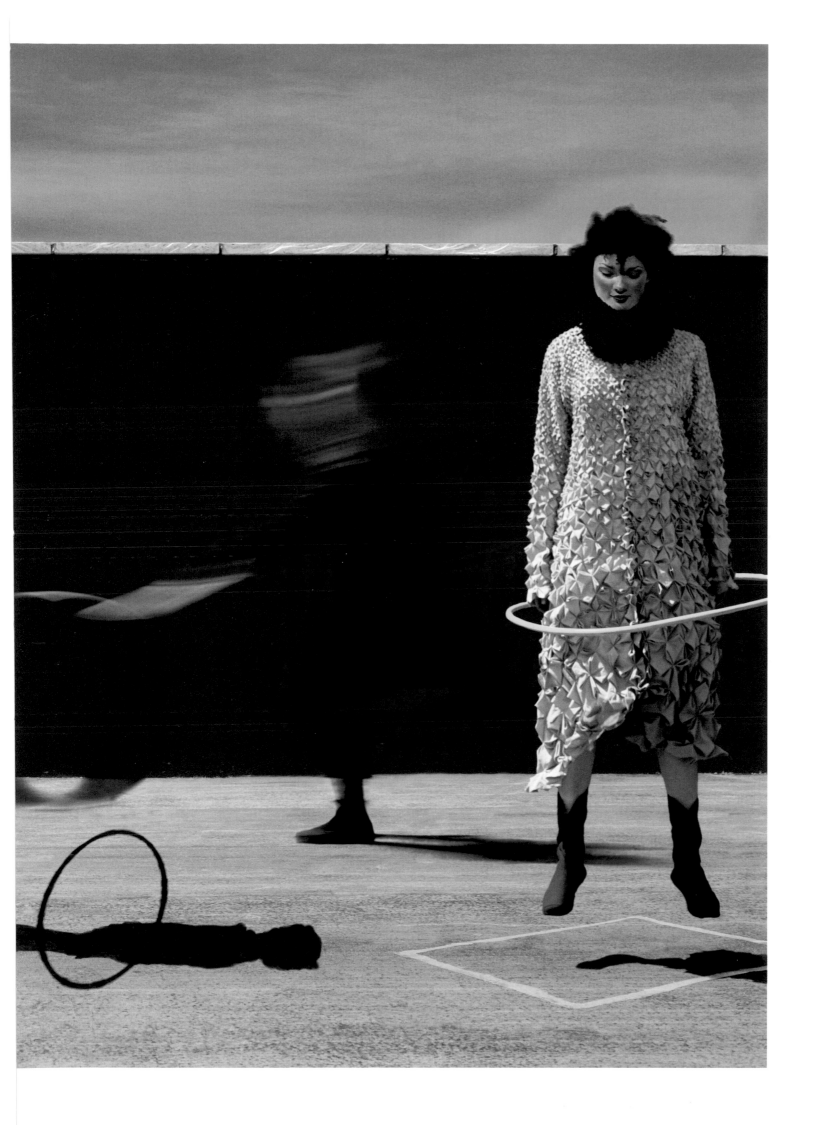

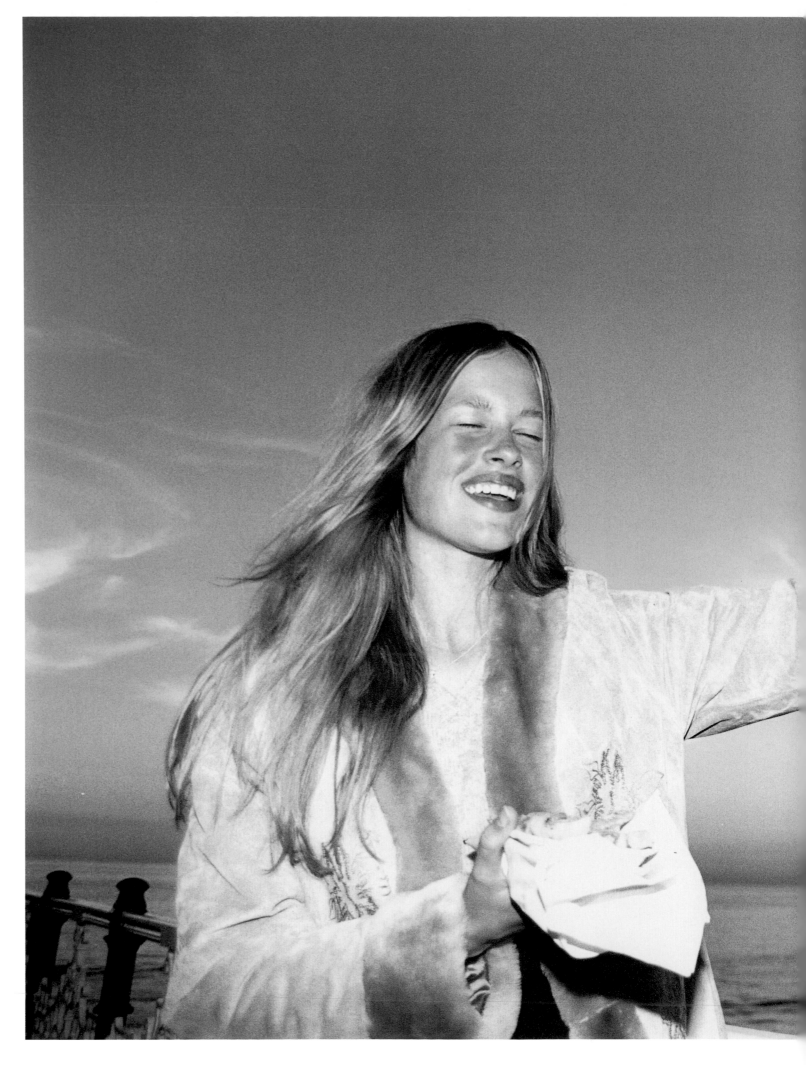

24 . elaine constantine . seagull . the face . 1997

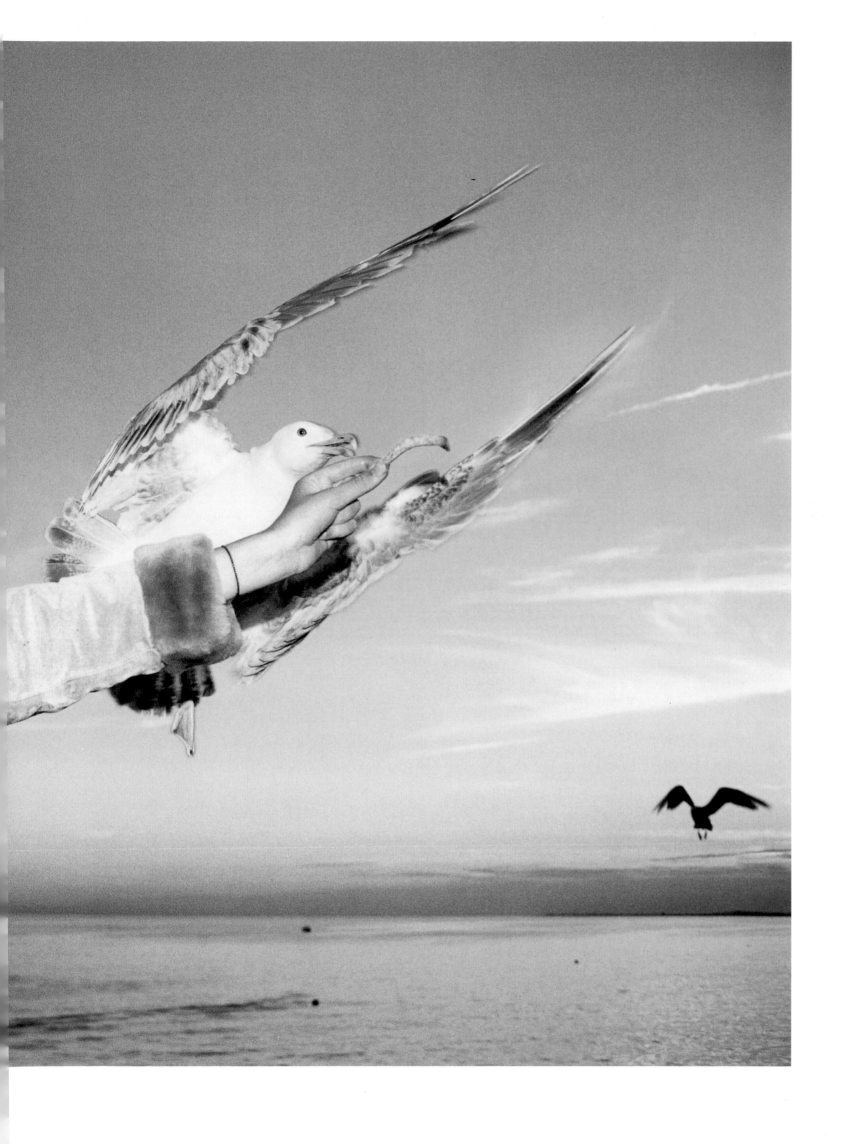

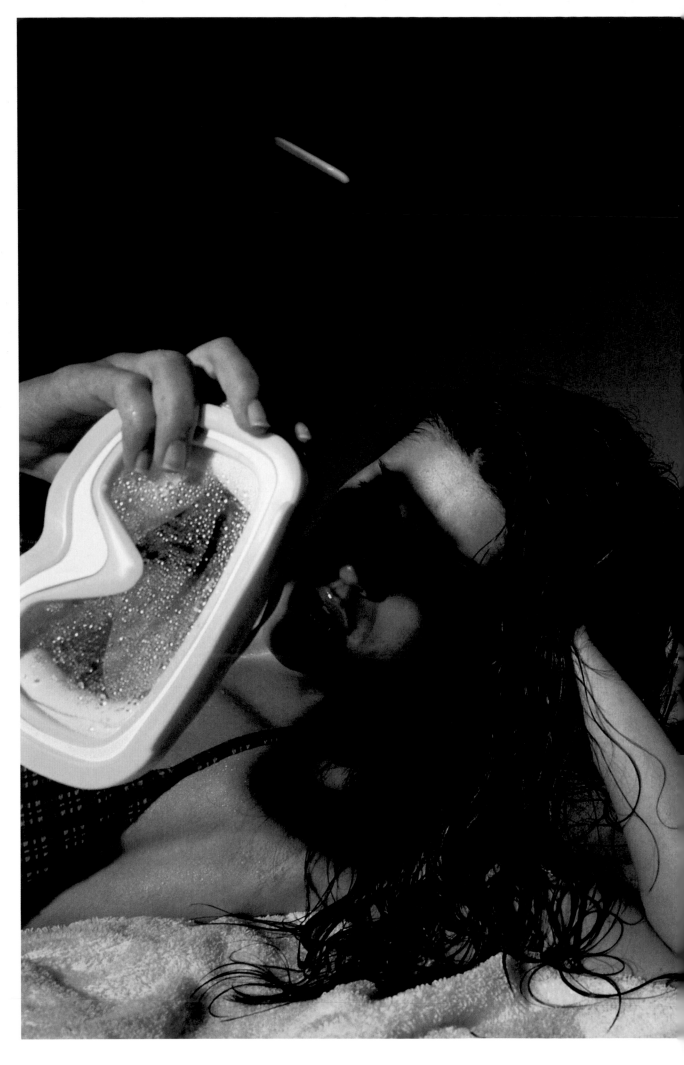

27 . steve hiett . frisbee . vogue italia . 1999

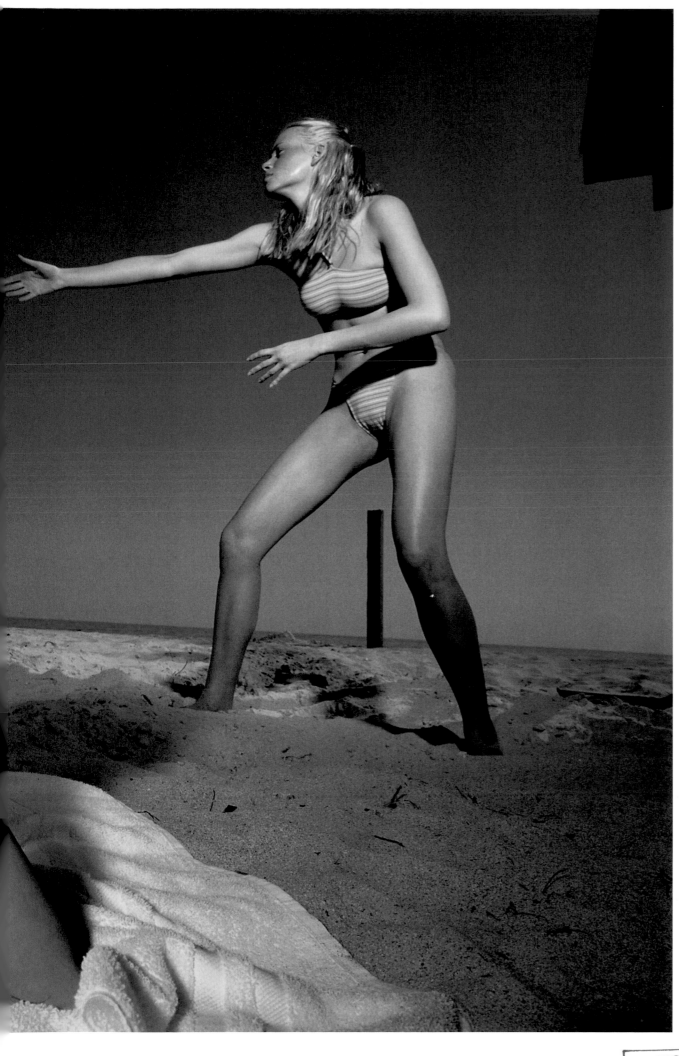

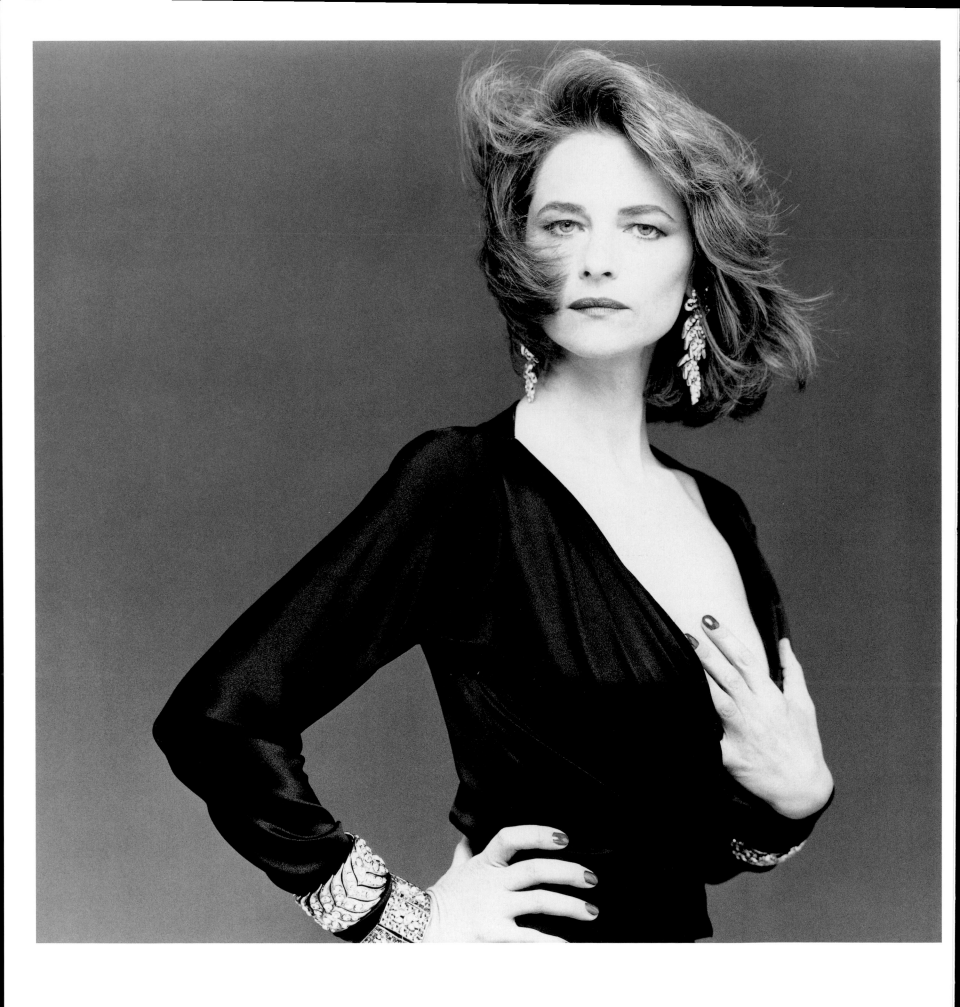

30 . bettina rheims . charlotte rampling, paris . female trouble . 1985

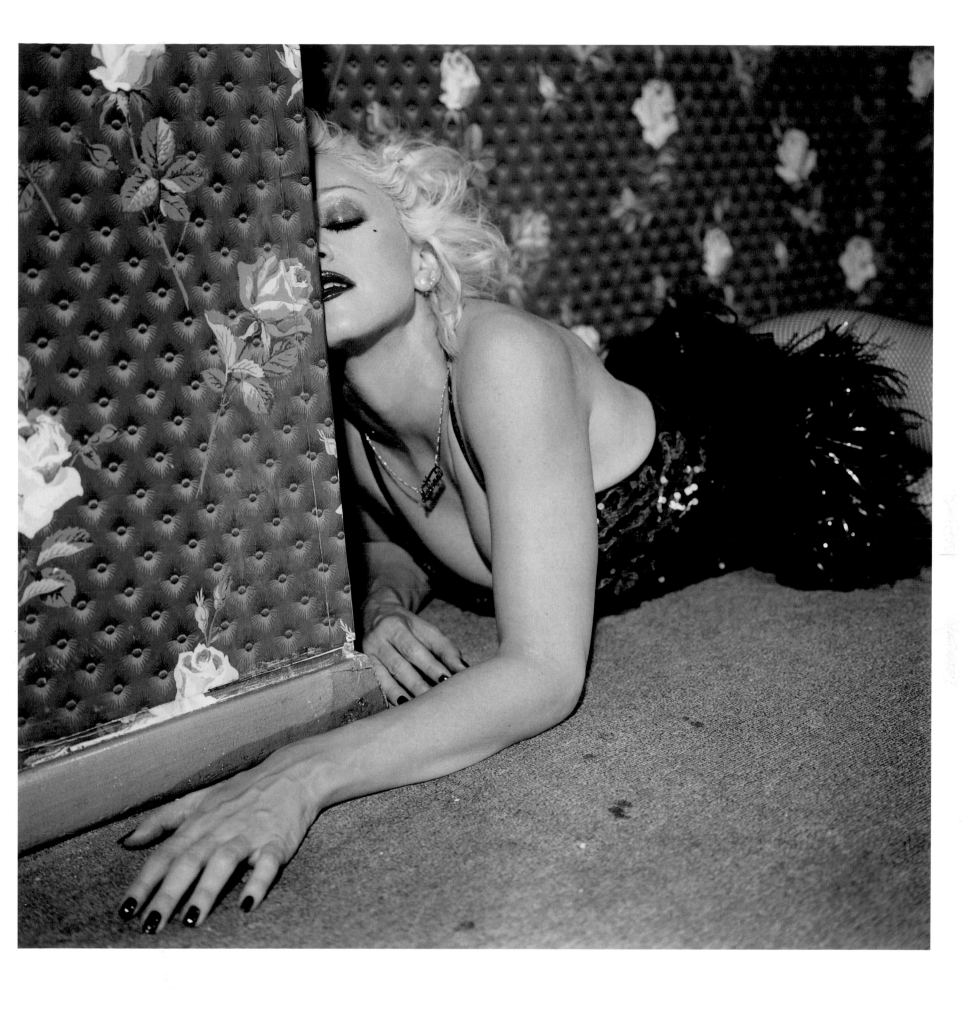

31 . bettina rheims . madonna lying on the floor of a red room I, new york . 1994

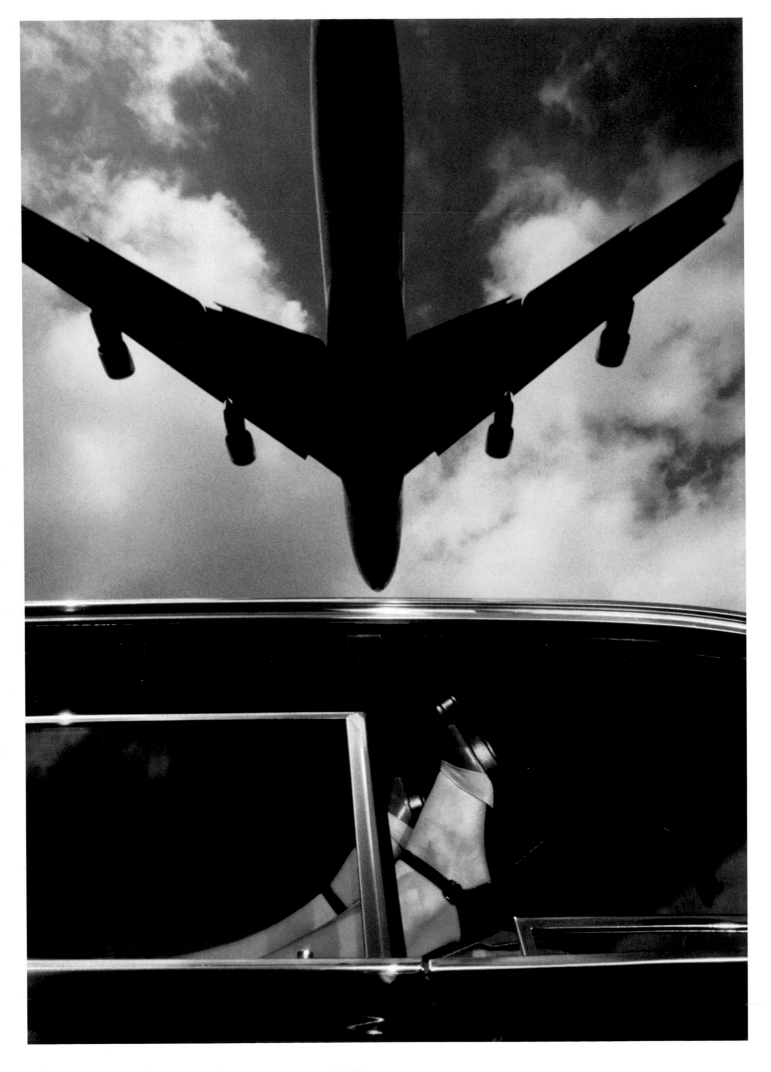

33 . guy bourdin . charles jourdan . 1972

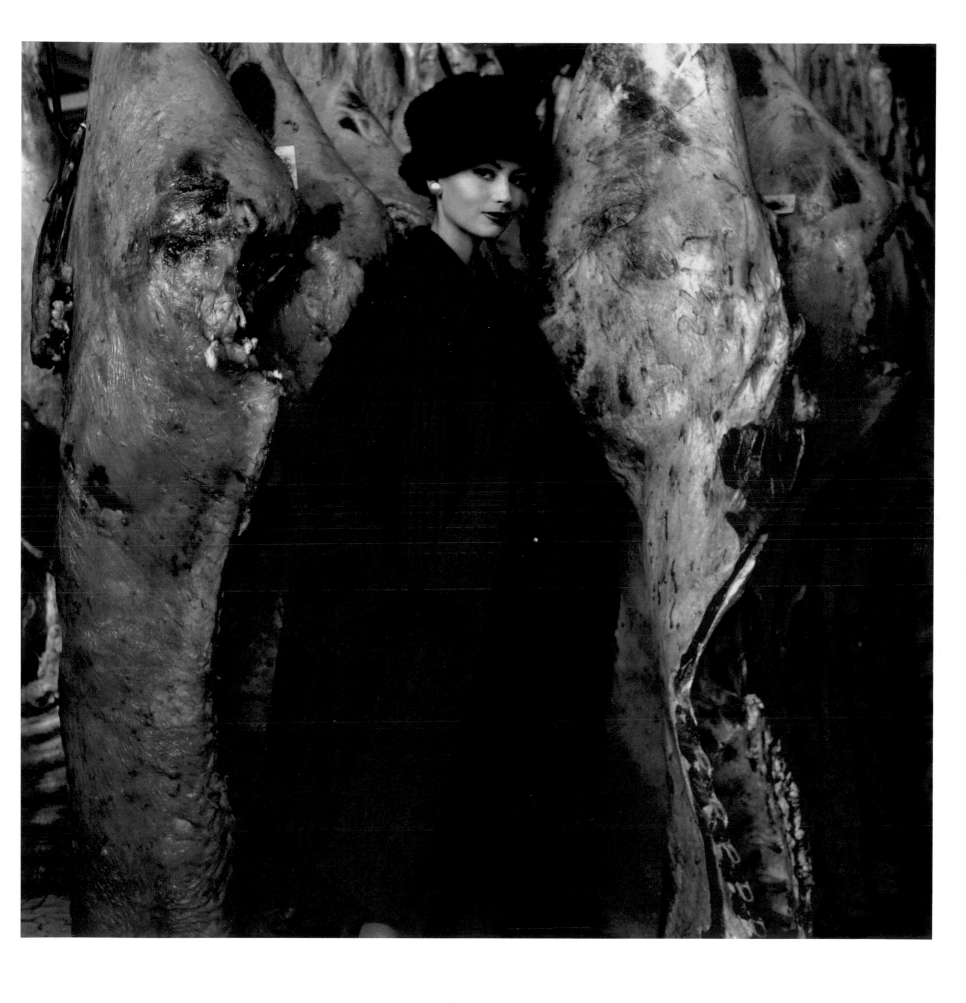

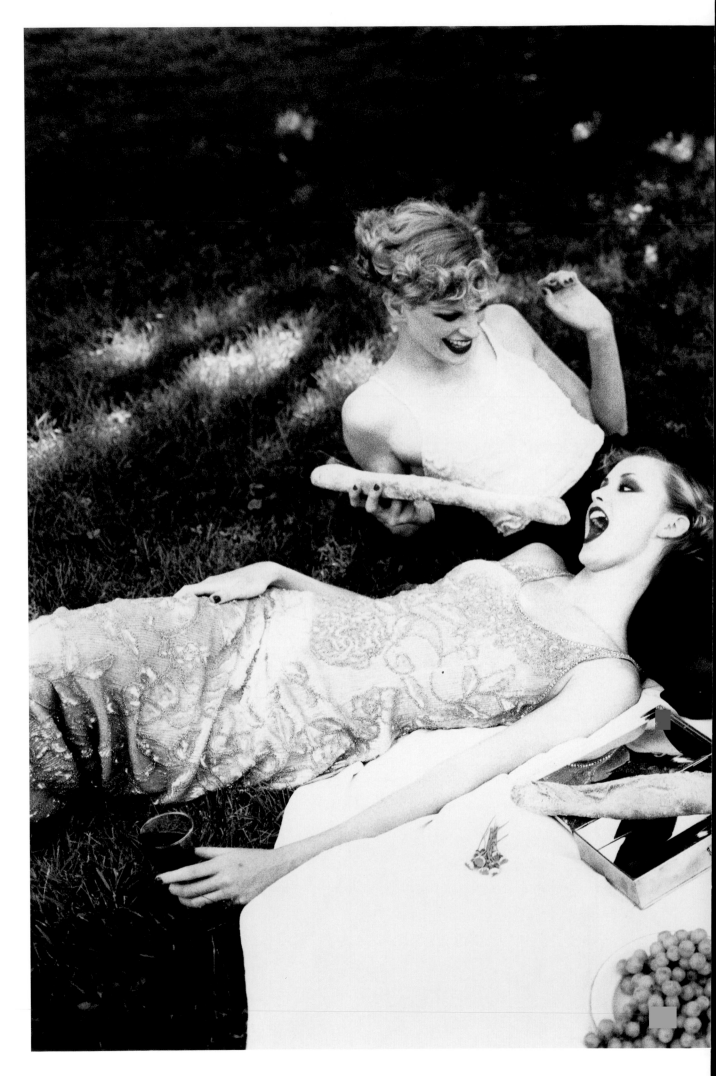

35 . ellen von unwerth . picnic, long island . 1996

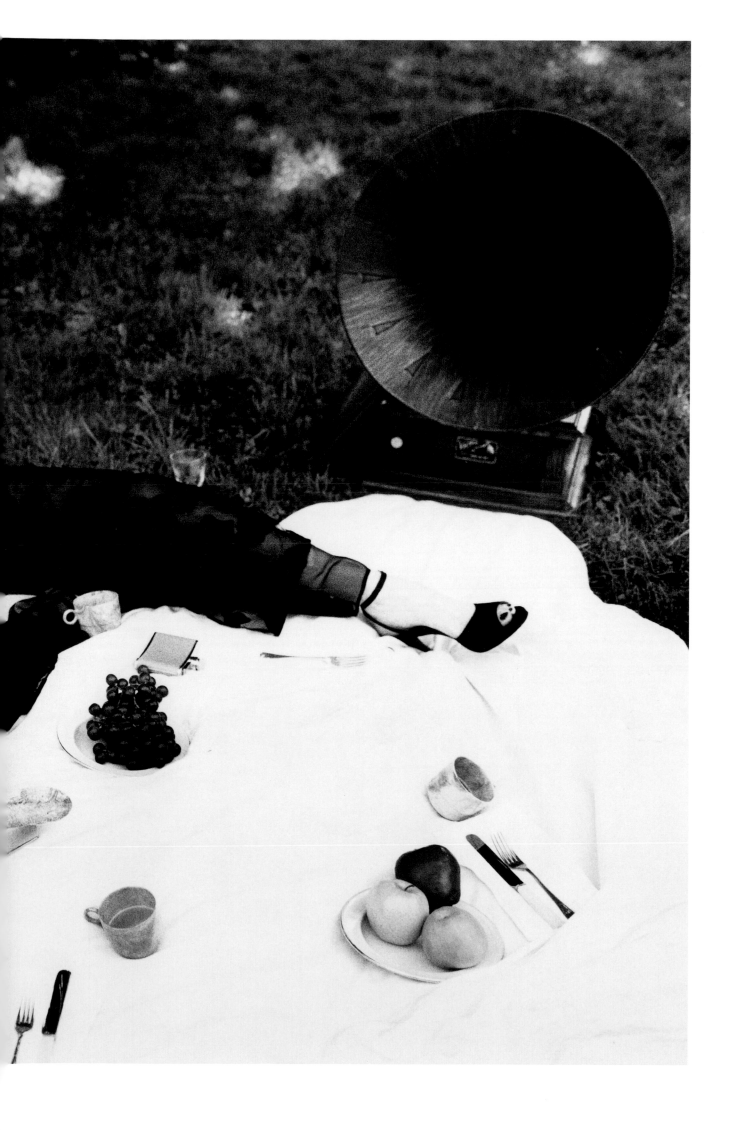

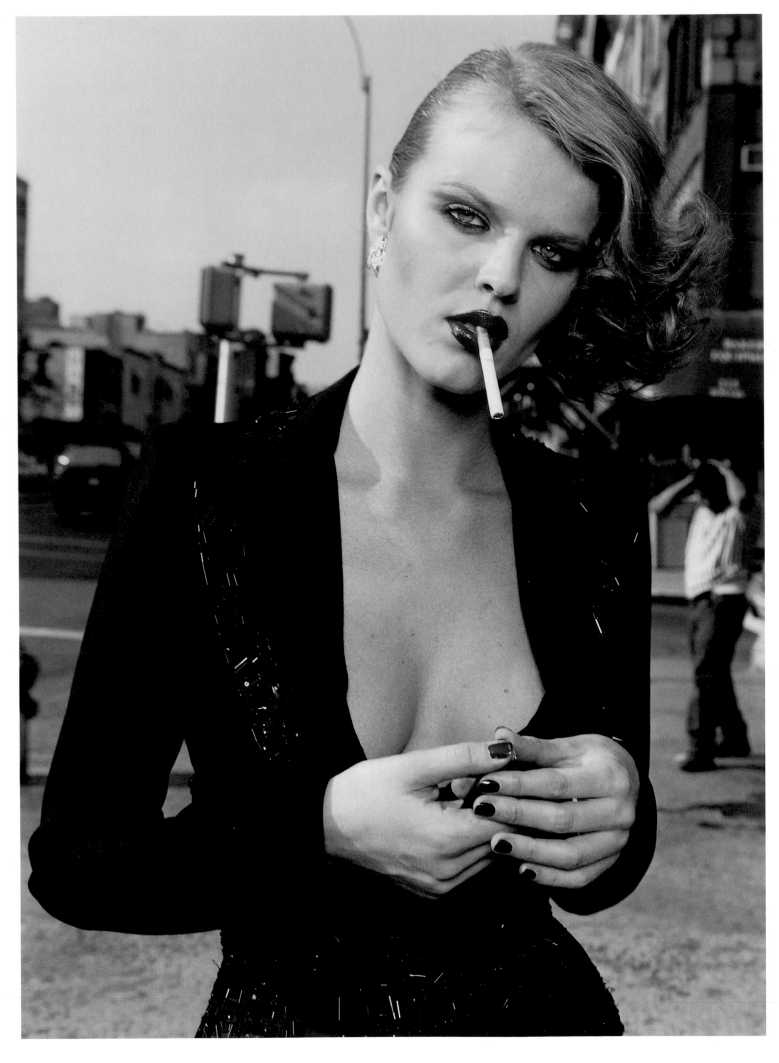

36 . terry richardson . eva smoking . mixte magazine . 1999

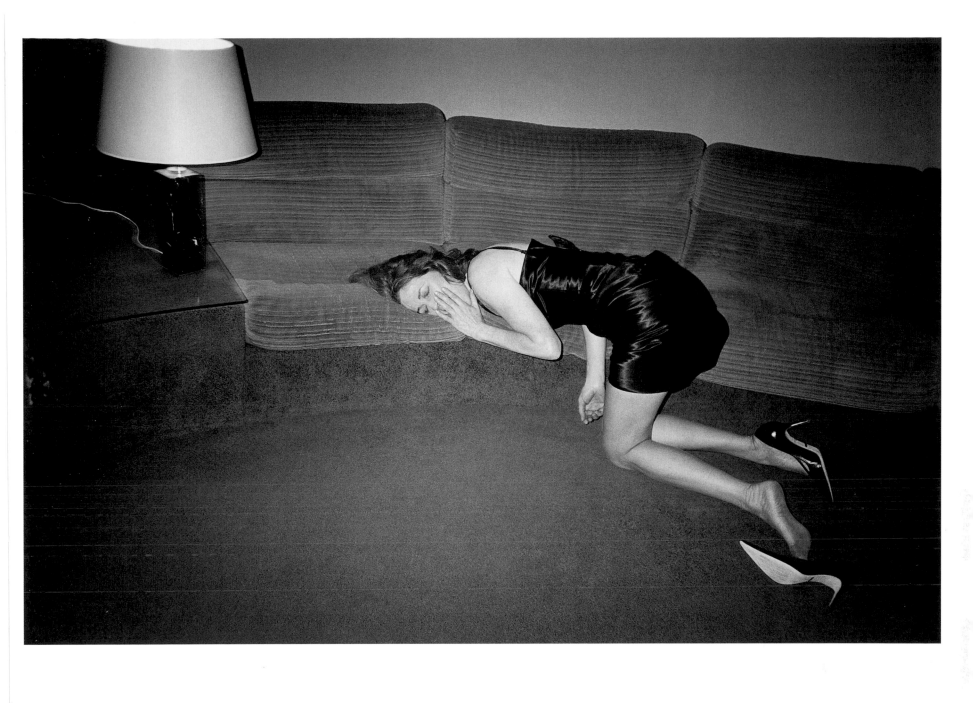

37 . juergen teller . charlotte rampling, paris . 2001

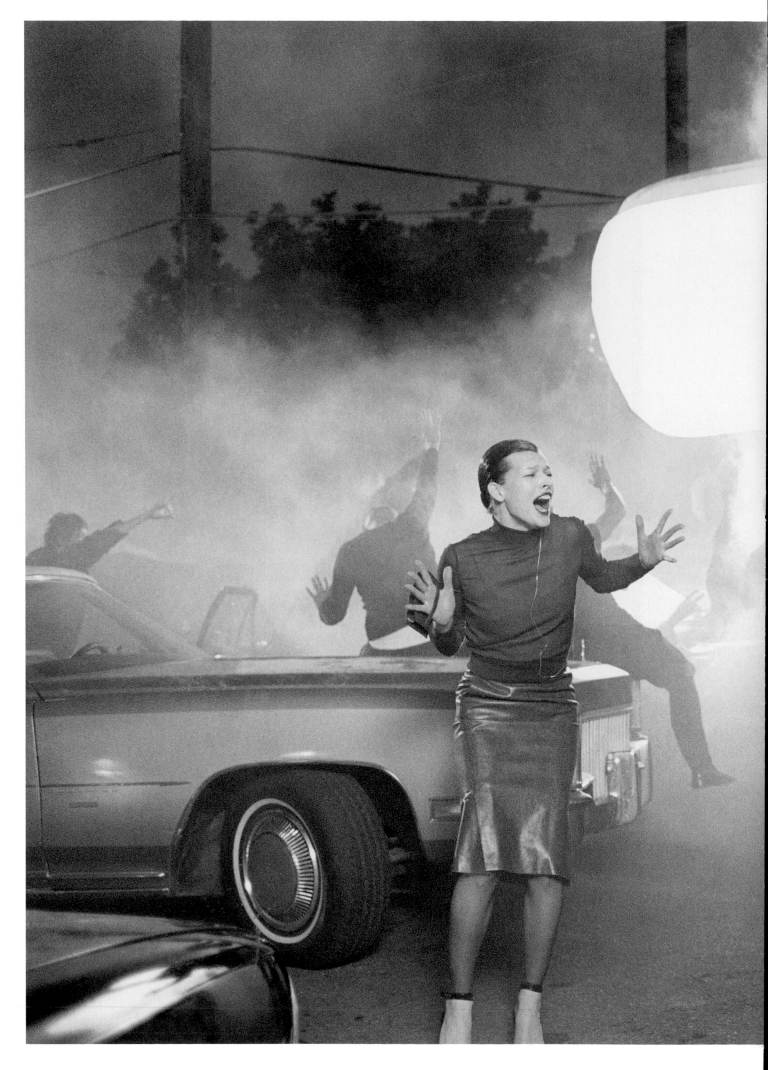

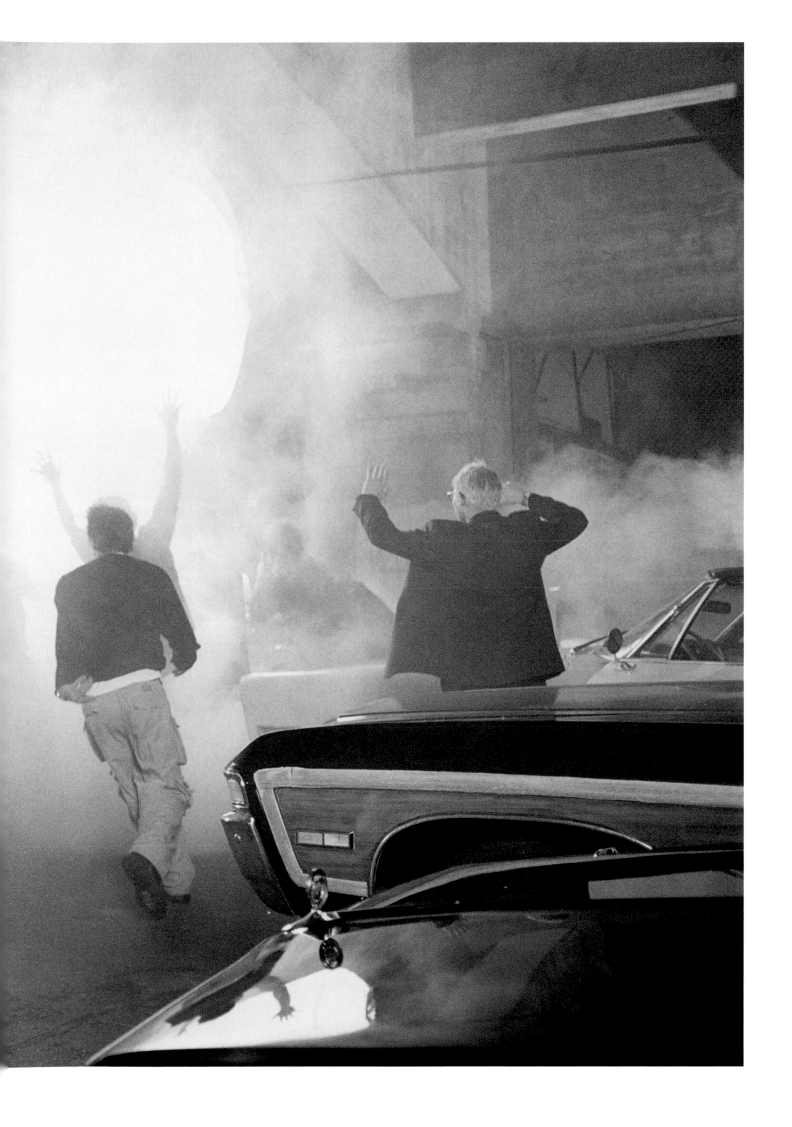

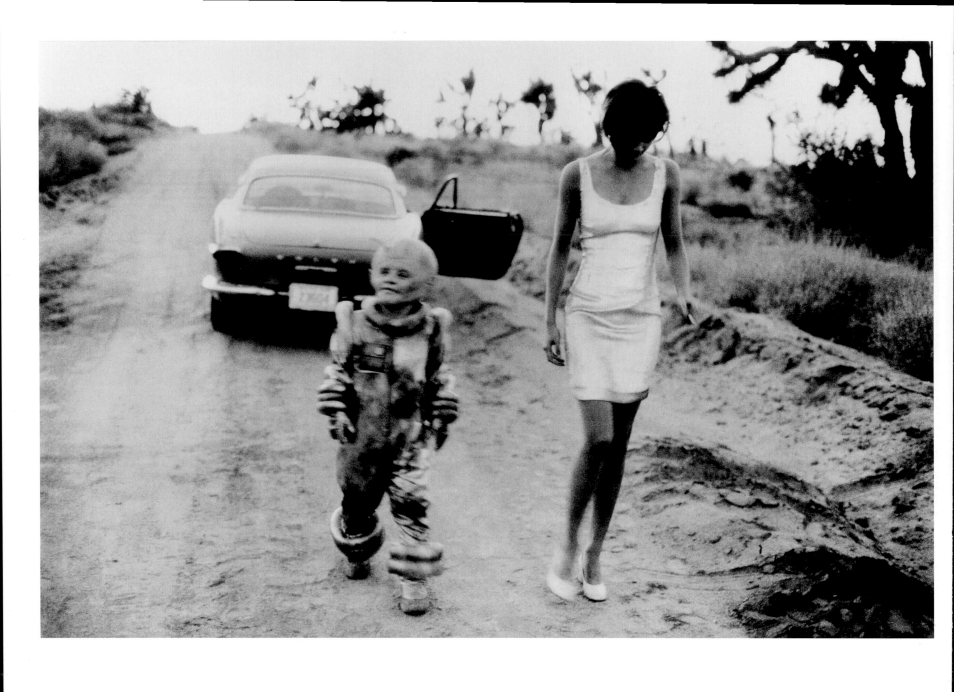

41 . peter lindbergh . helena christensen, e.t., los angeles . vogue italia . 1990

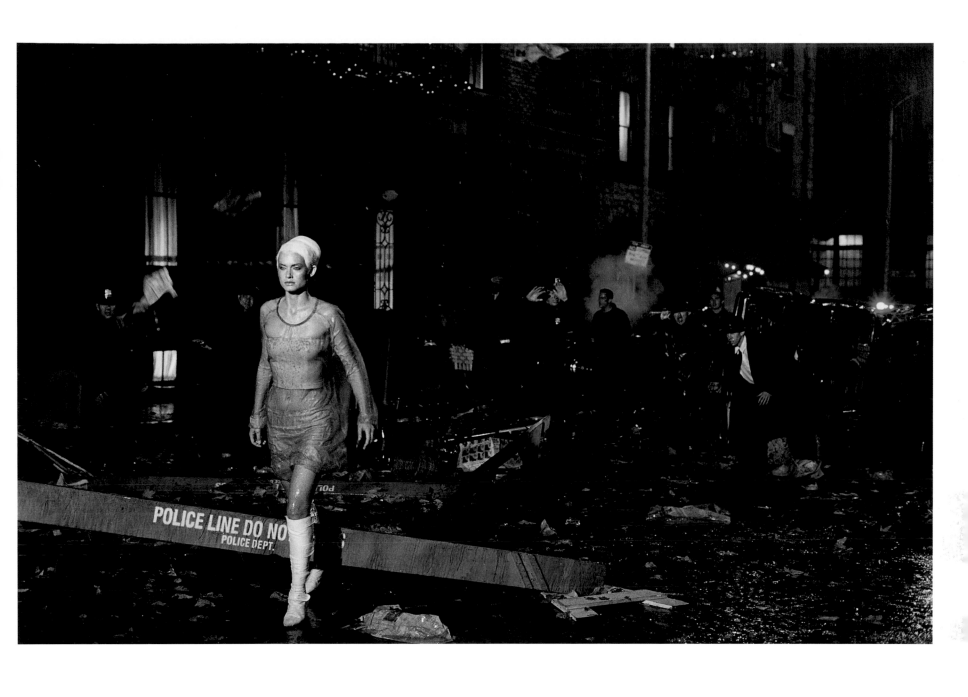

42 . peter lindbergh . amber valletta, los angeles . vogue italia . 1999

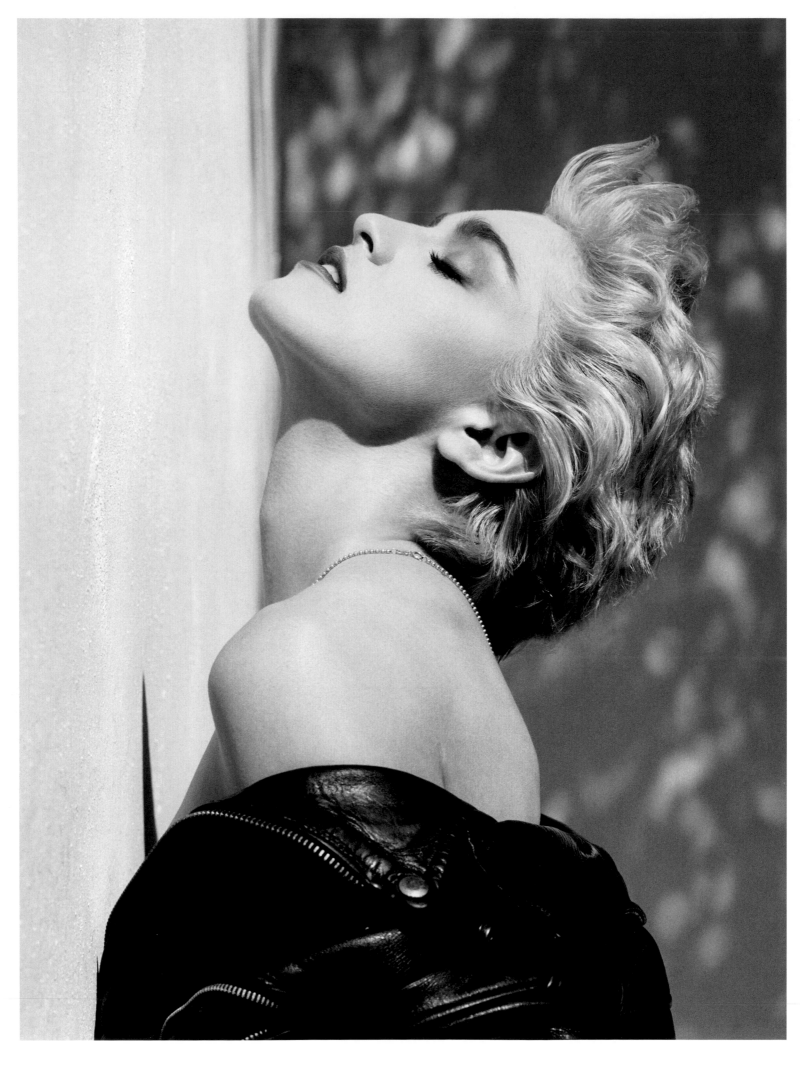

43 . herb ritts . madonna (true blue profile), hollywood . 1986

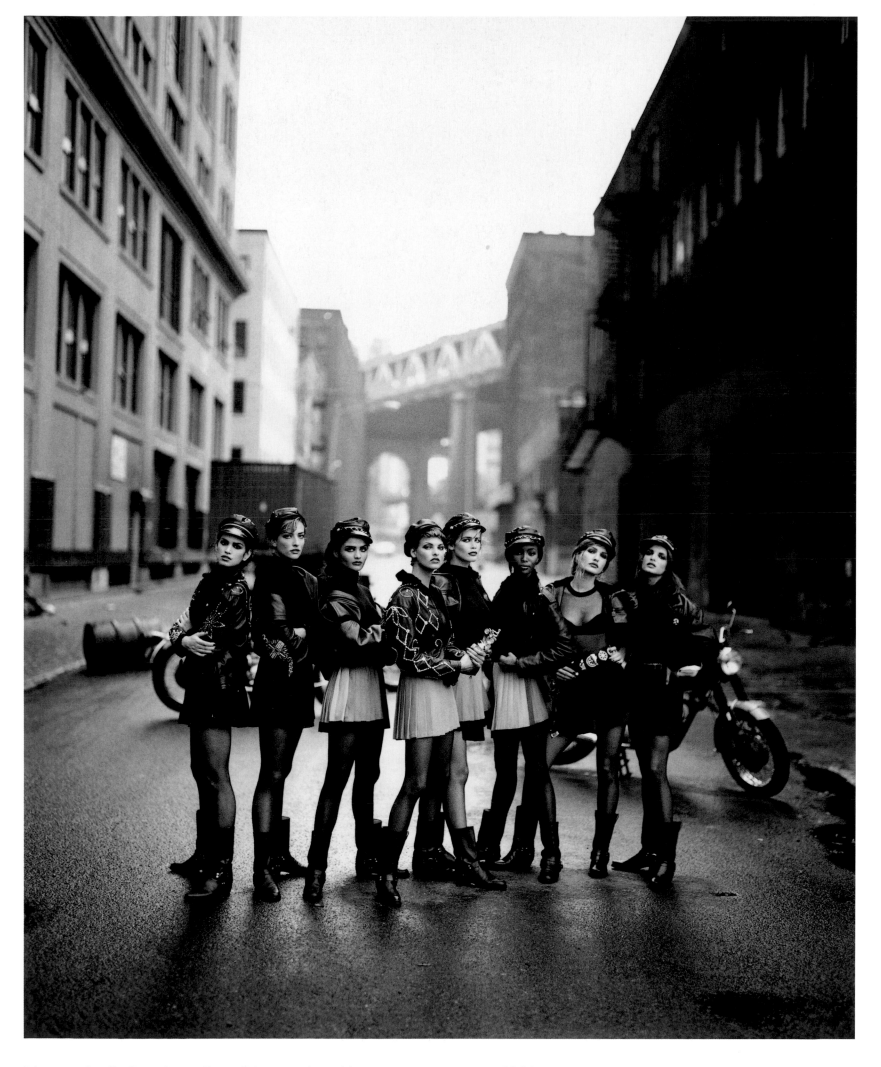

44 . peter lindbergh . the wild ones, brooklyn . vogue usa . 1991

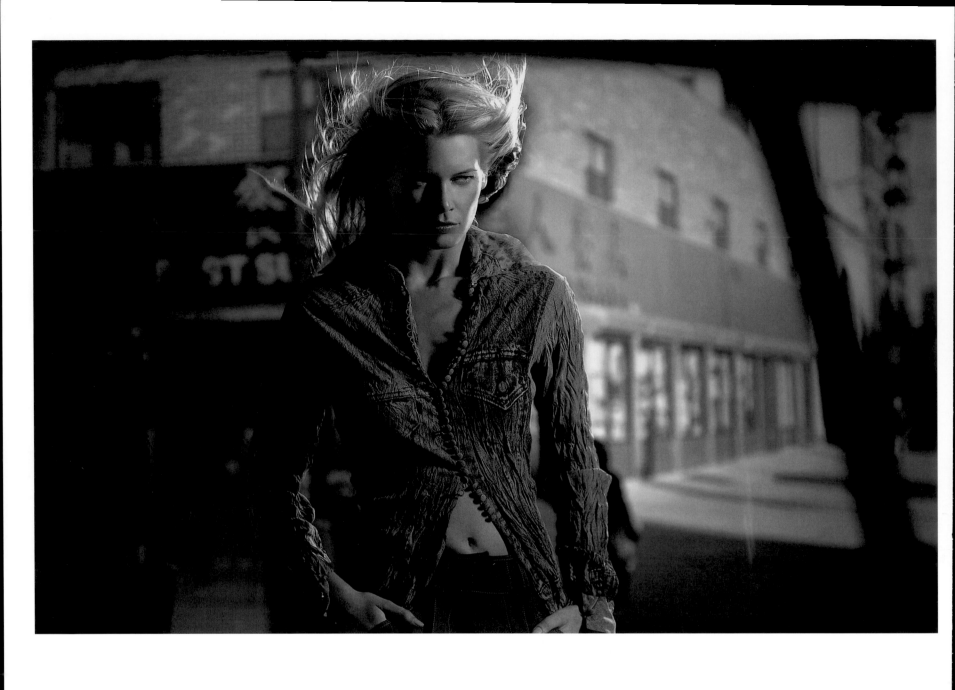

45 . stéphane sednaoui . claudia schiffer . 1999

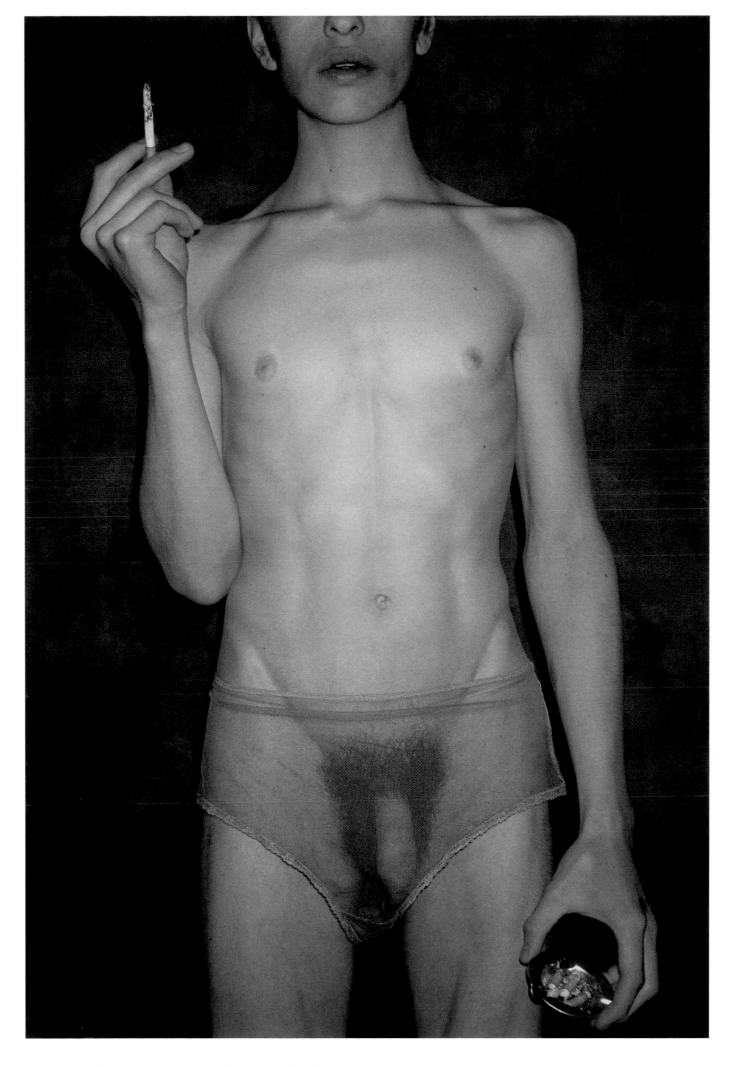

46 . matthias vriens . untitled . dutch . 1999

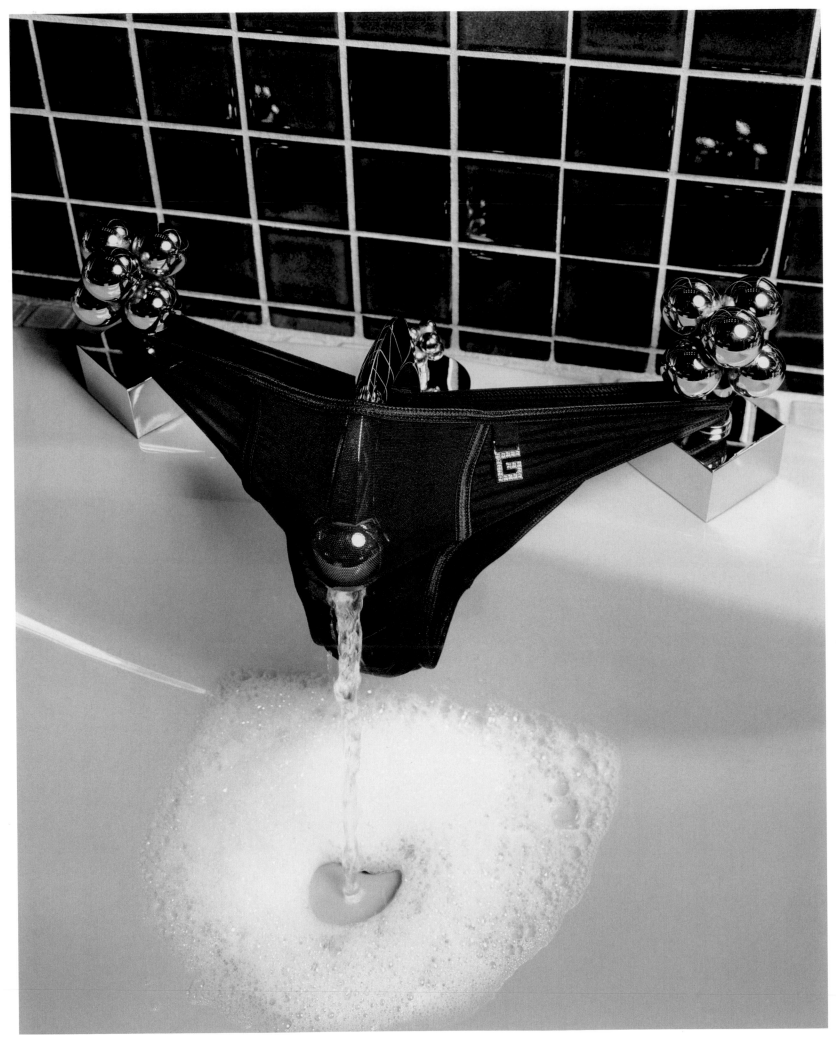

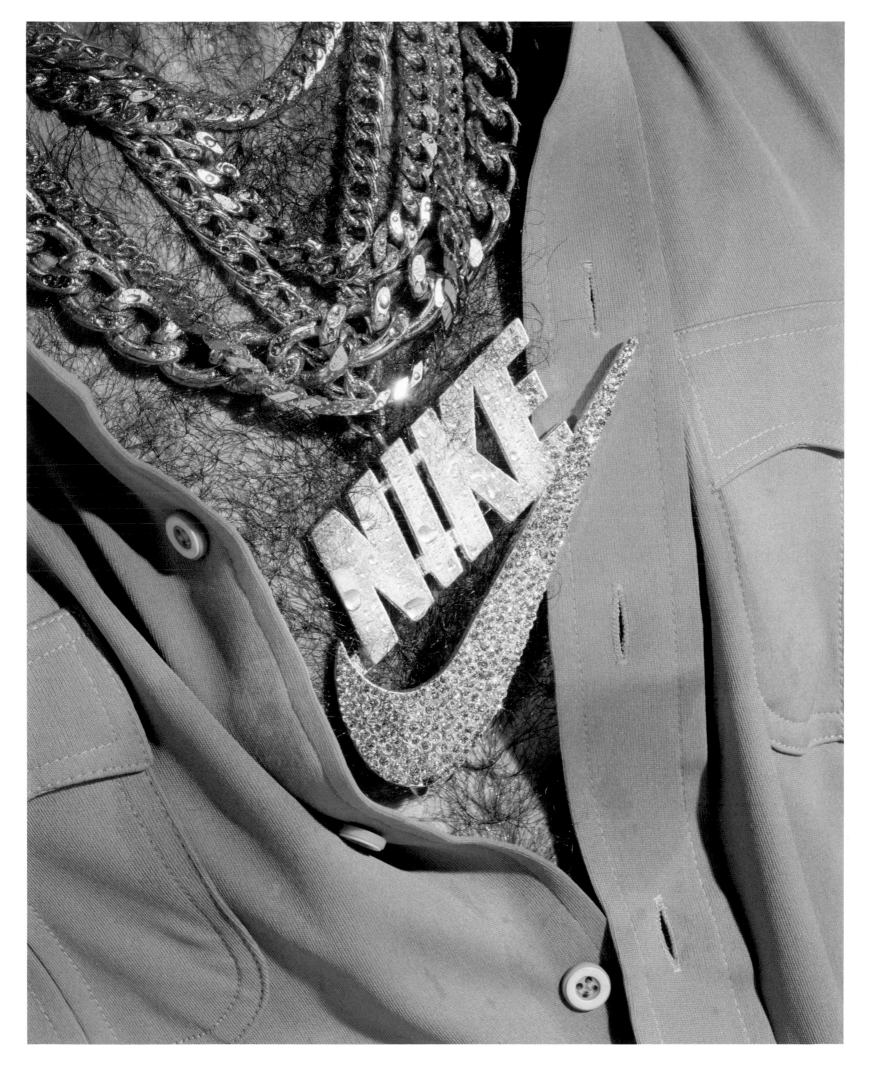

48 . james wojcik . just done it . unpublished . 1997

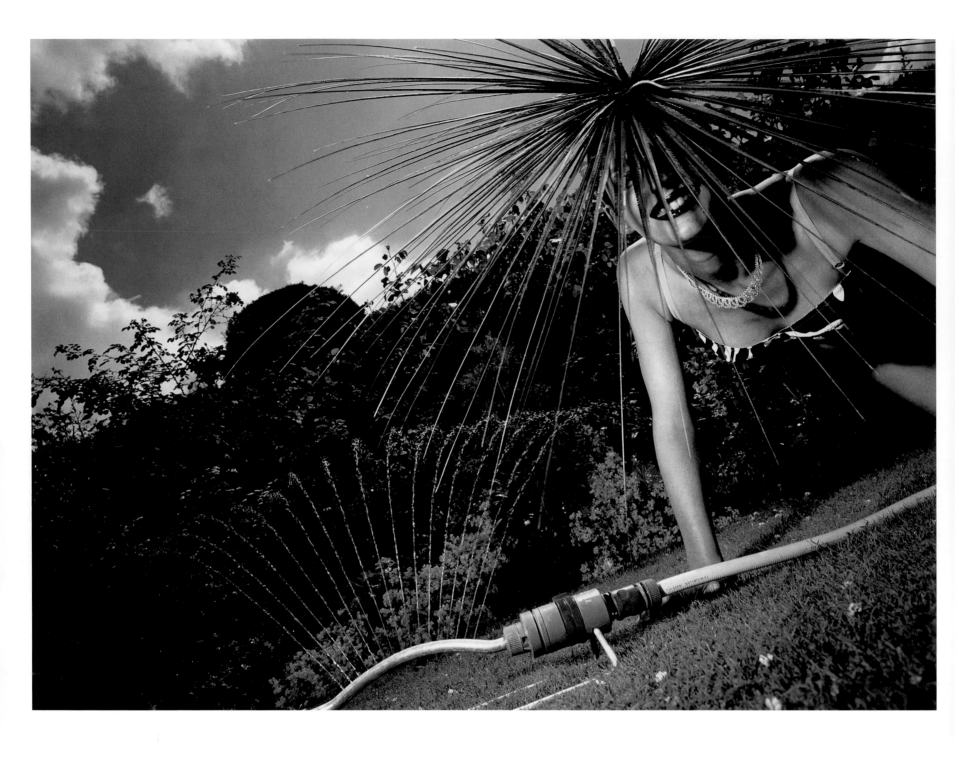

49 . steve hiett . lawn sprinkler . vogue italia . 1999

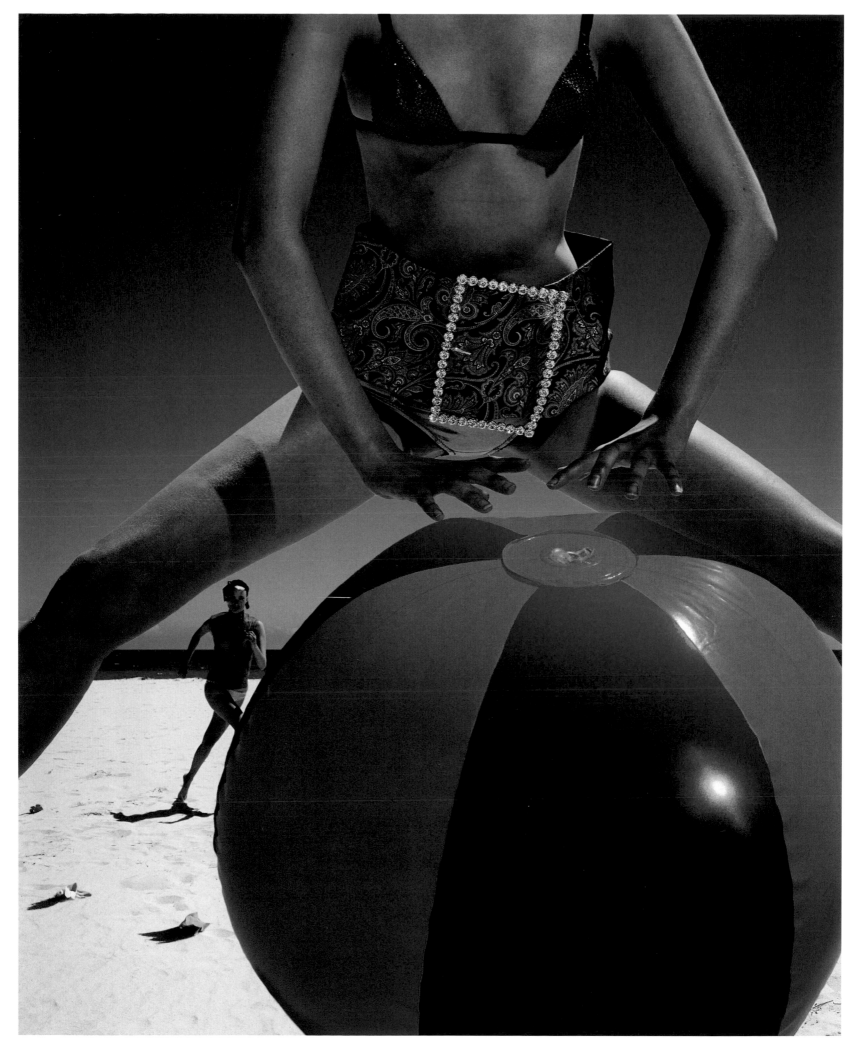

50 . thierry van biesen . saute ballon . jalouse . 2000

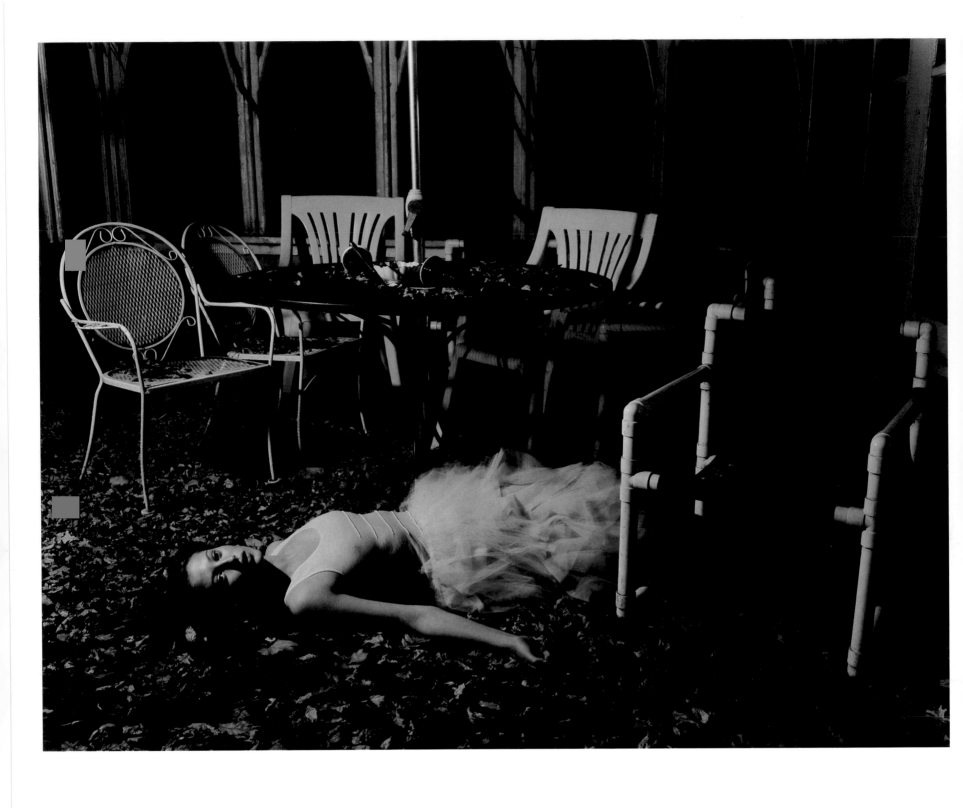

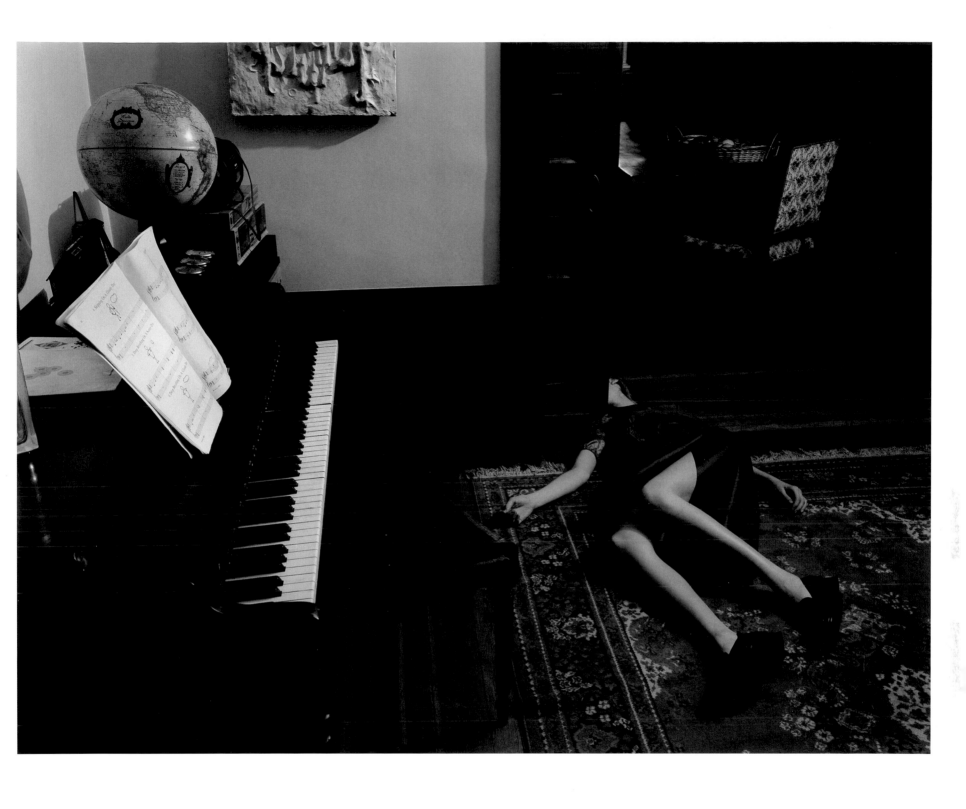

53 . mario sorrenti . dead story II . the face . 1999

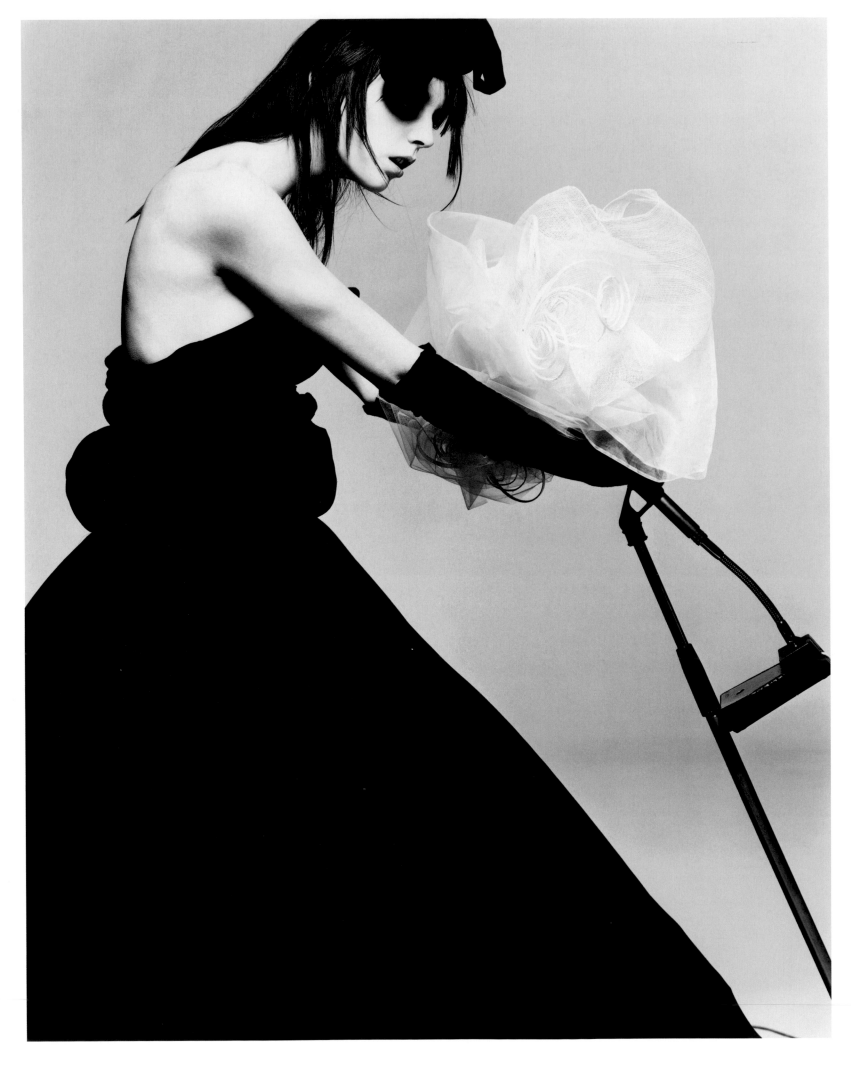

54 . inez van lamsweerde & vinoodh matadin . yamamoto, hannelore (mic) . 1998

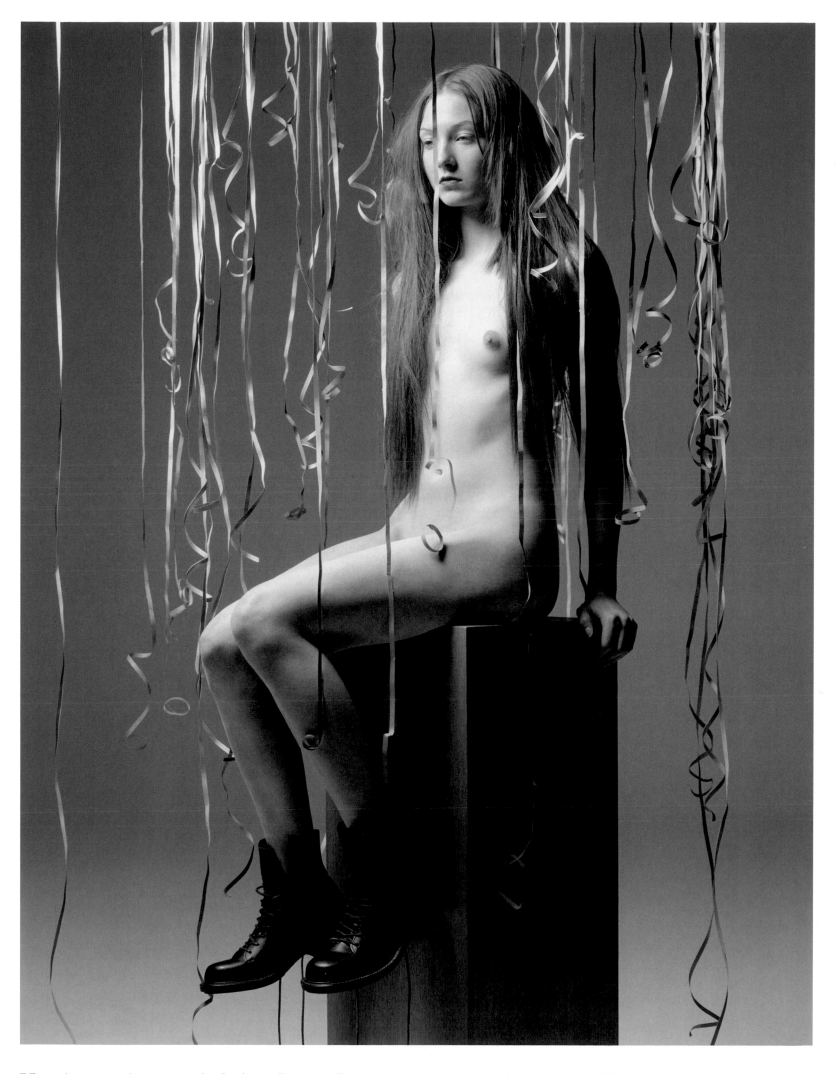

55 . inez van lamsweerde & vinoodh matadin . yamamoto, maggie nude . 1997

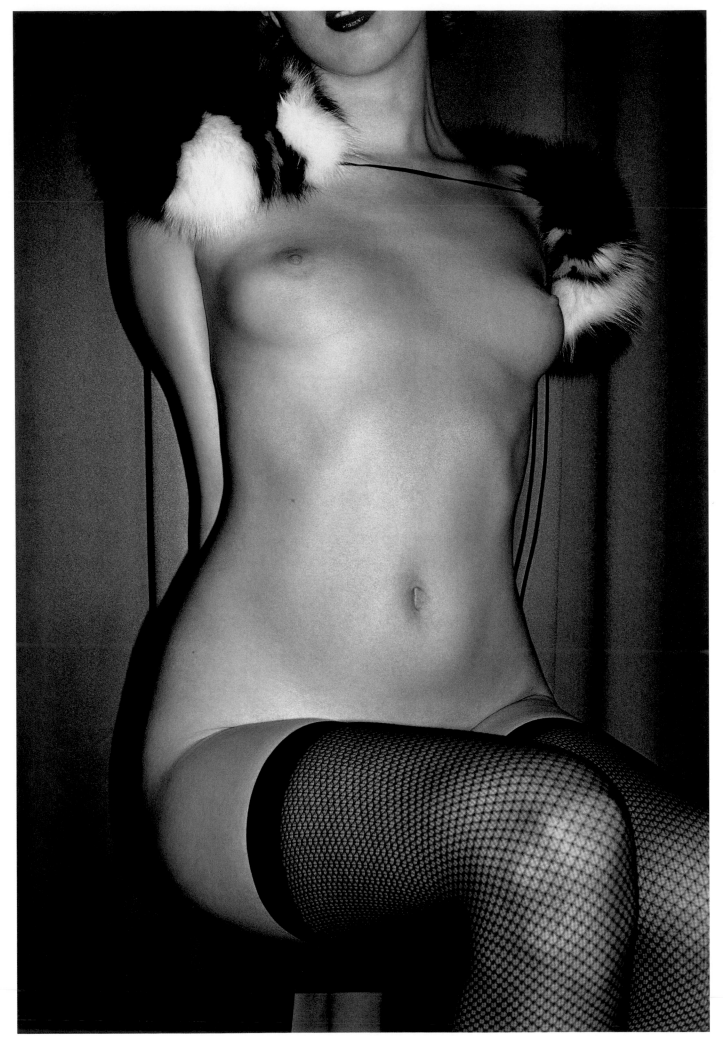

56 . matthias vriens . untitled . dutch . 2000

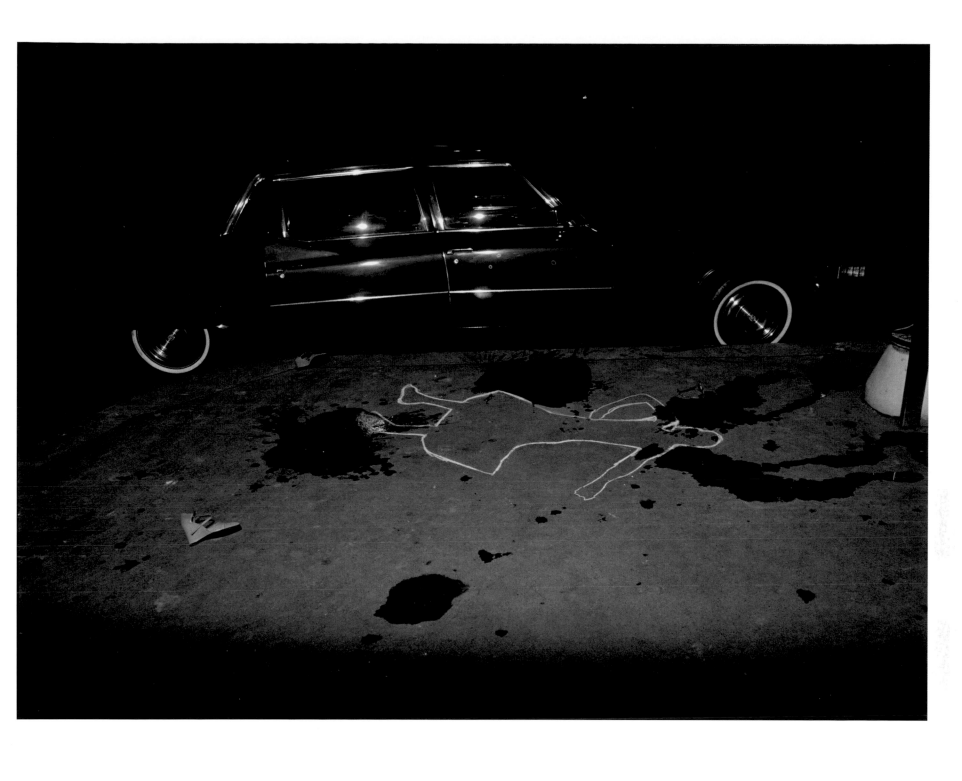

57 . guy bourdin . charles jourdan . 1975

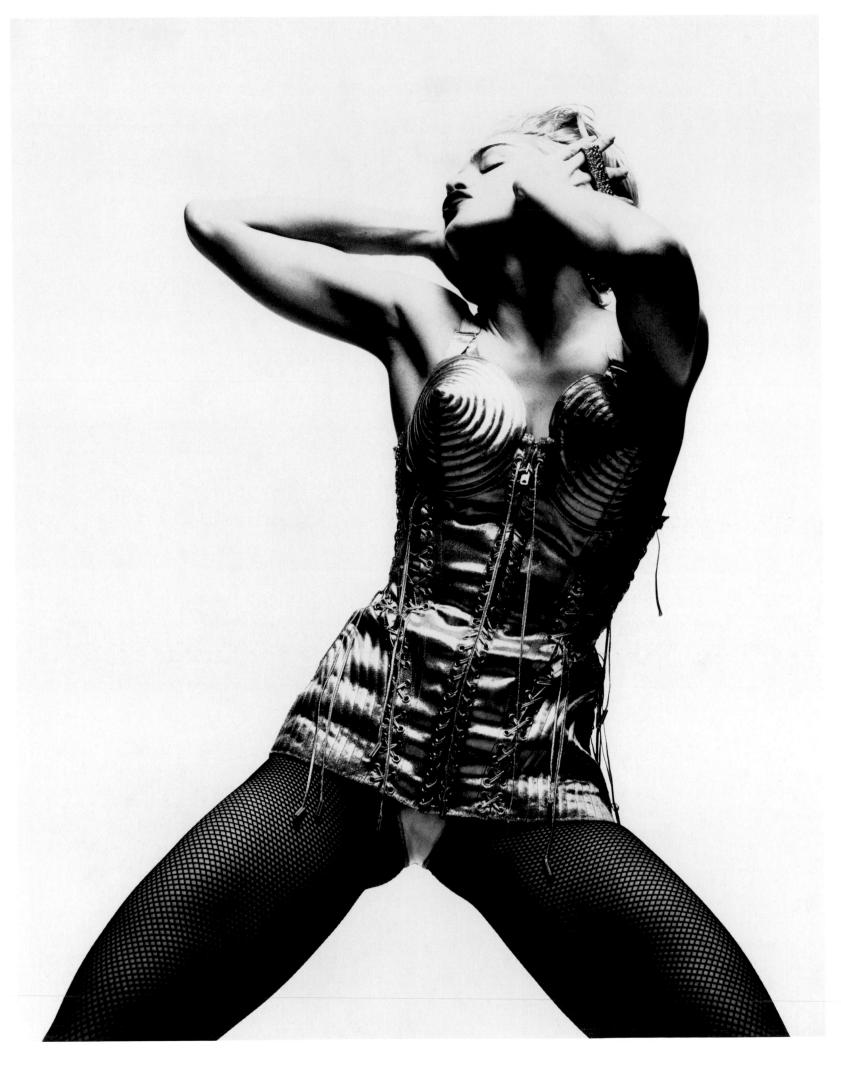

58 . jean-baptiste mondino . madonna . jean-paul gaultier bustier . 1987

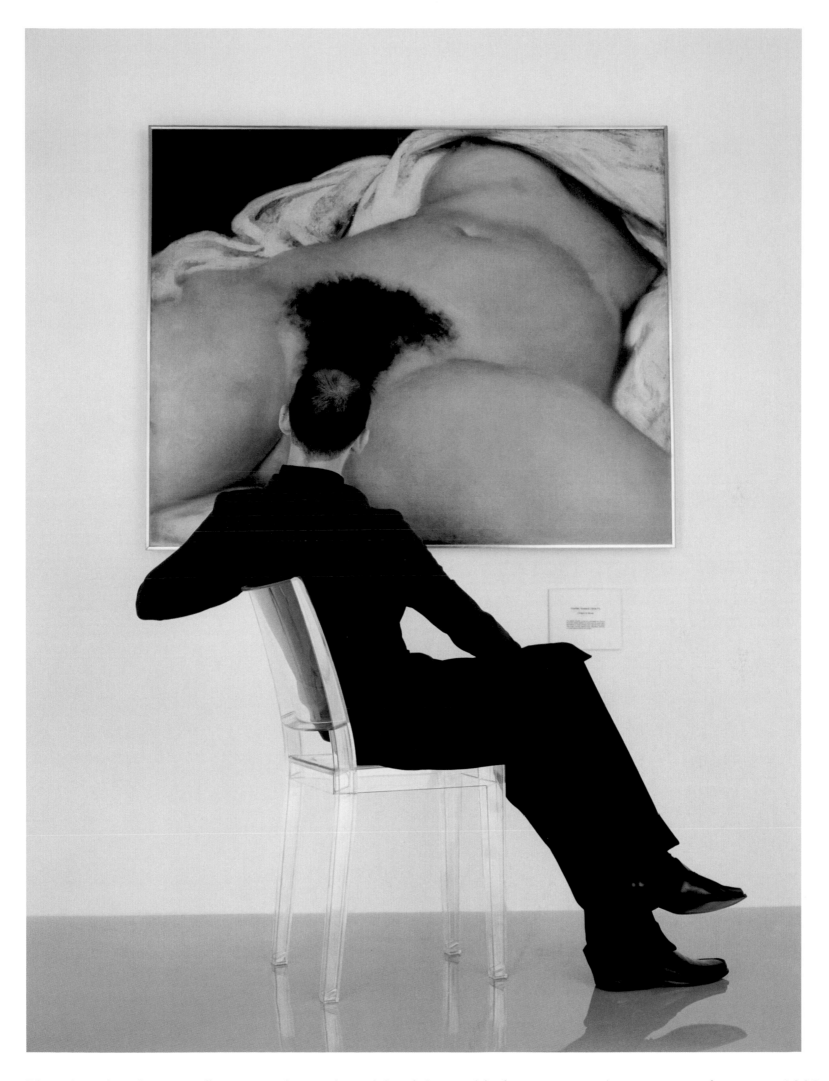

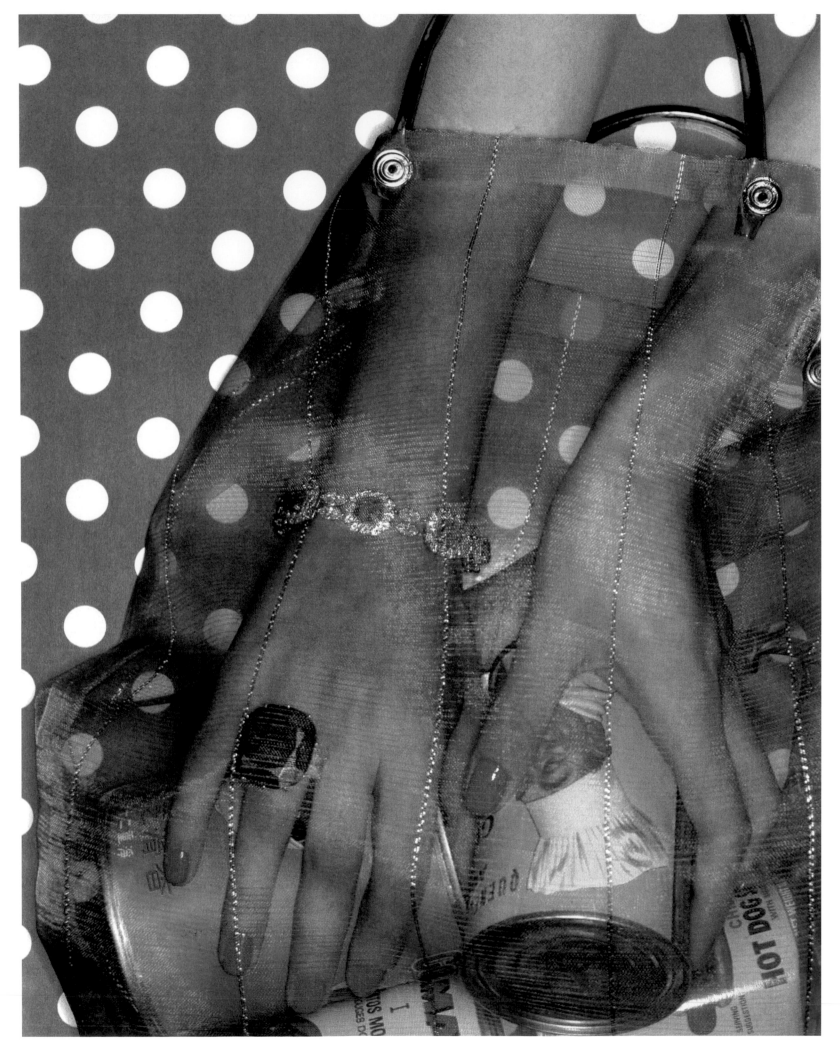

60 . laurence sackman . untitled . bazaar italia . 1974

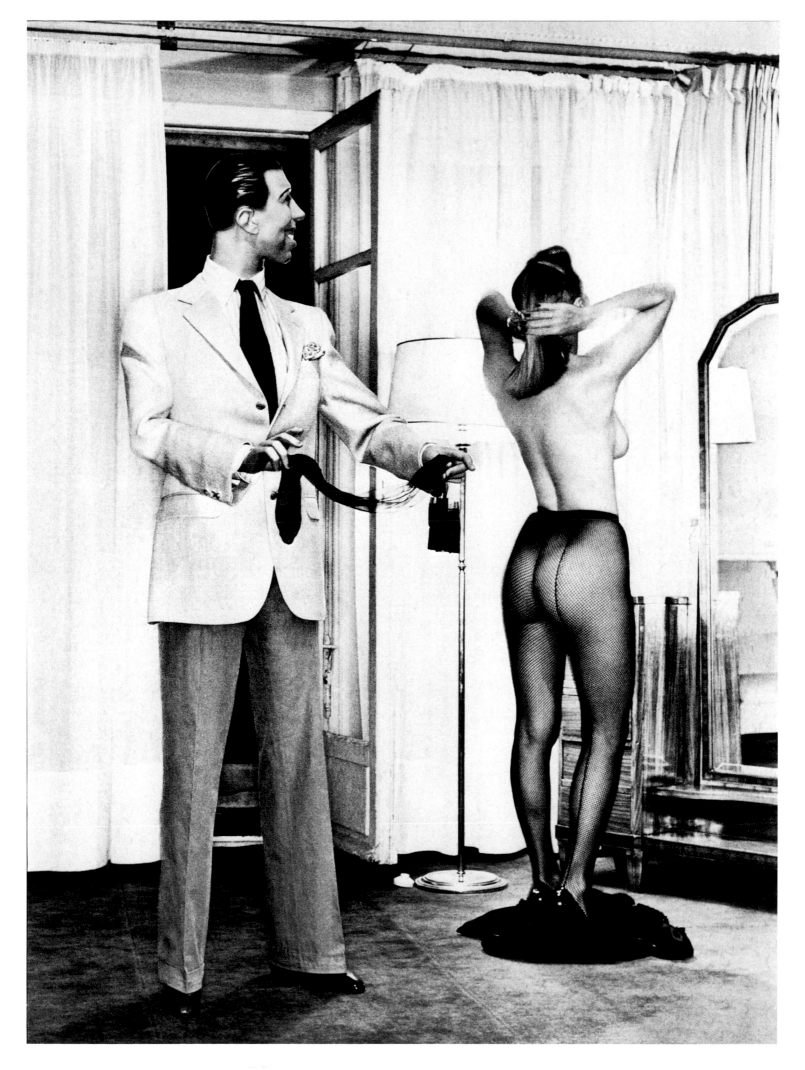

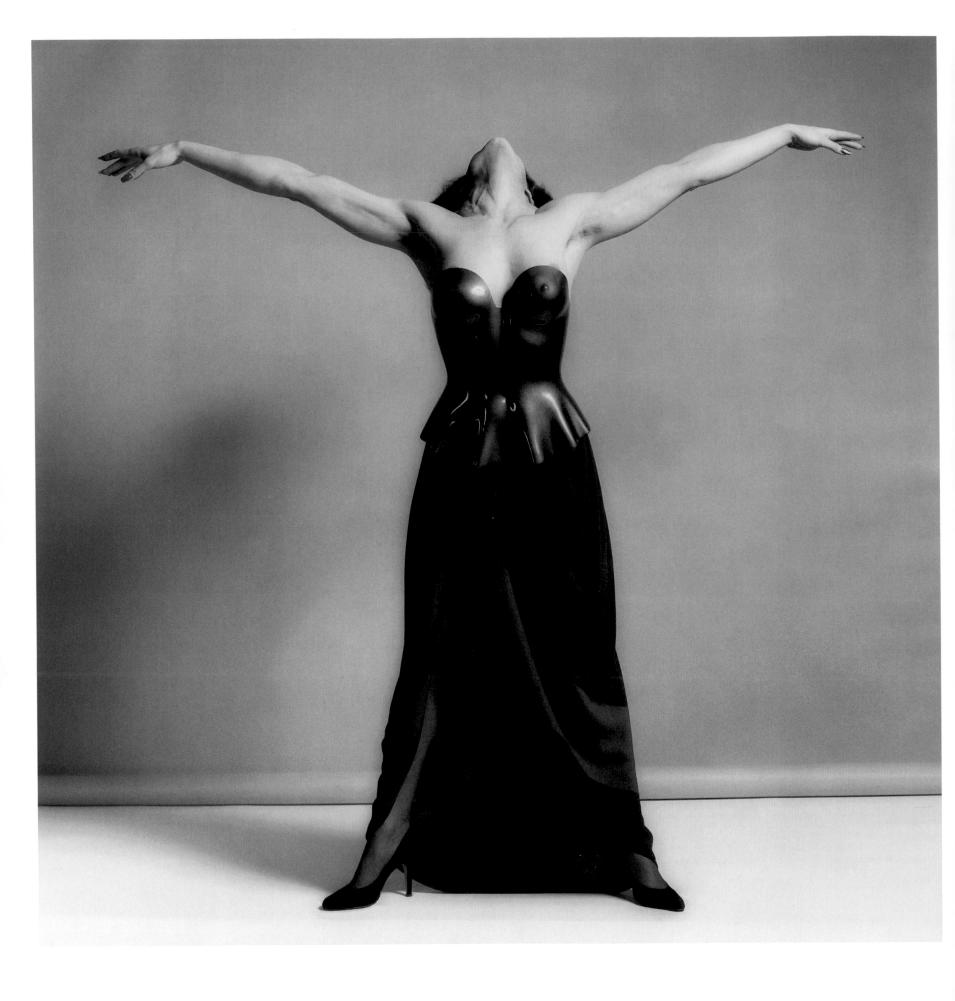

62 . robert mapplethorpe . lisa lyon . 1982

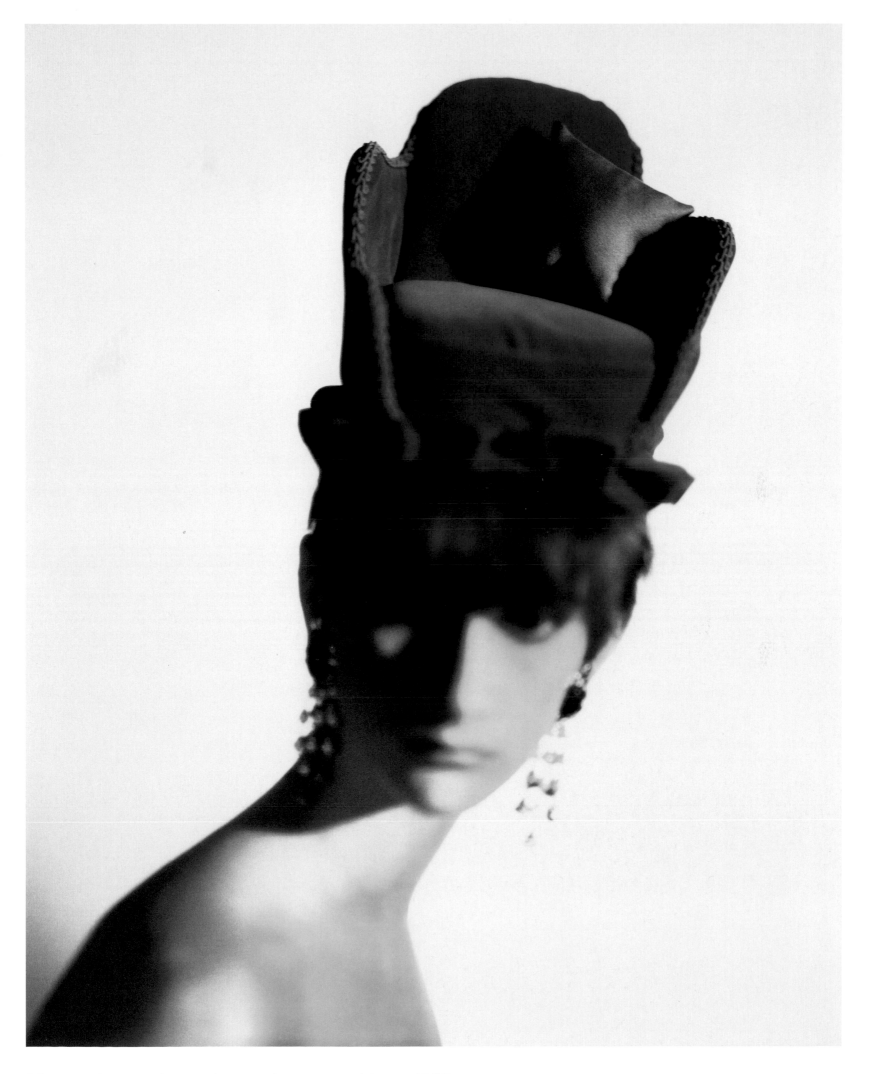

63 . paolo roversi . audrey, paris . max mixte . 1998

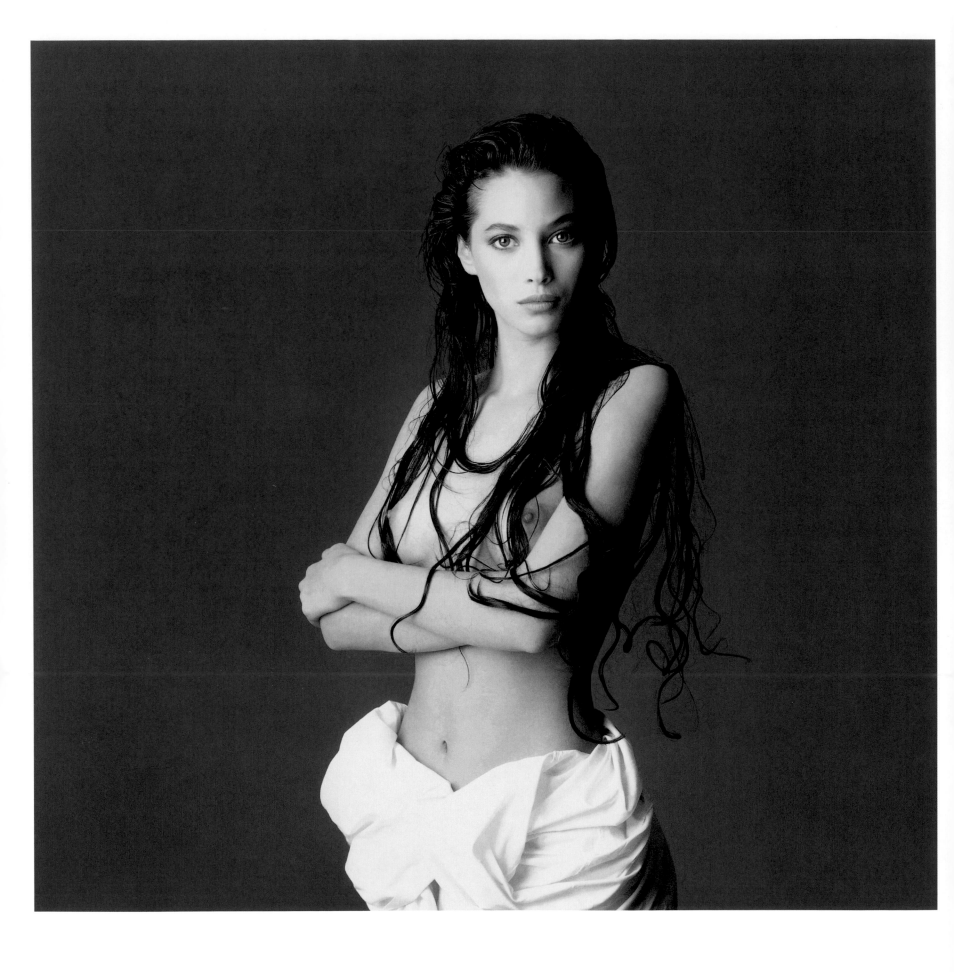

64 . patrick demarchelier . christy, new york . 1986

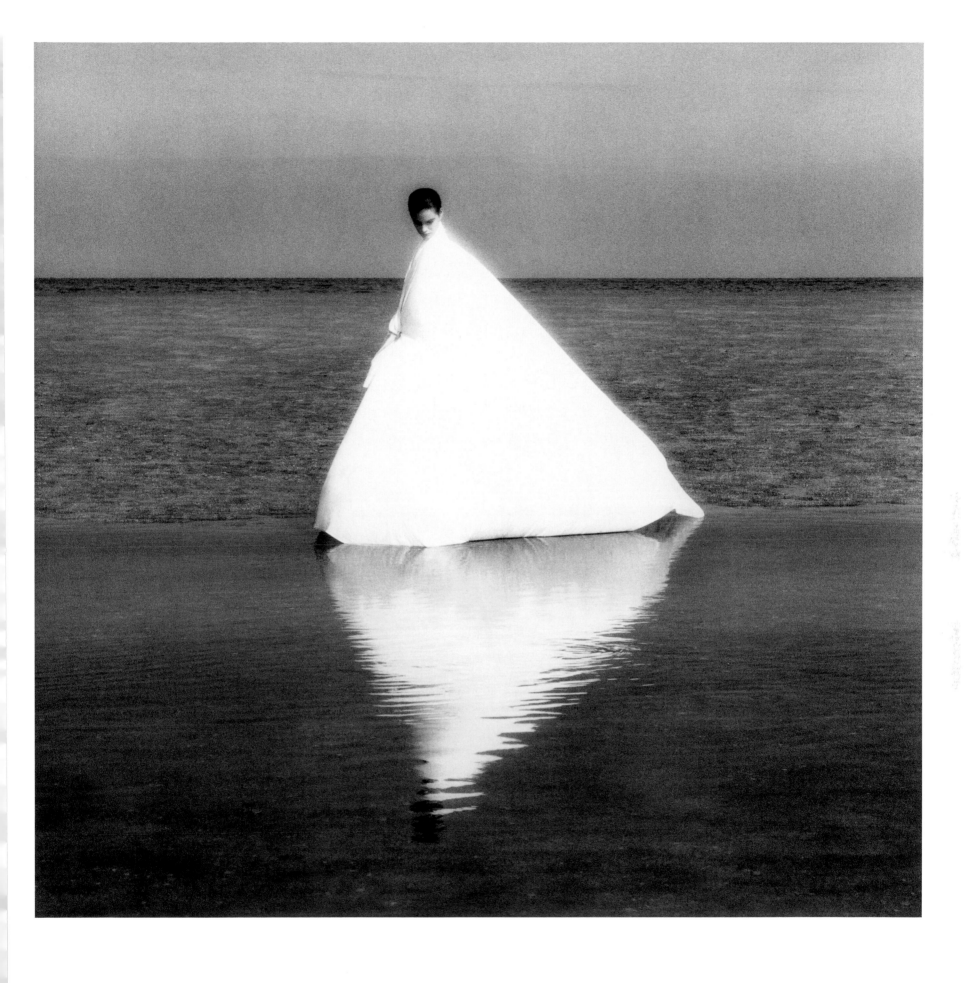

65 . dominique issermann . susan hauser . parko calendar, japan . 1985

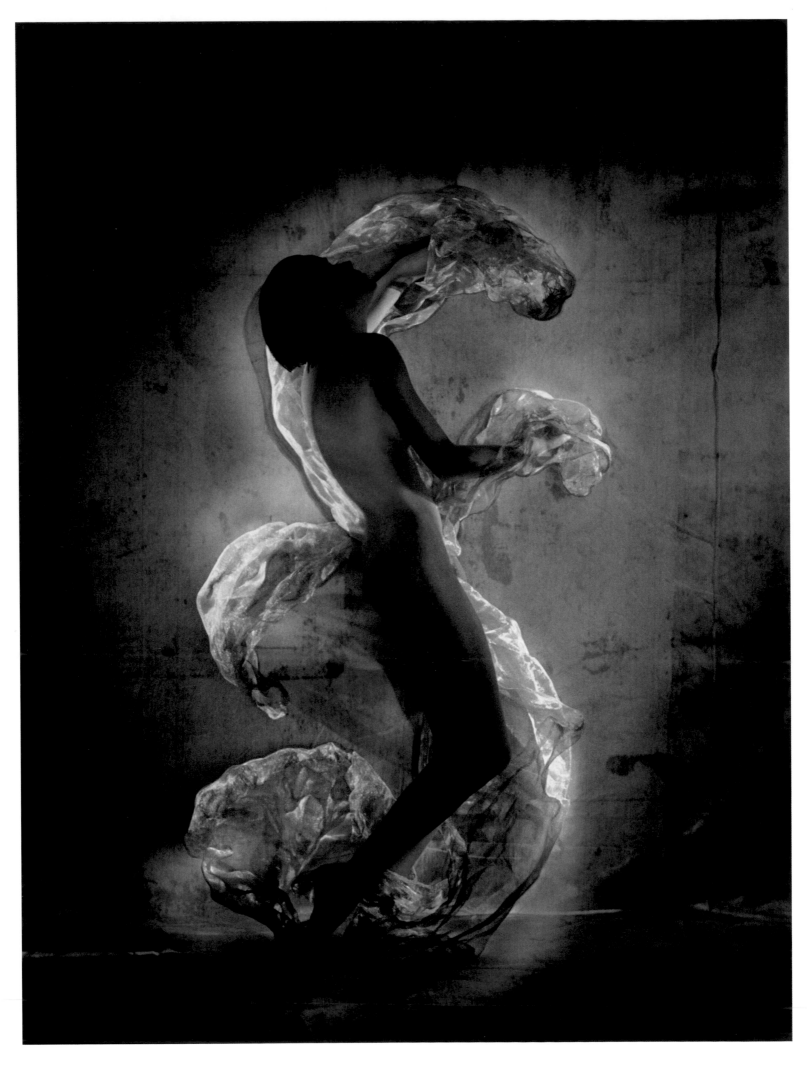

68 . javier vallhonrat . lettre f . vogue gioielli, italia . 1989

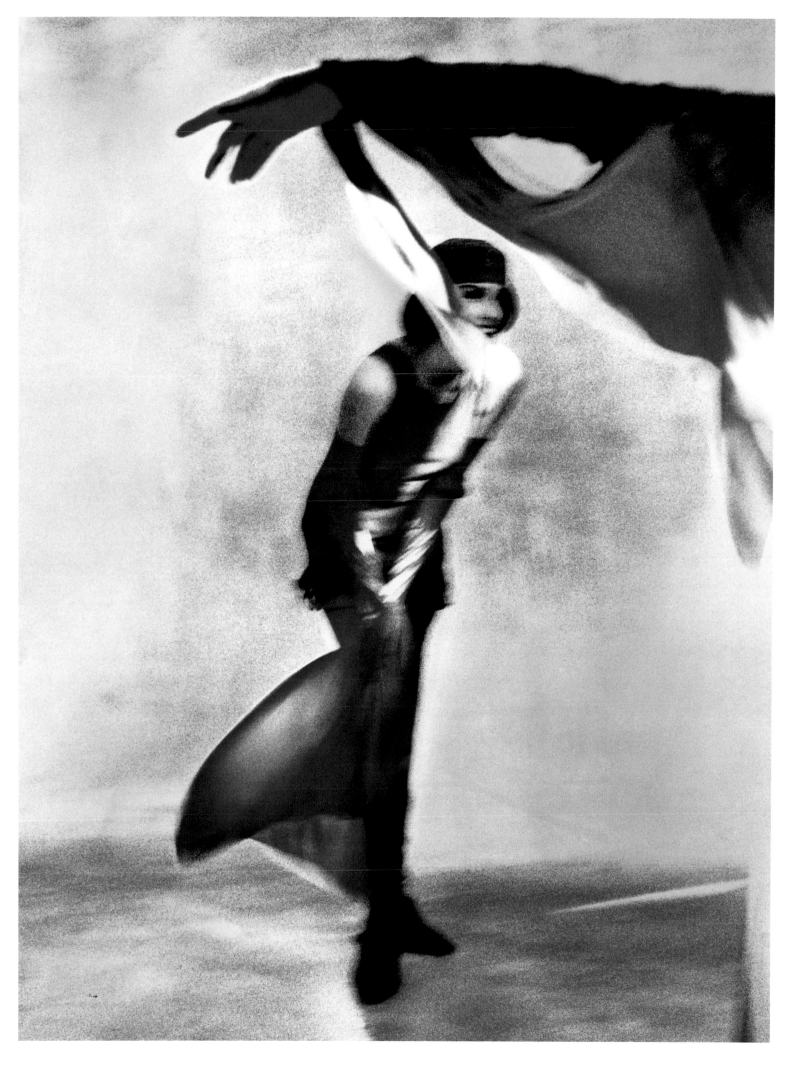

69 . javier vallhonrat . john galliano, red . press international, catalogue . 1988

75 . jean-pierre khazem . east of eden I . details . 2000

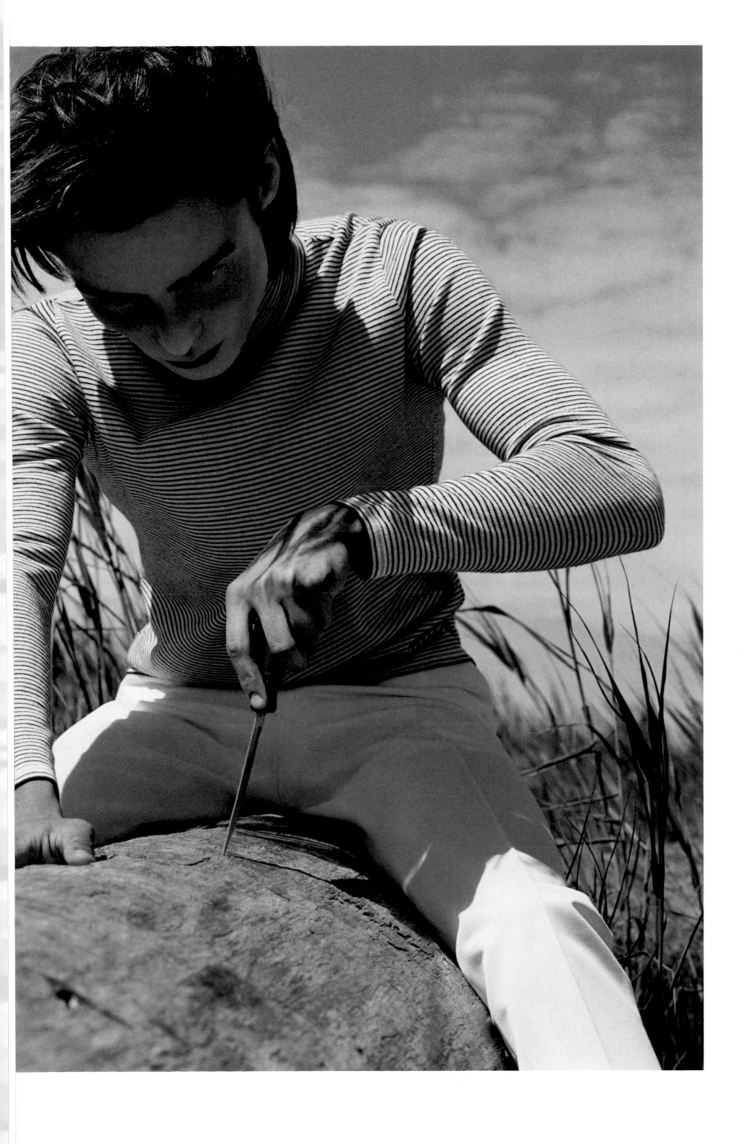

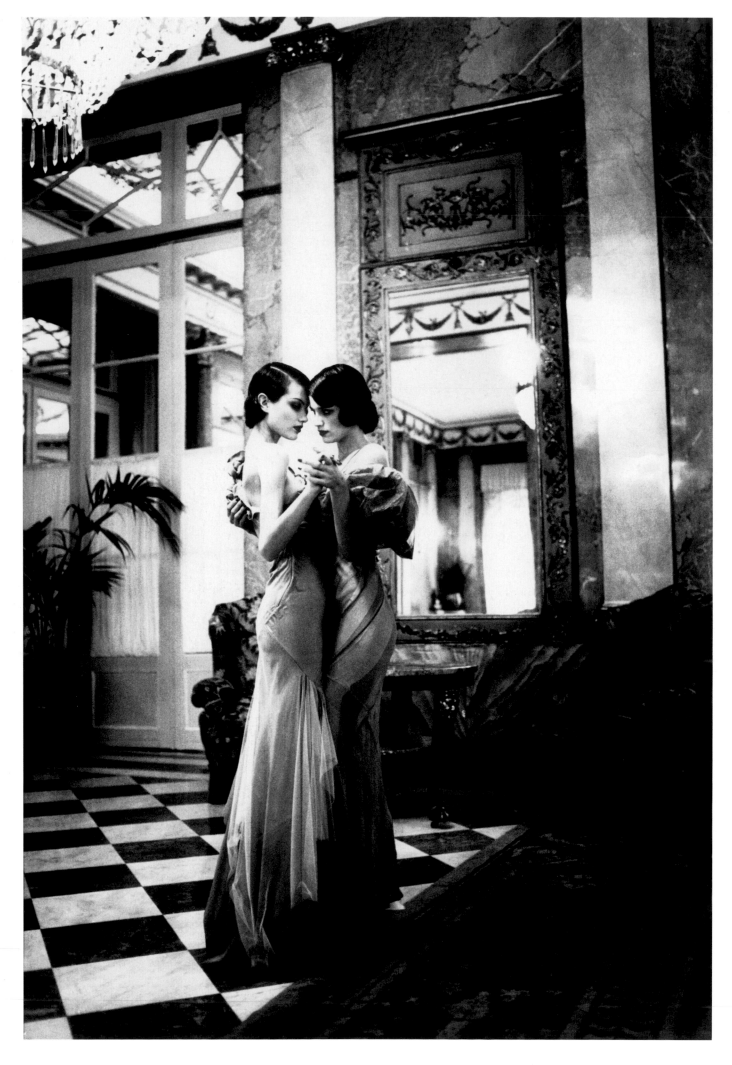

80 . ellen von unwerth . galliano, paris . 1993

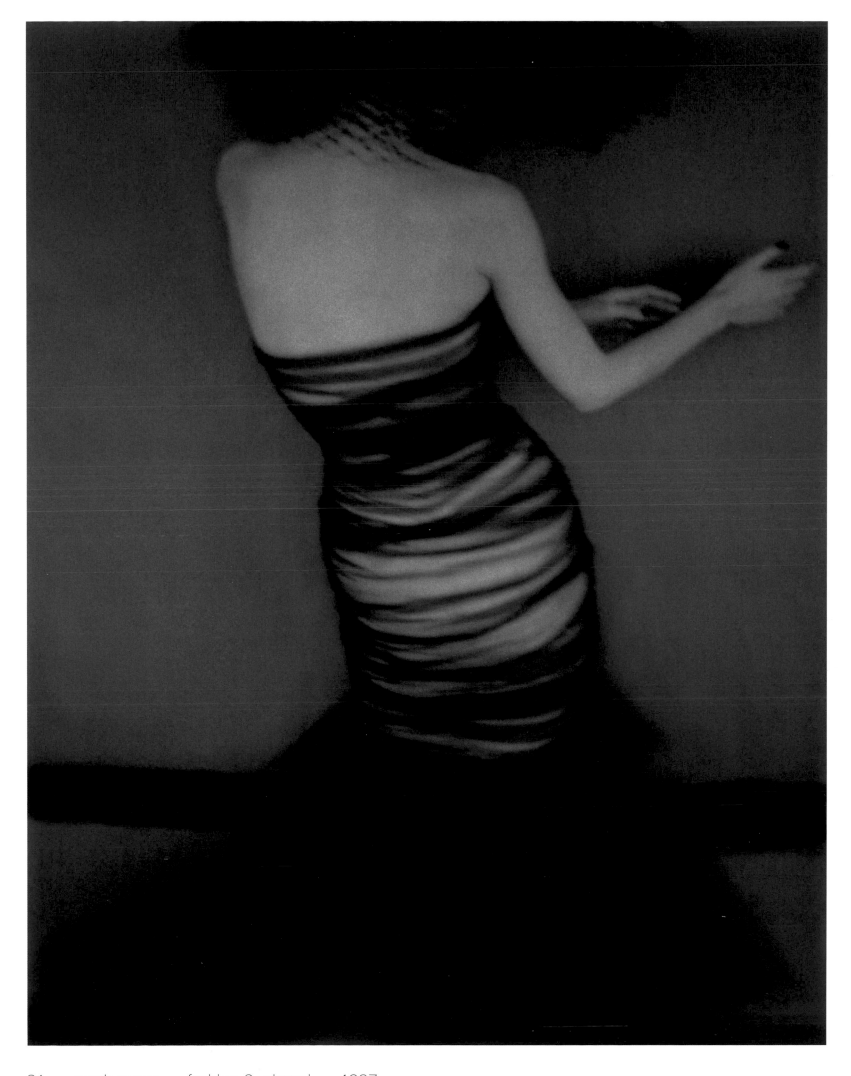

81 . sarah moon . fashion 3, chanel . 1997

punk rock

punk rock

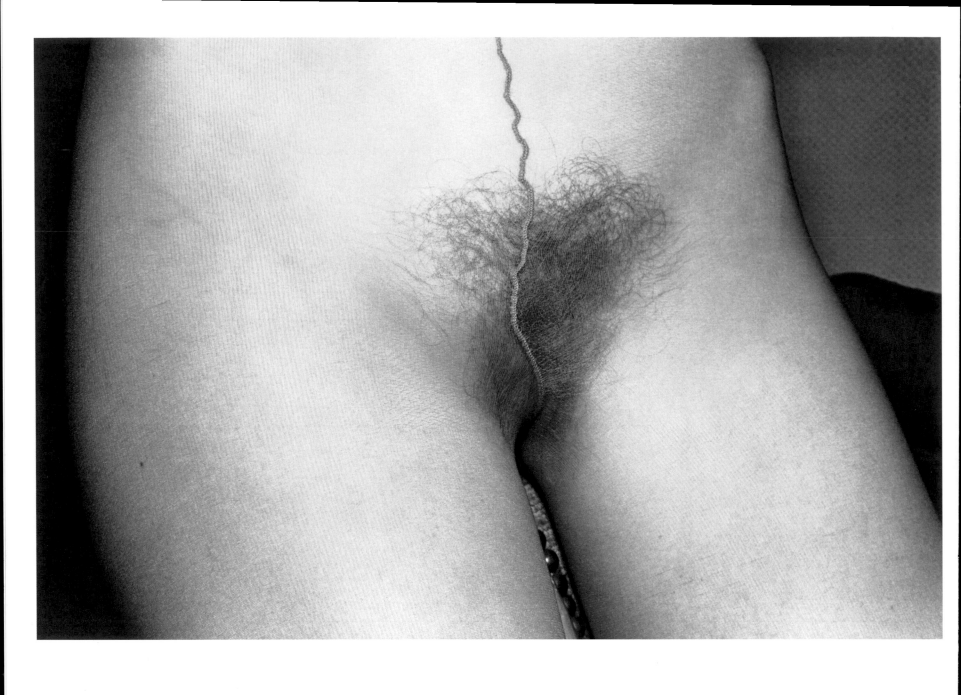

88 . laurence sackman . the seam . 1973

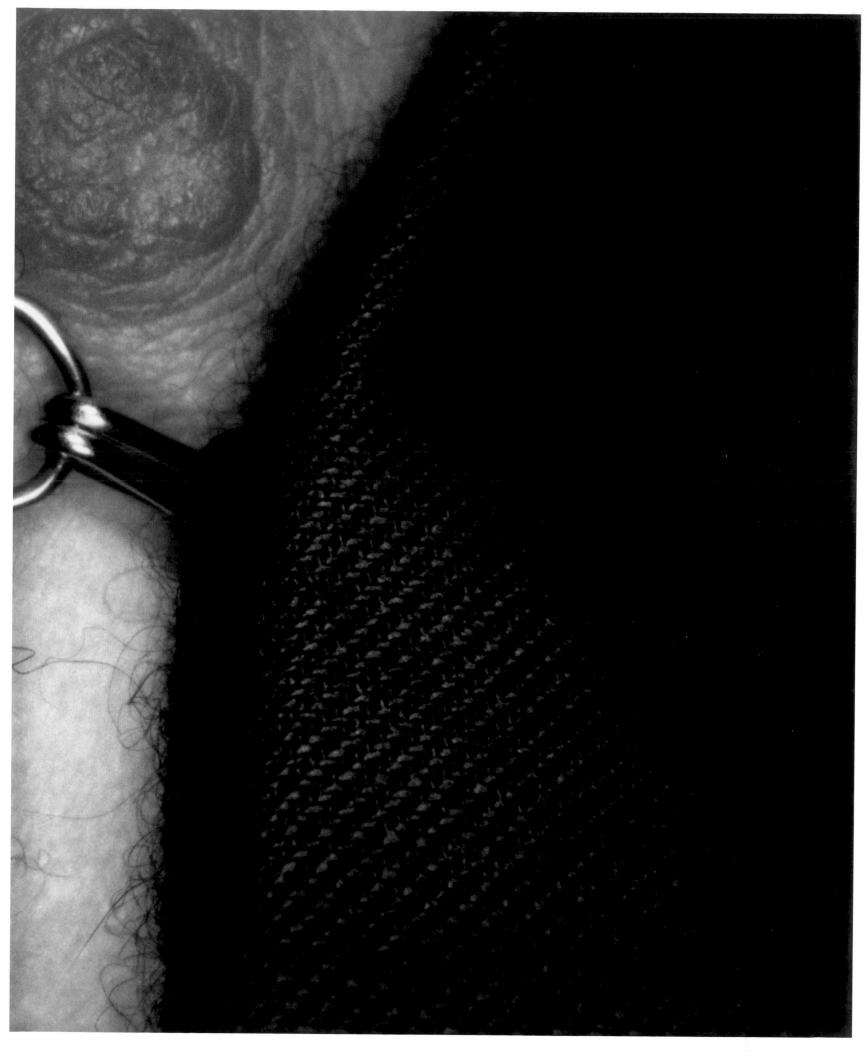

89 . dino dinco . untitled (heather-comme des garçons) . *surface magazine . 1998

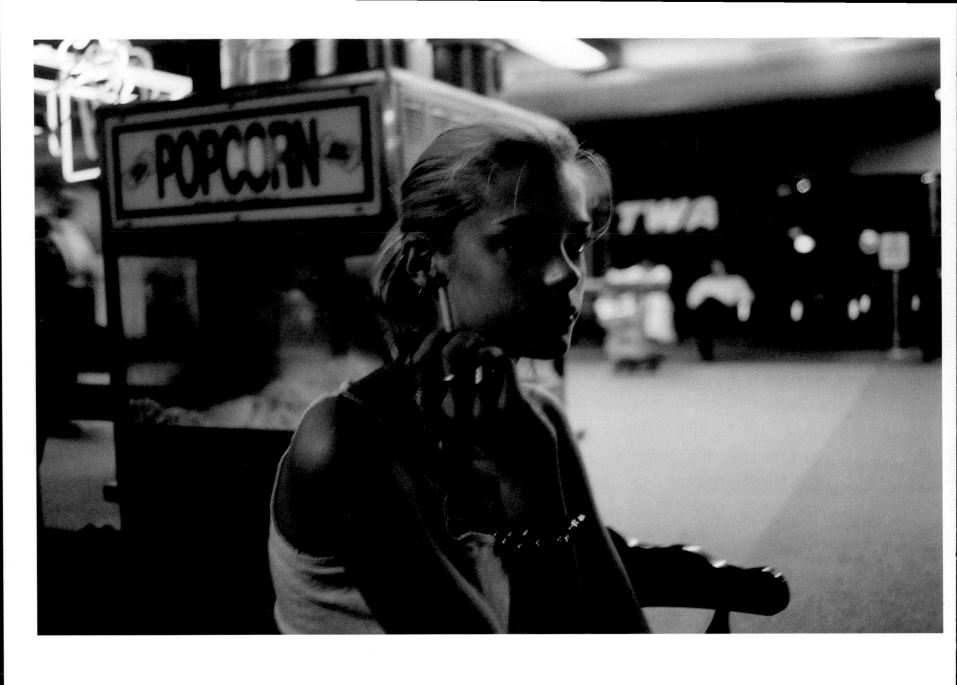

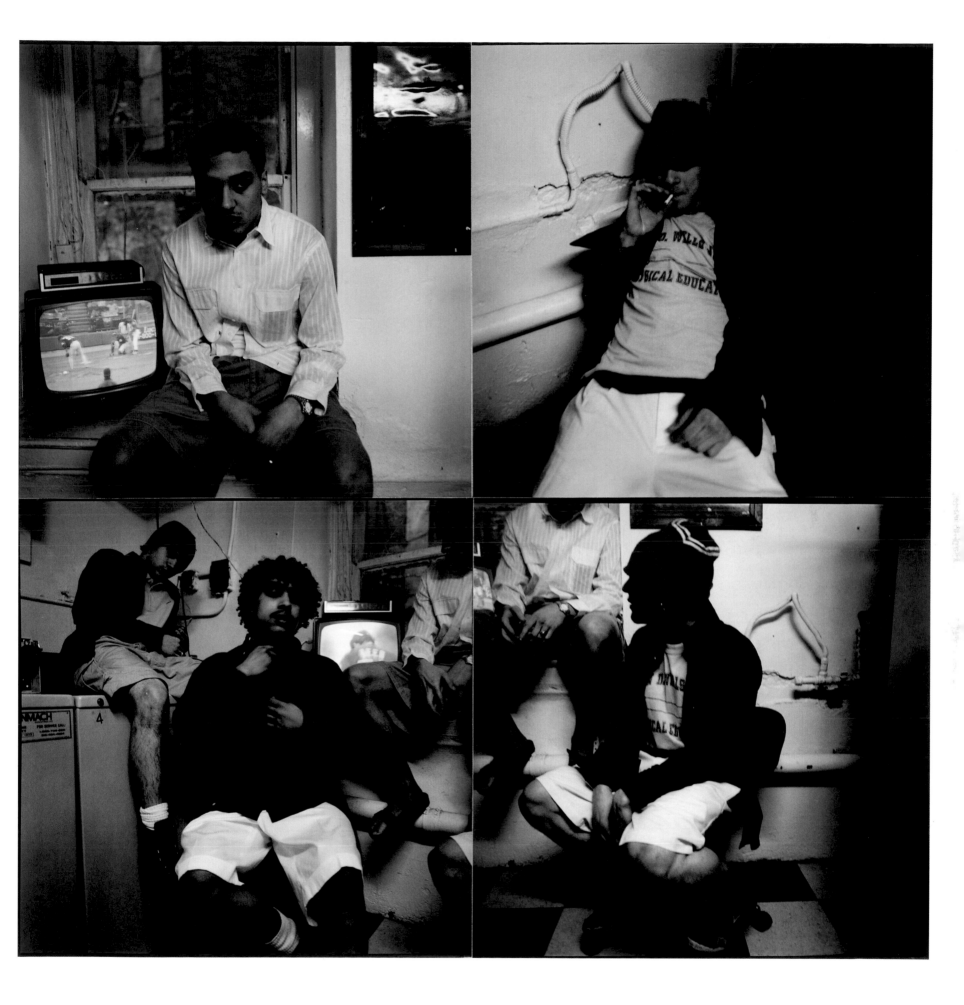

91 . davide sorrenti . untitled . interview magazine . 1996

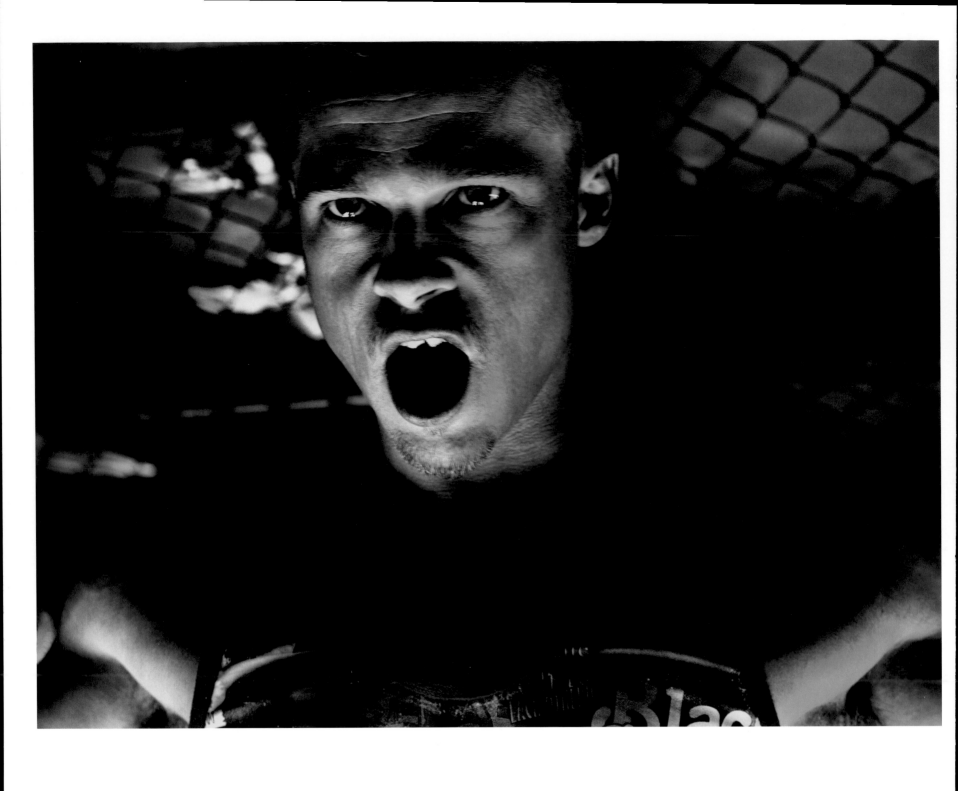

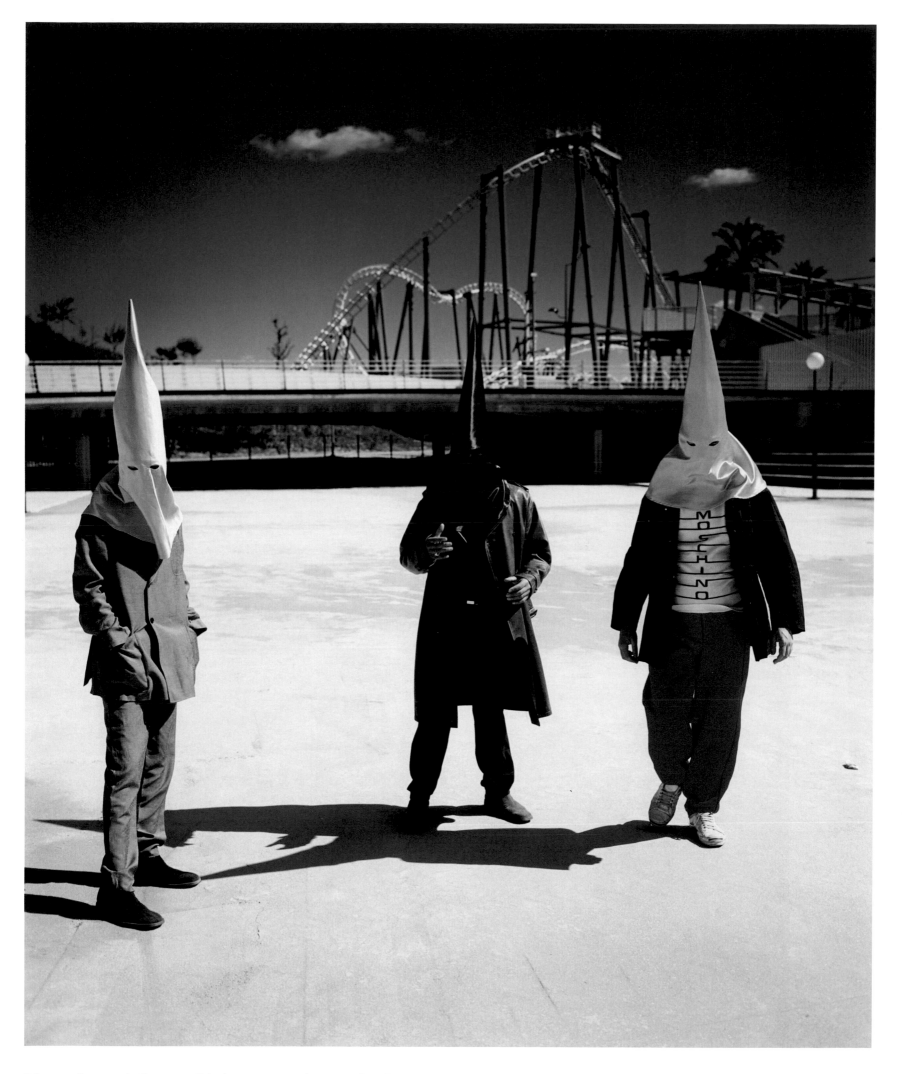

93 . pierre winther . this is not america . dutch . 1998

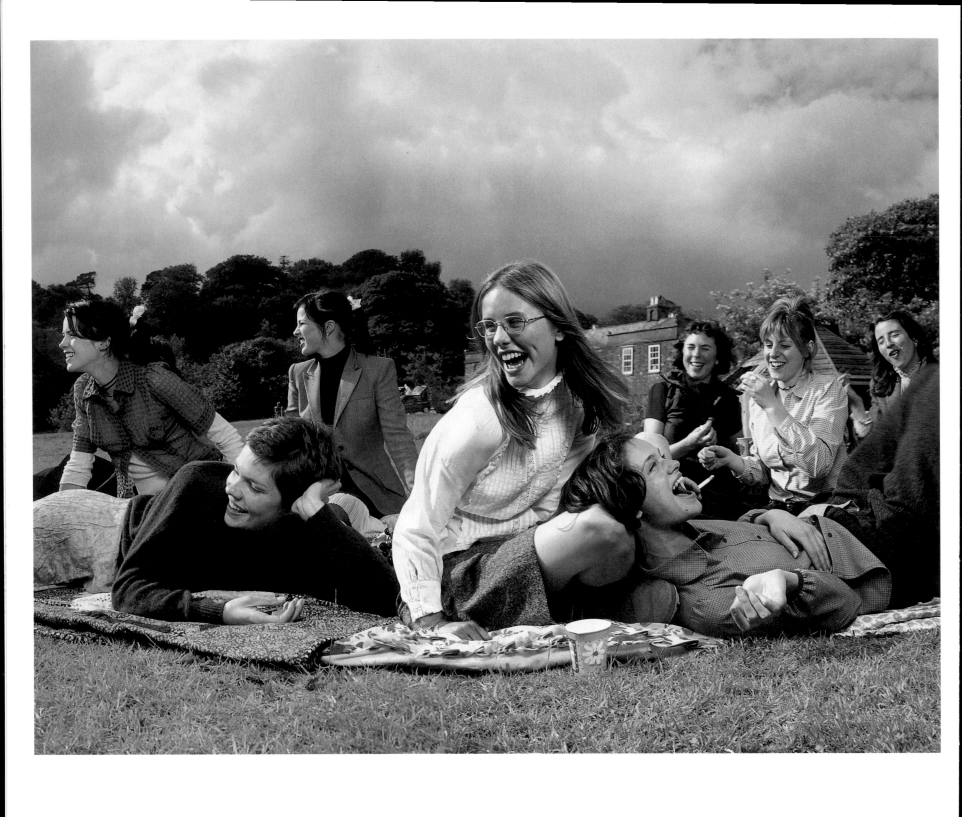

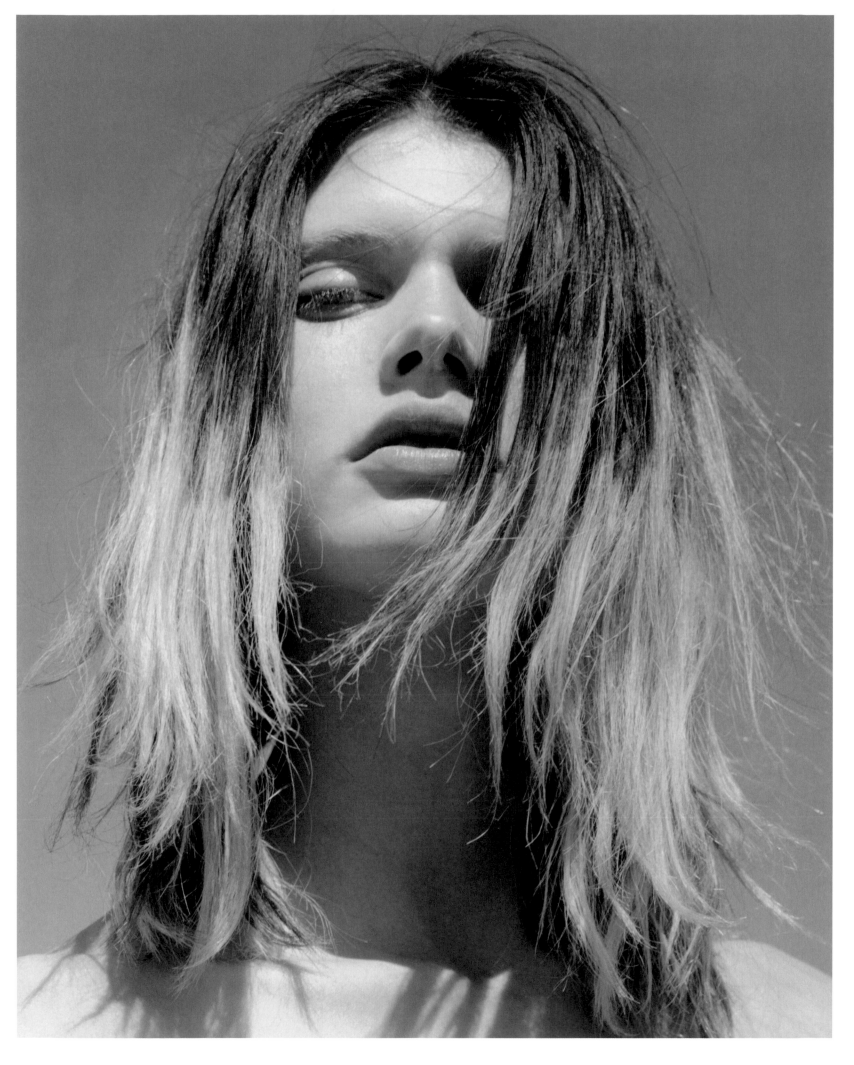

97 . david sims . malgosia, jil sander II . 1999

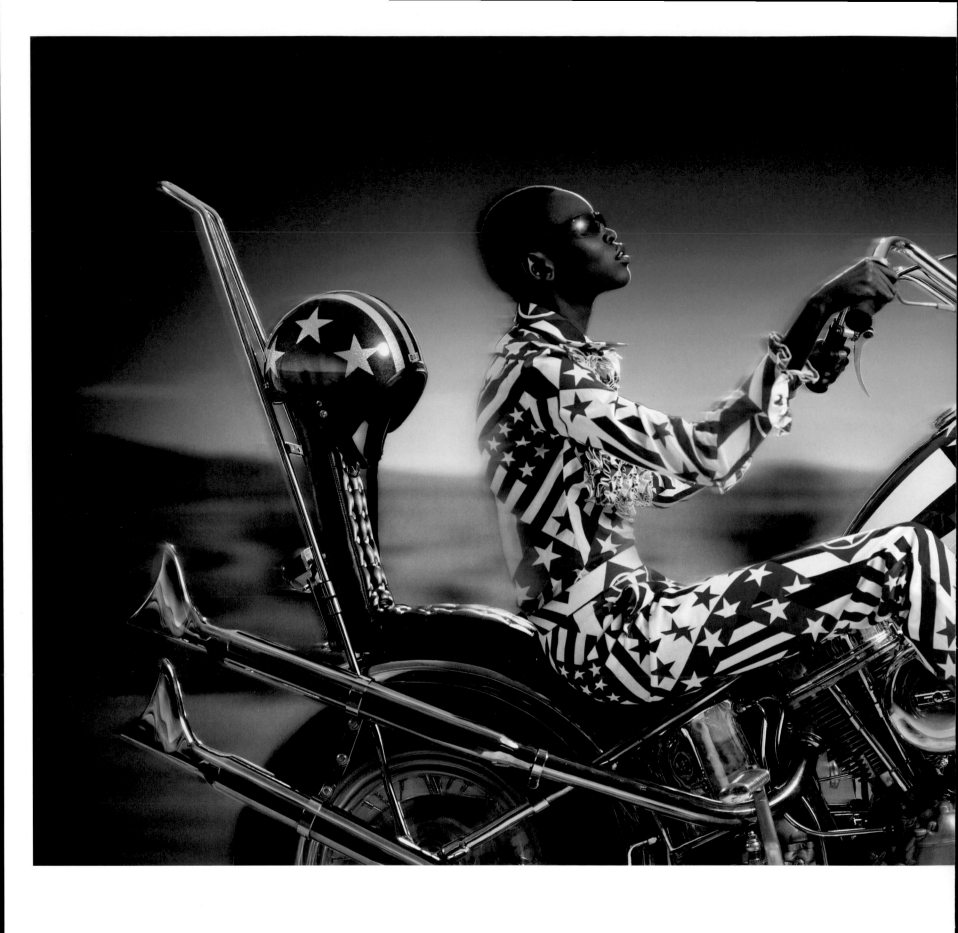

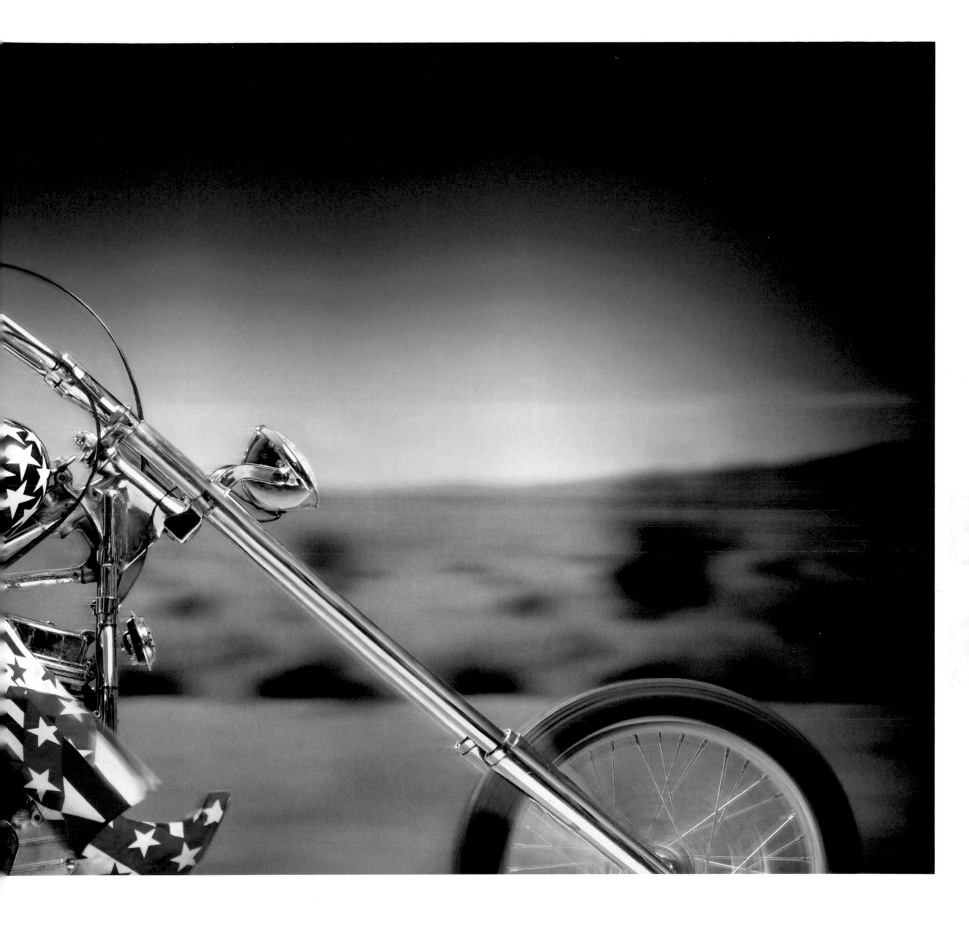

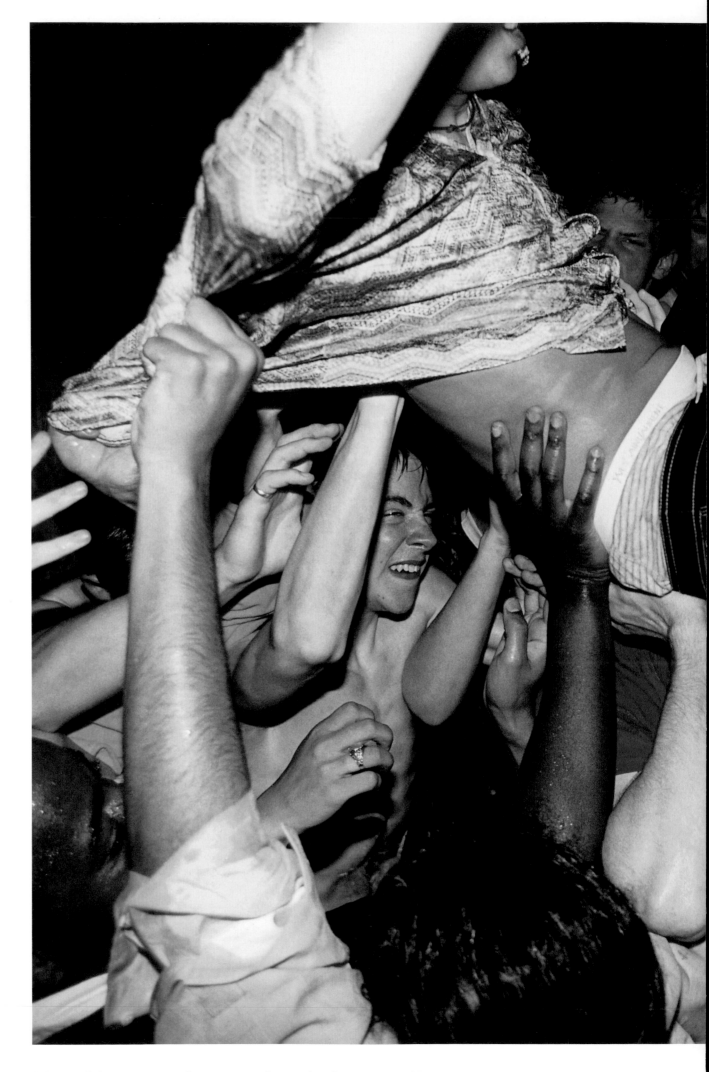

99 . elaine constantine . mosh . the face . 1997

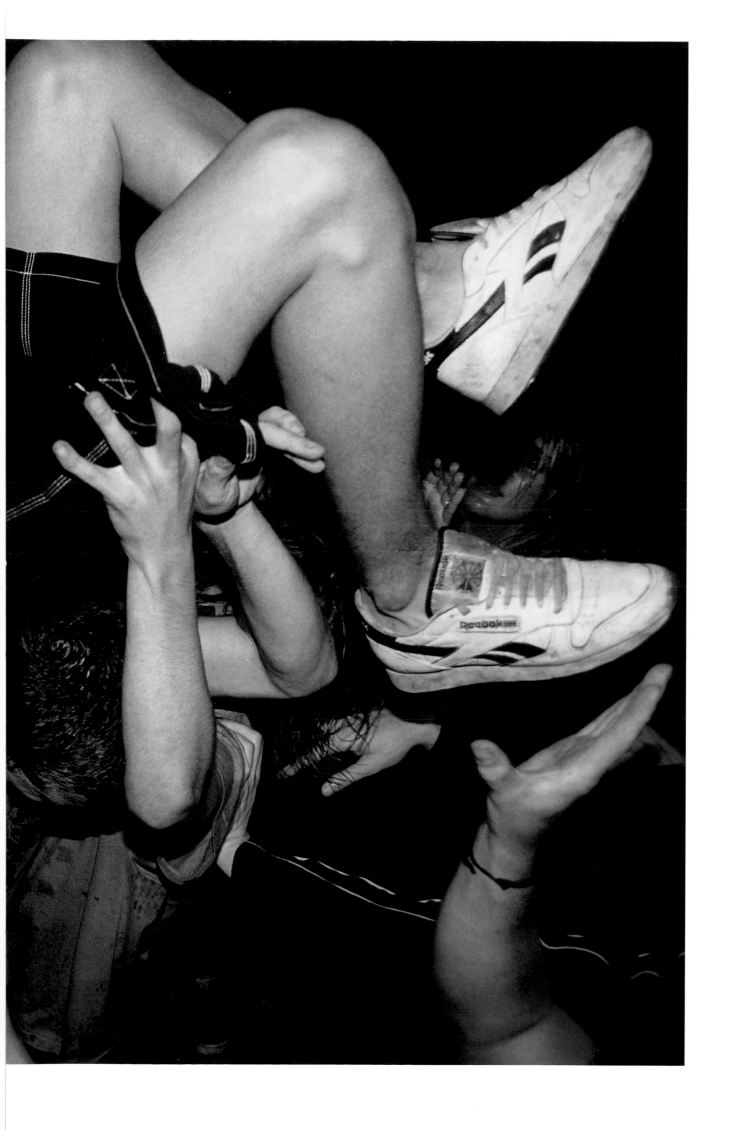

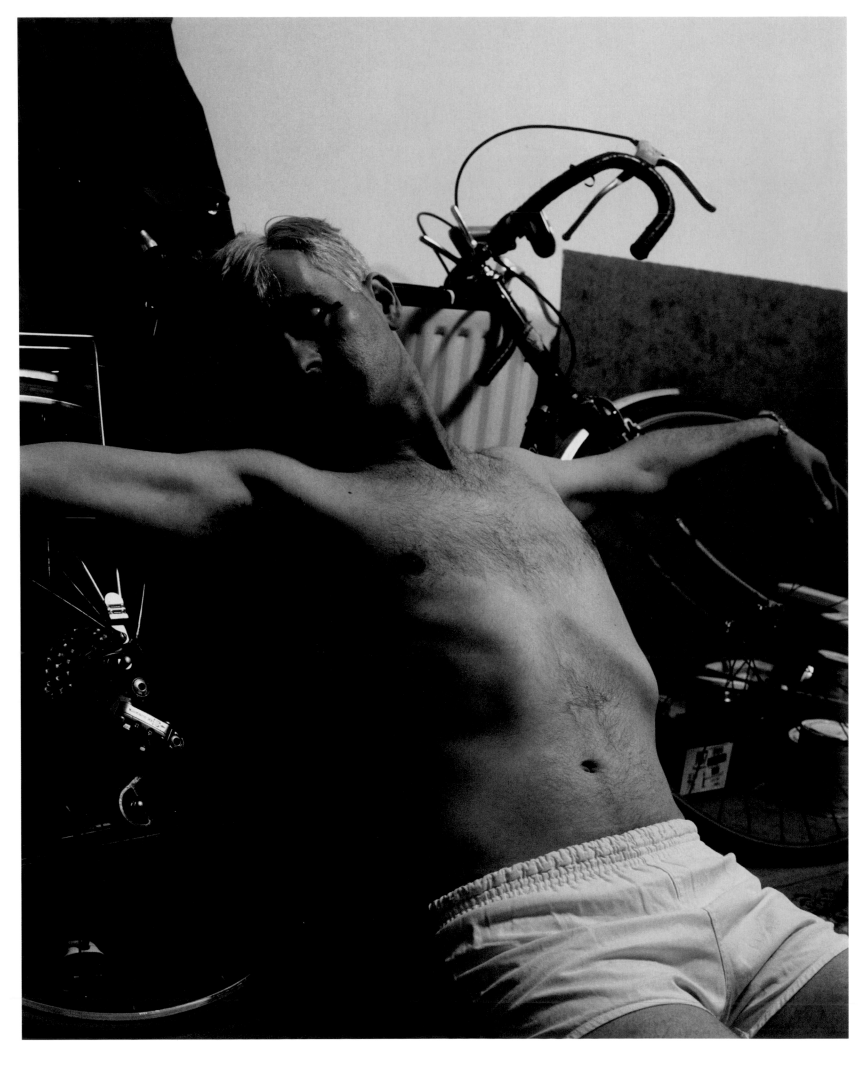

102 . david sims . daniel cycle crucifixion . 2000

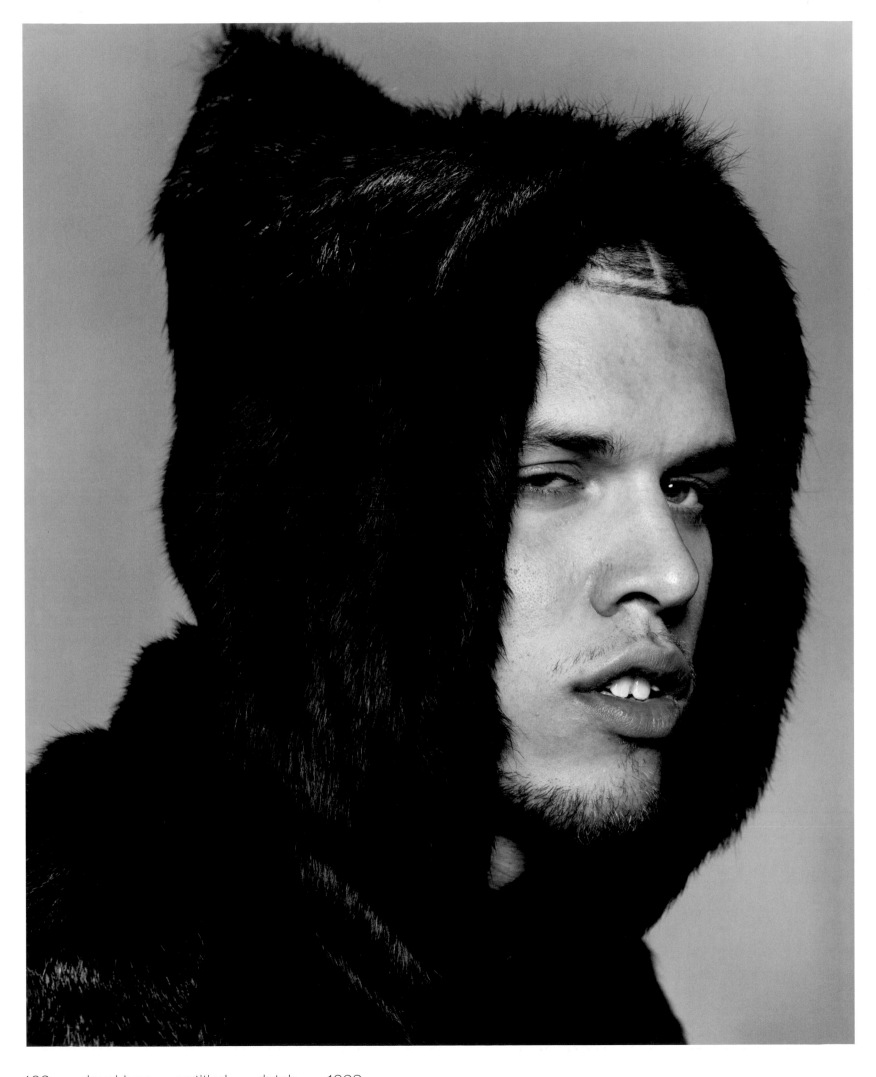

103 . alexei hay . untitled . dutch . 1998

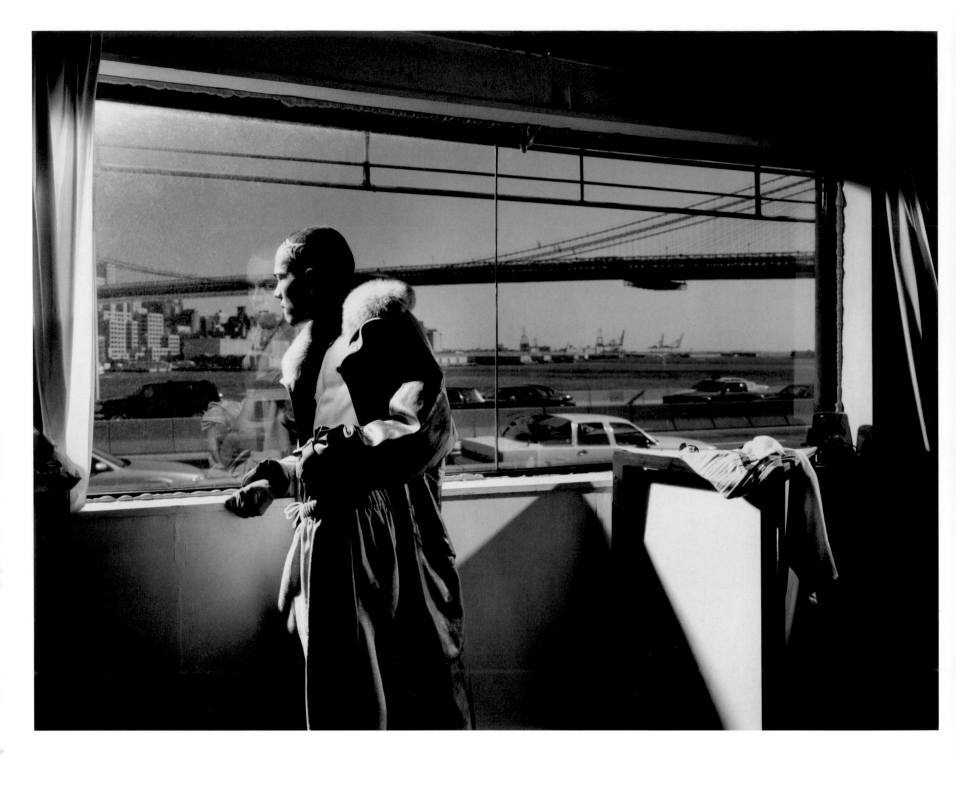

104 . alexei hay . untitled . dutch . 1998

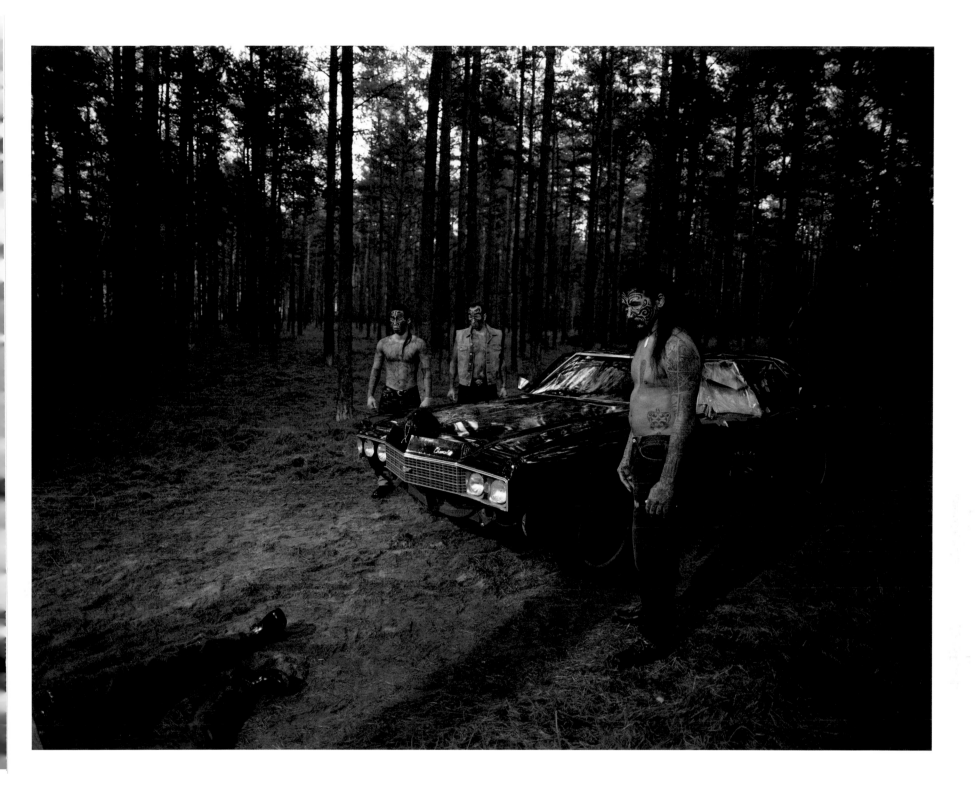

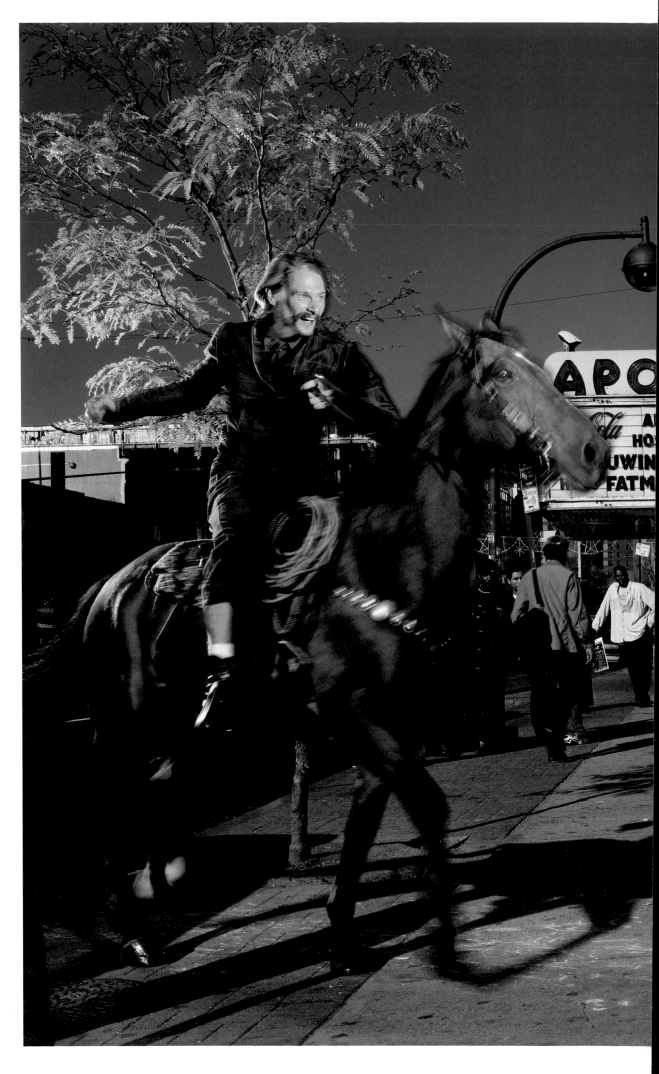

109 . taryn simon . harlem, new york . l'uomo vogue . 2000

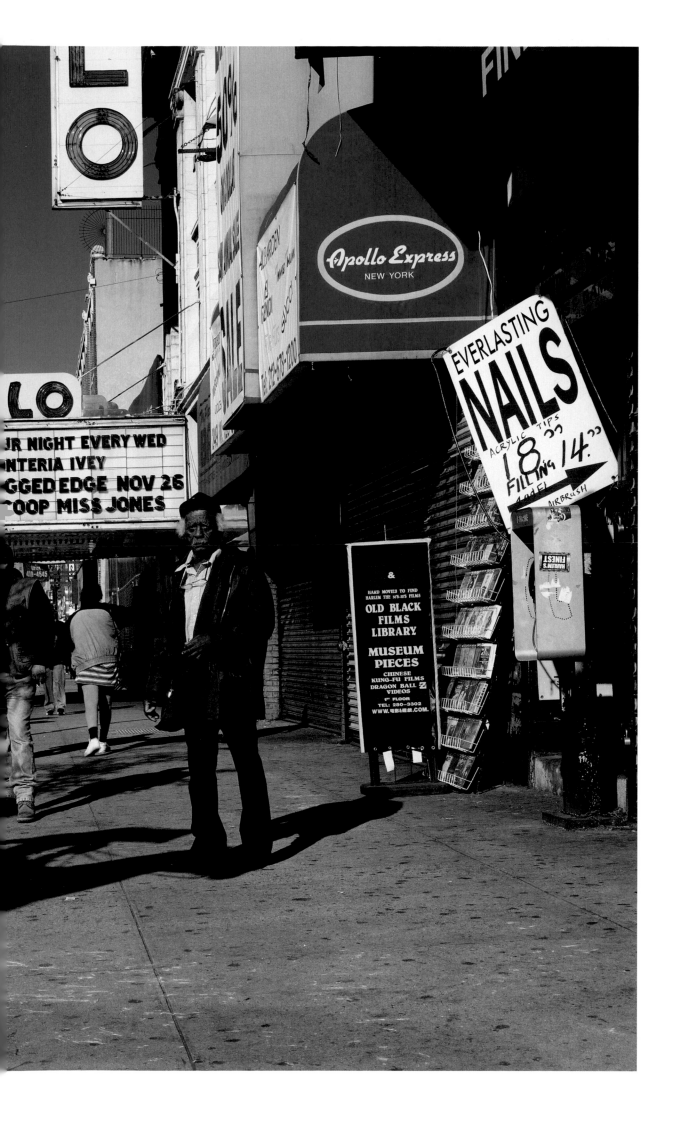

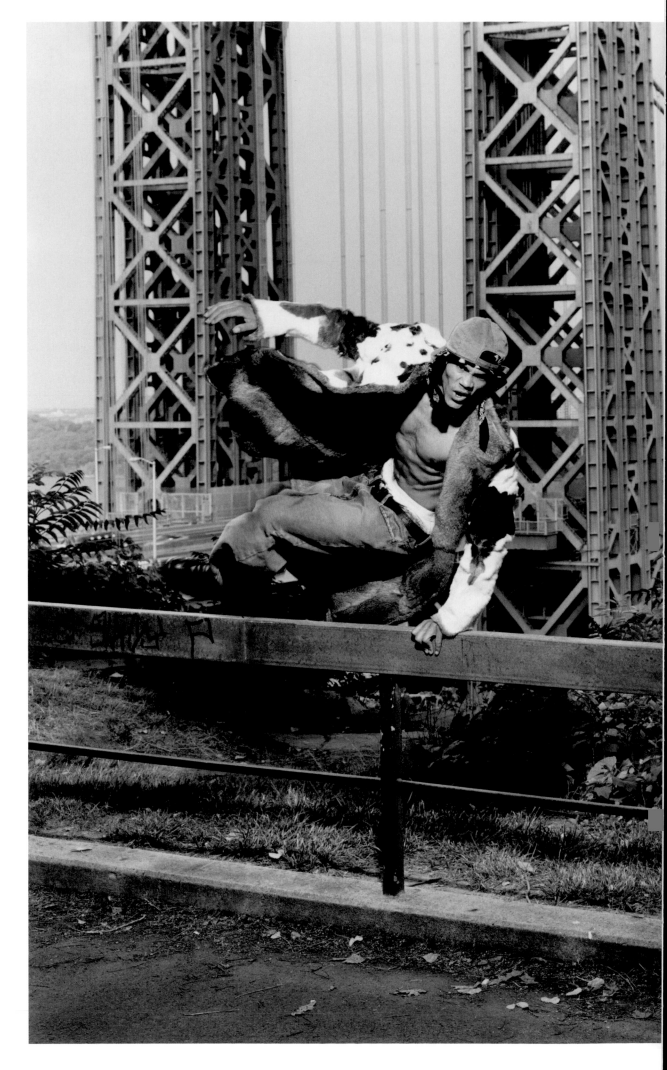

112 . alexei hay . untitled . dutch . 1998

115 . mark borthwick . untitled chloe II . i-d magazine . 1995

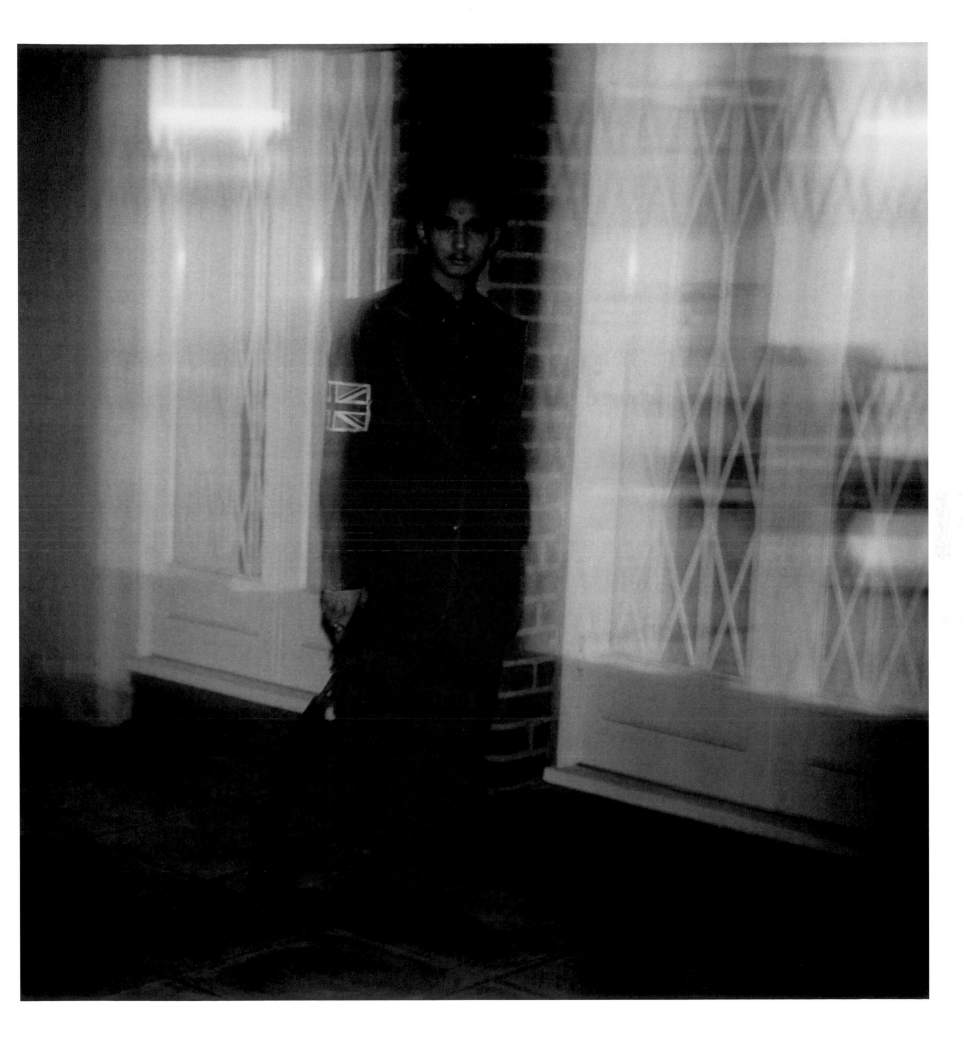

119 . mark lebon . mitzi lorenz . i-d magazine . 1984

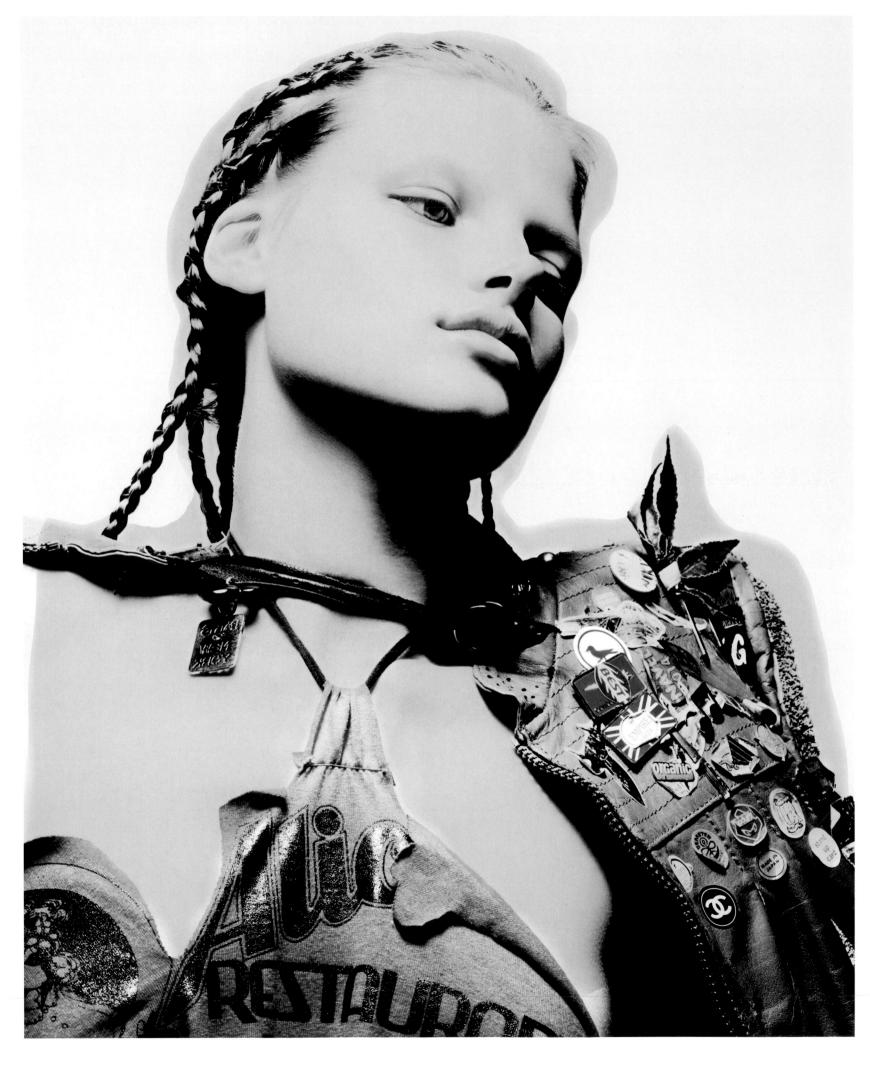

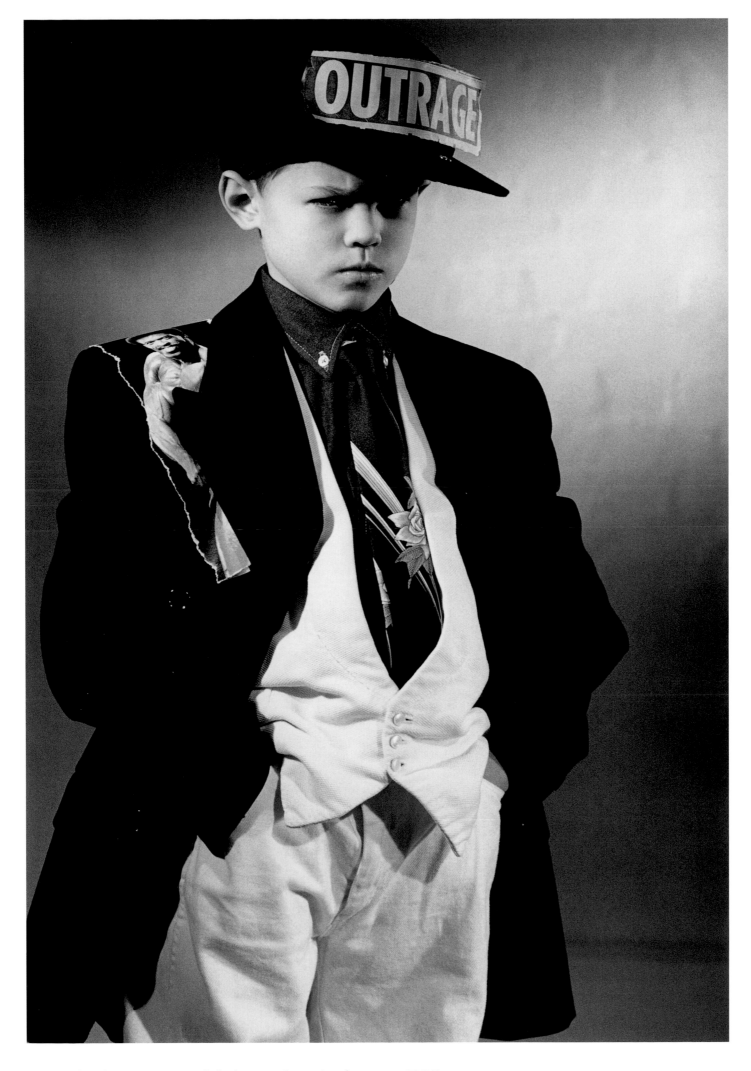

121 . jamie morgan . felix howard . the face . 1985

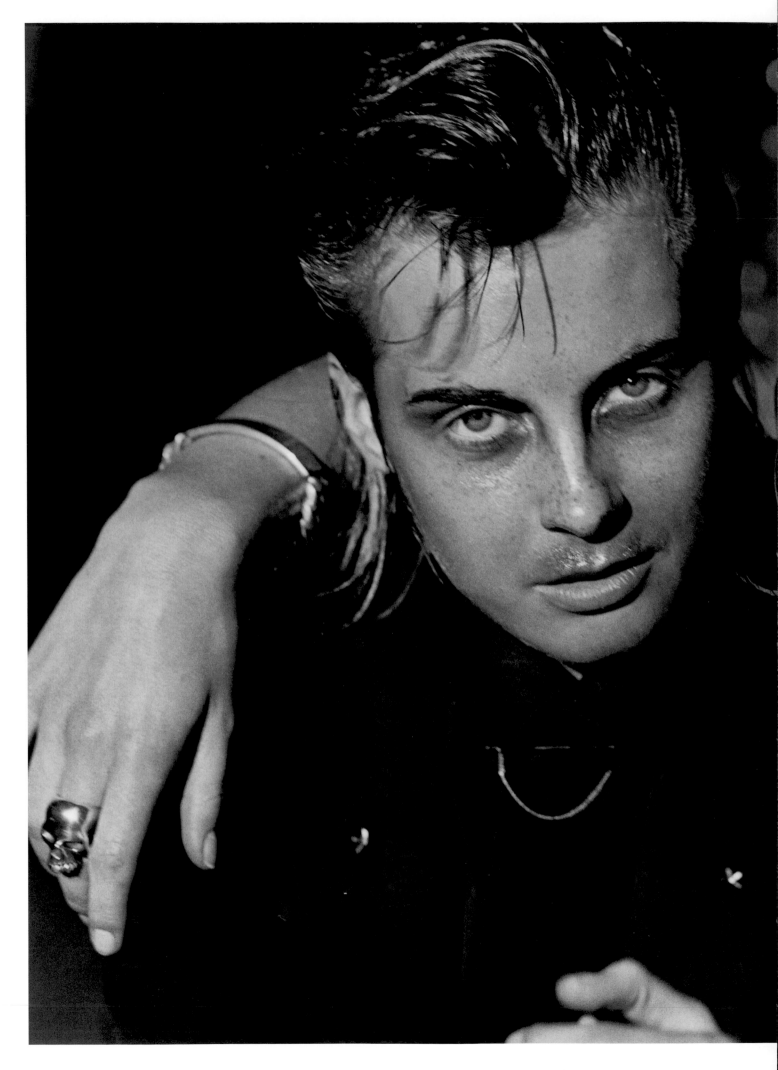

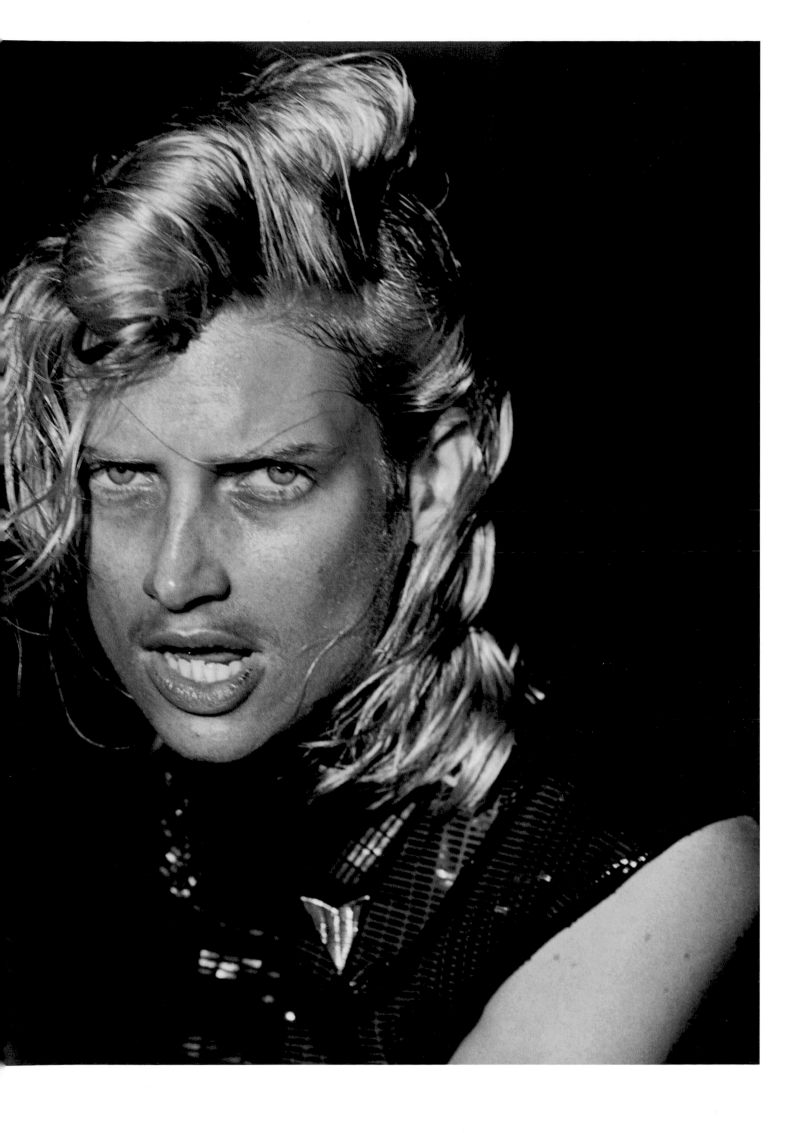

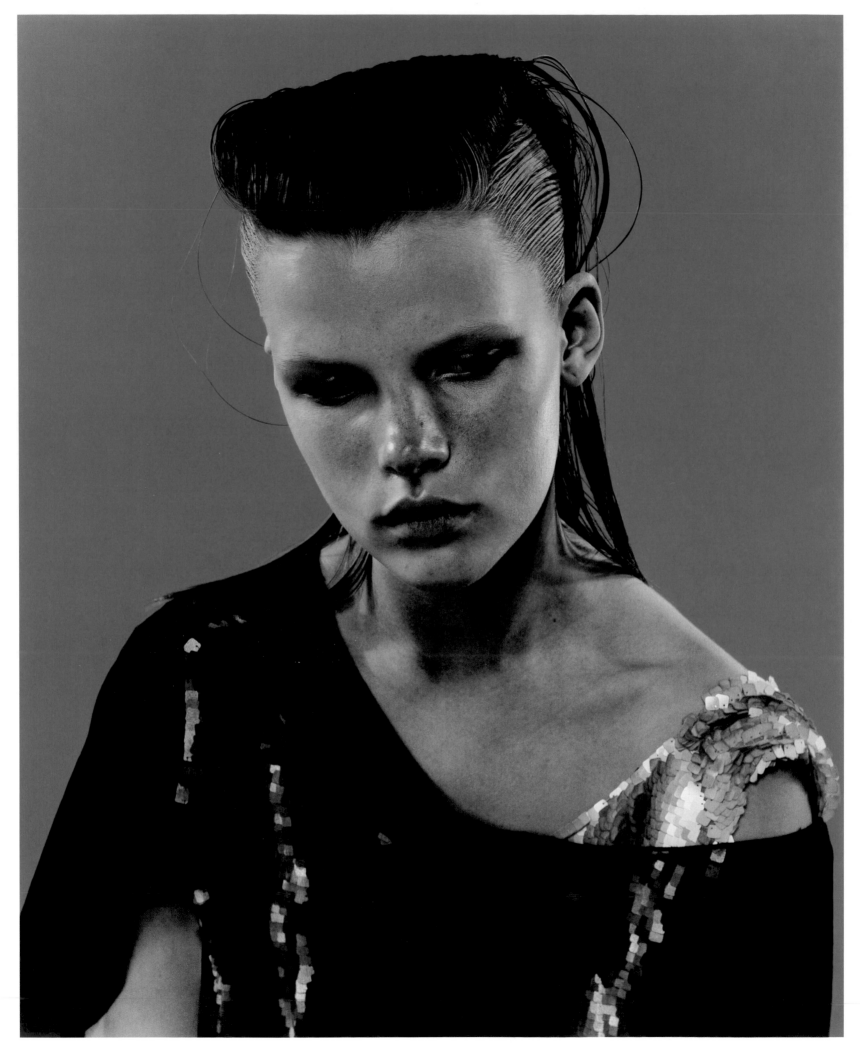

123 . mario sorrenti . untitled (bekka green background) . w magazine . 2000

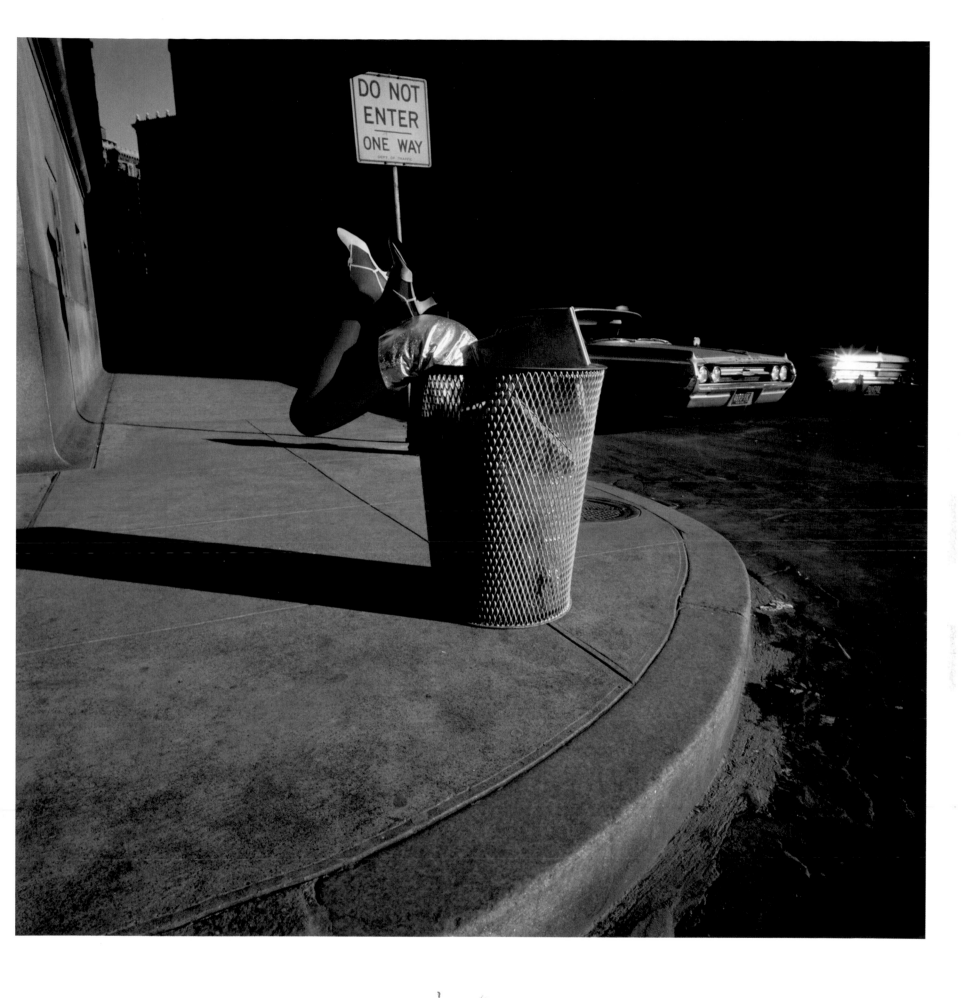

124 ▪ guy bourdin ▪ charles jourdan ▪ 1968

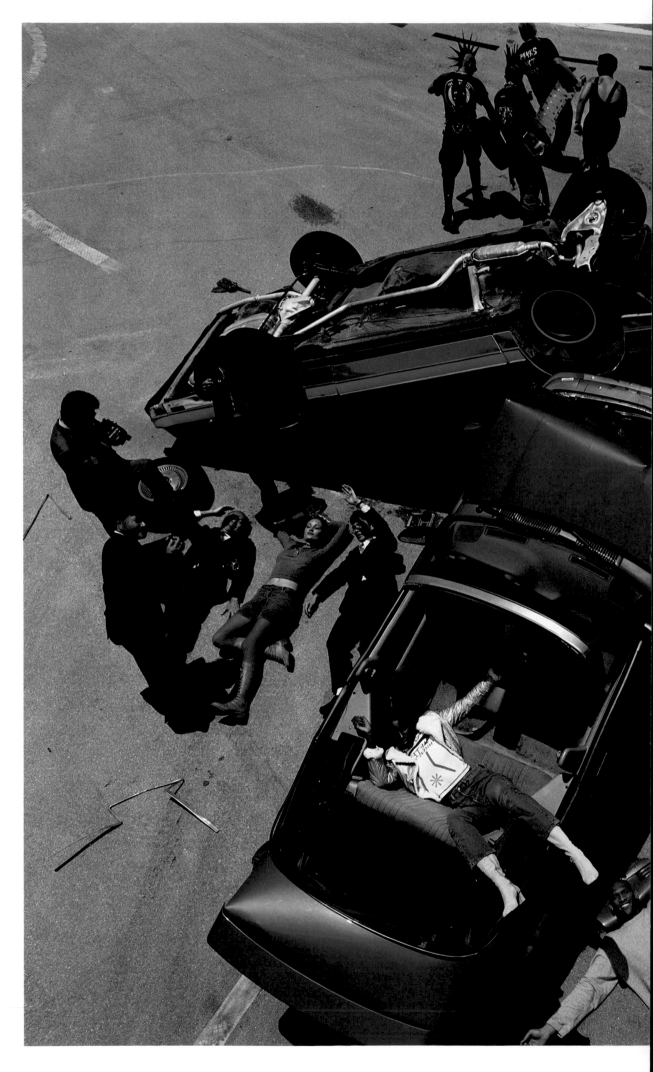

125 . pierre winther . car crash . diesel . 1995

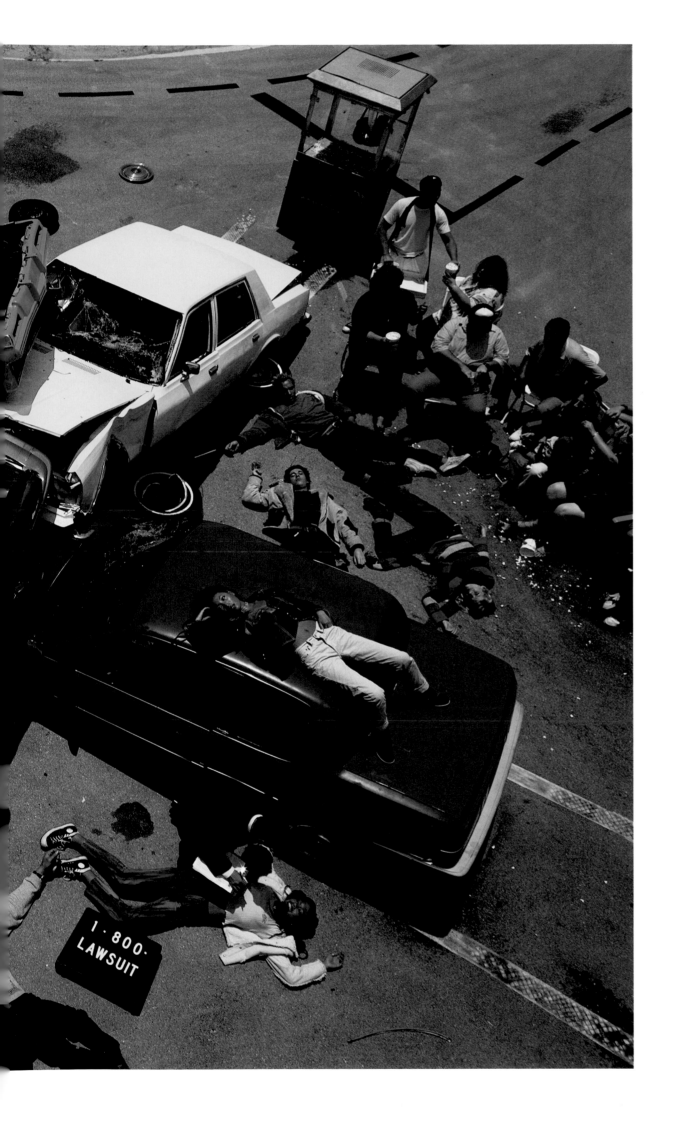

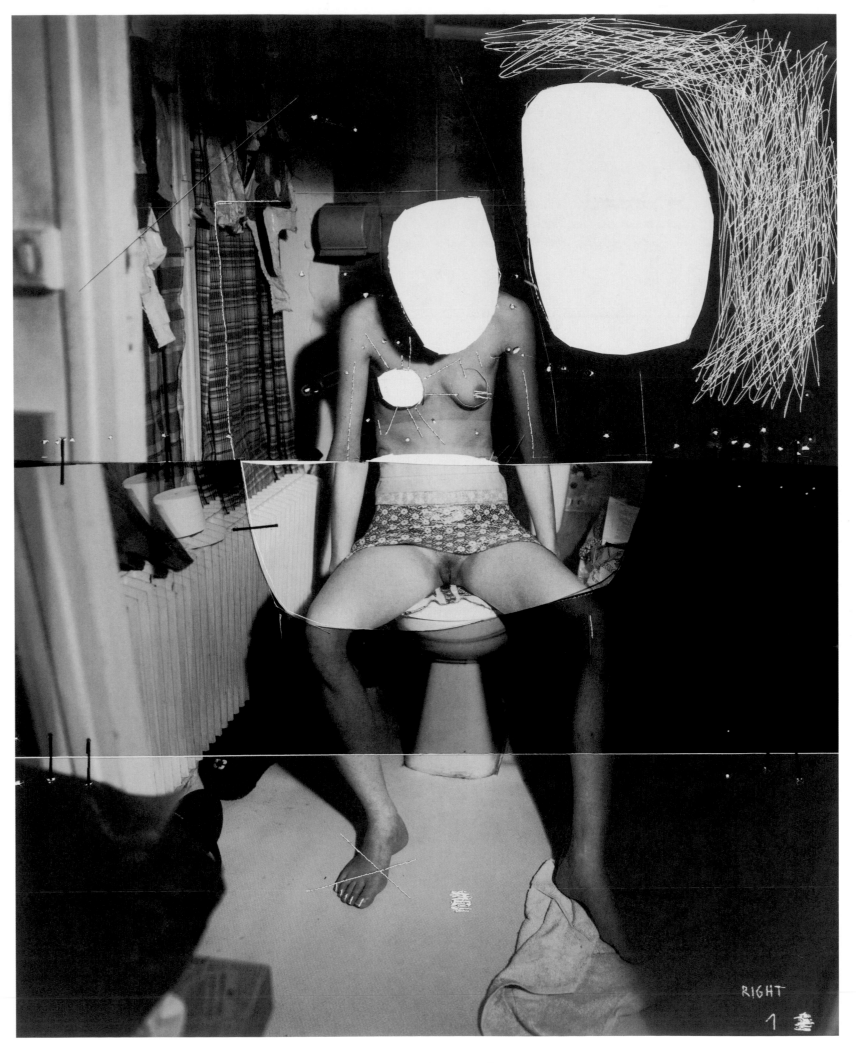

RIGHT

126 . jean-françois lepage . untitled I . spoon magazine . 1999

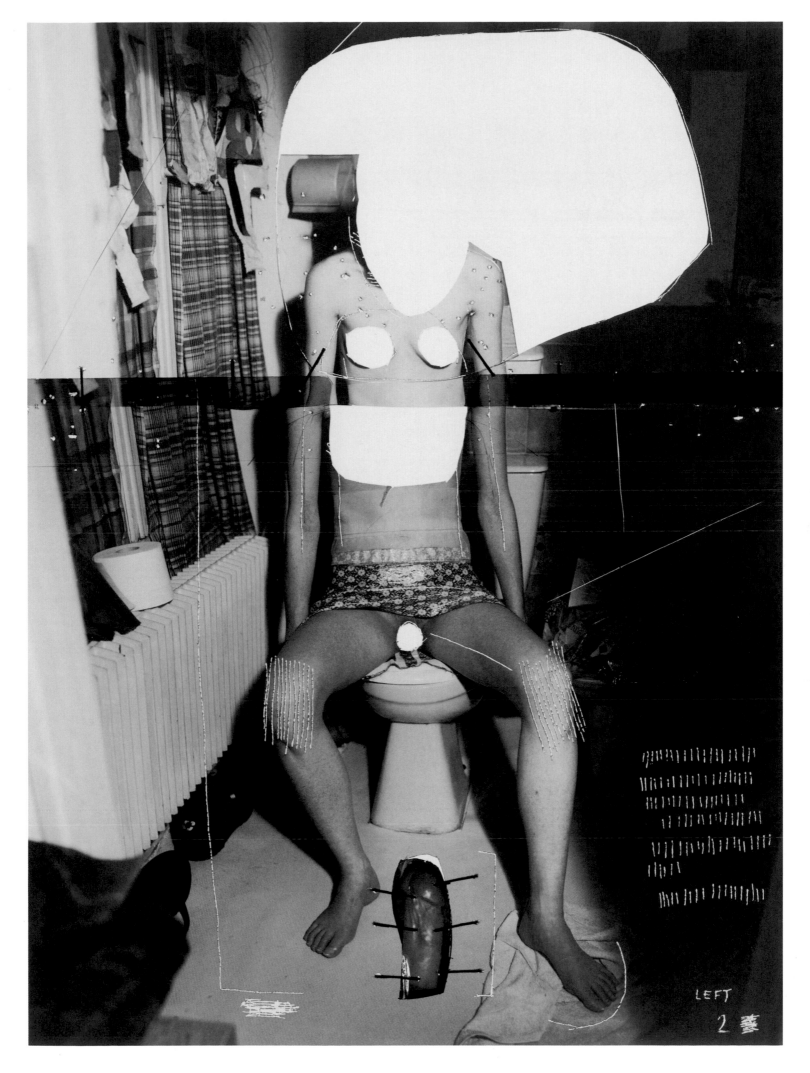

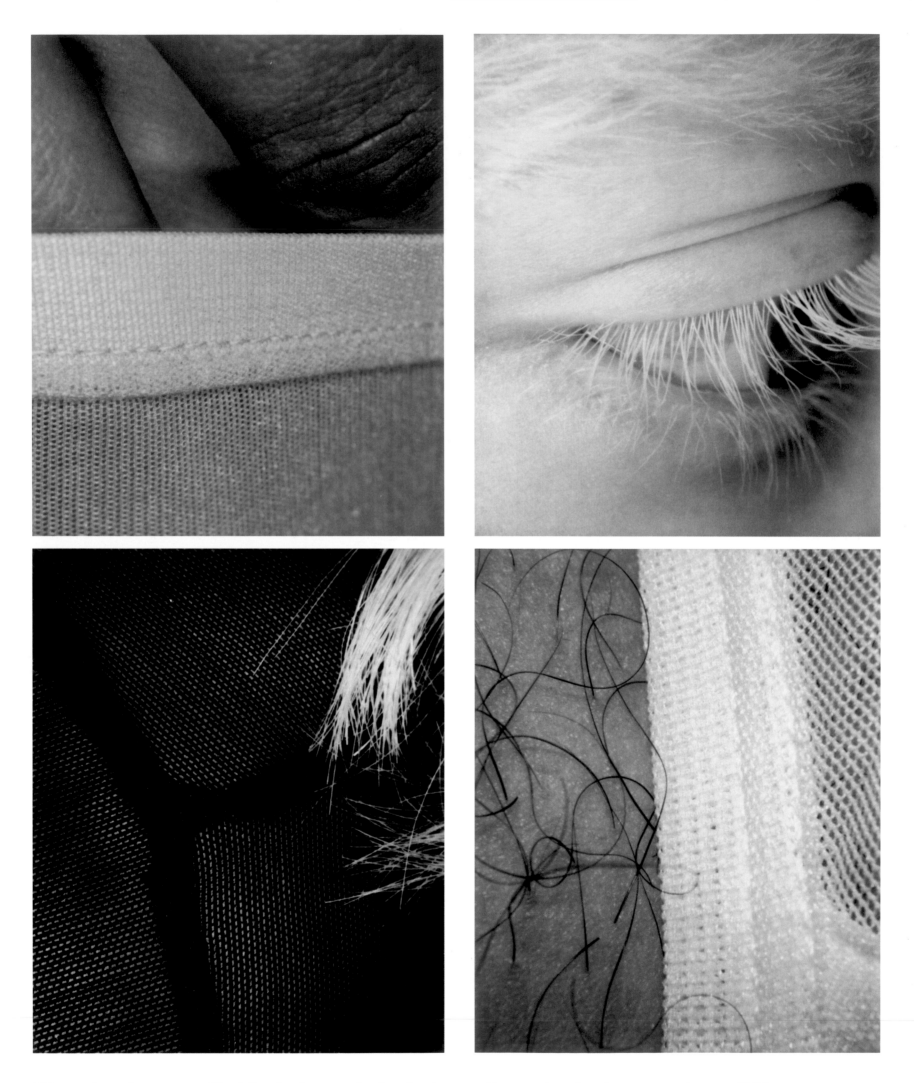

128 . dino dinco . untitled (joe I – hannsy I – joe II – hannsy II), gucci . *surface magazine . 1998

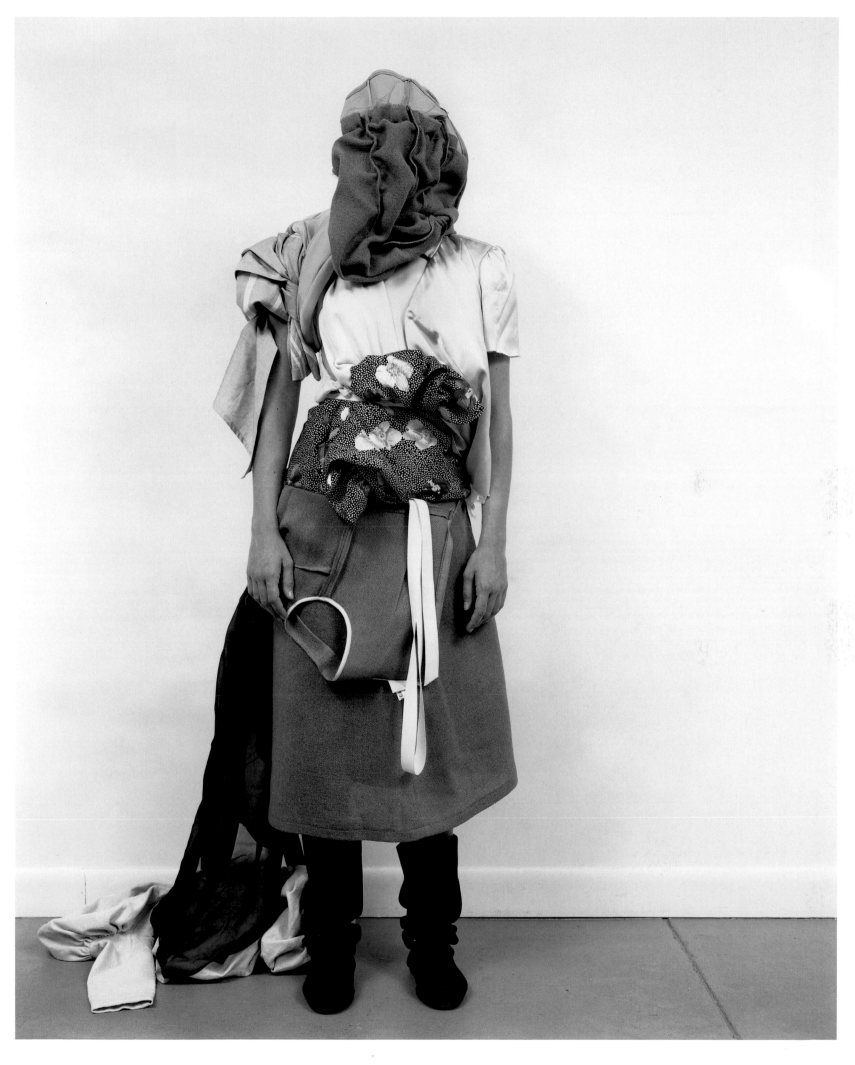

129 . mark borthwick . untitled chloe (fashion show) . purple . 1999

high-tech
and futurism

high-tech
and futurism

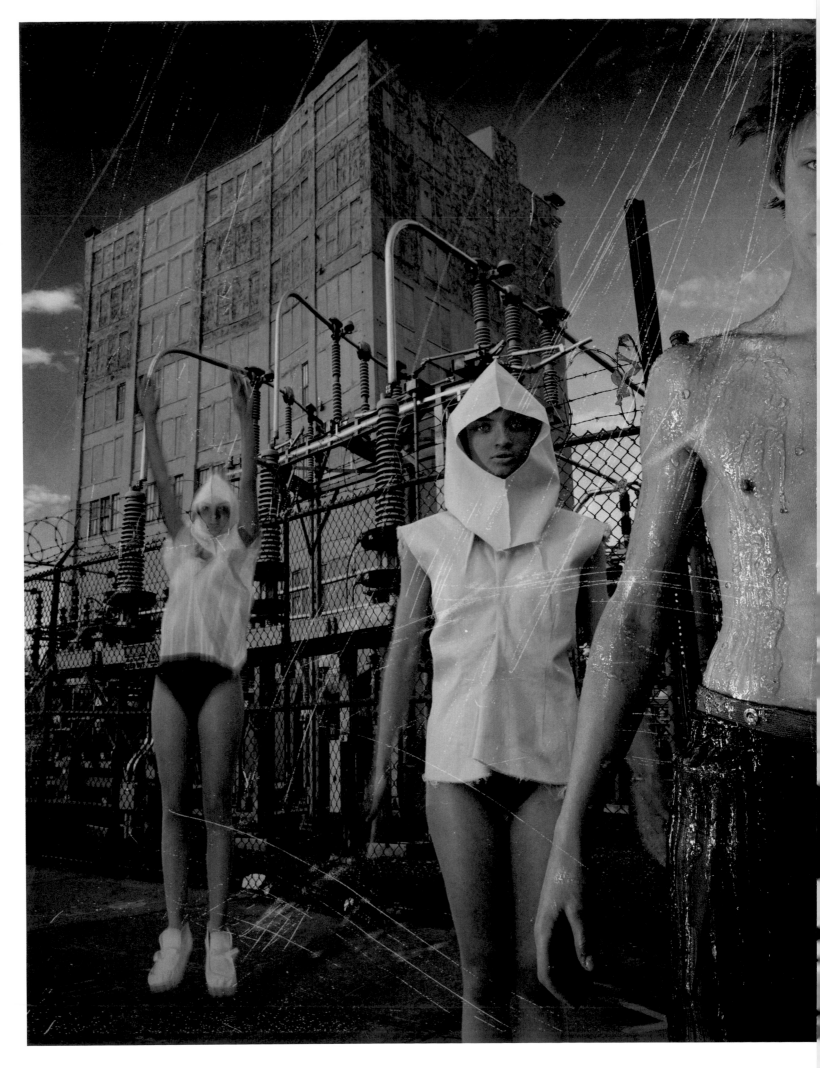

133 . andrea giacobbe . brooklyn 1996 . cube . 1998

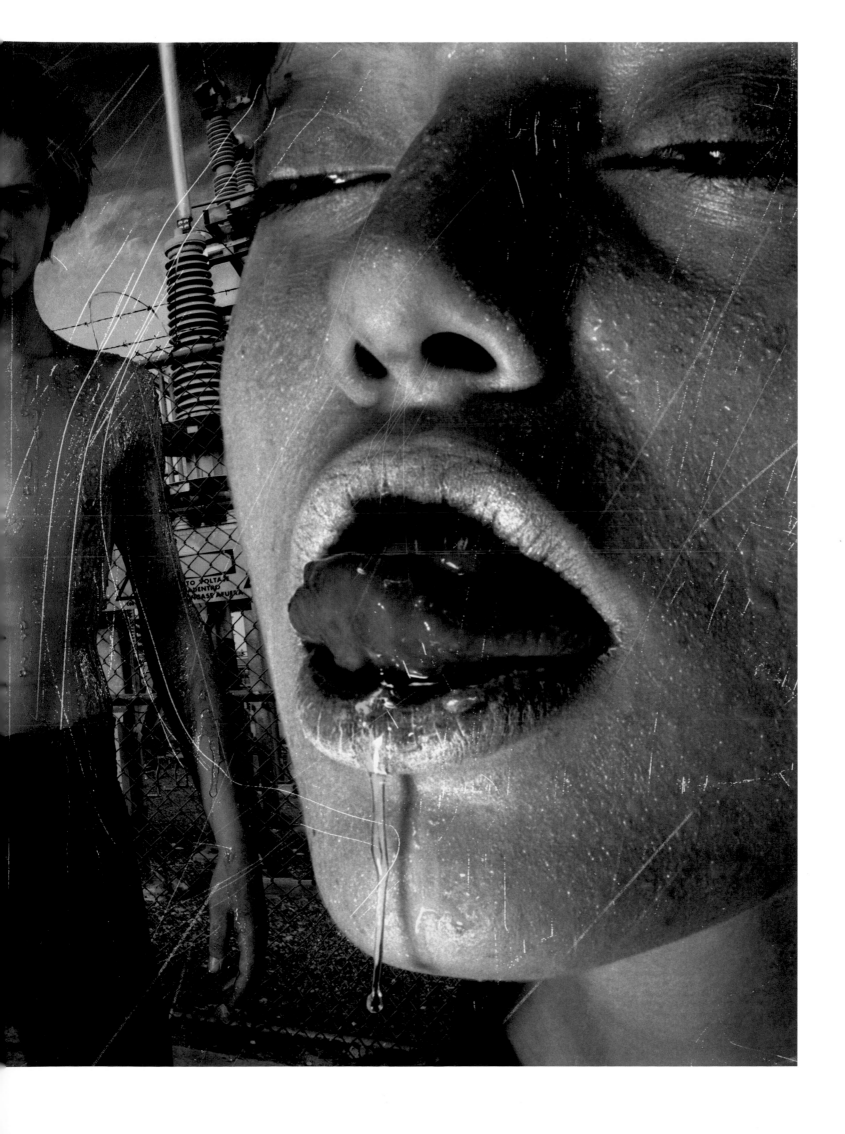

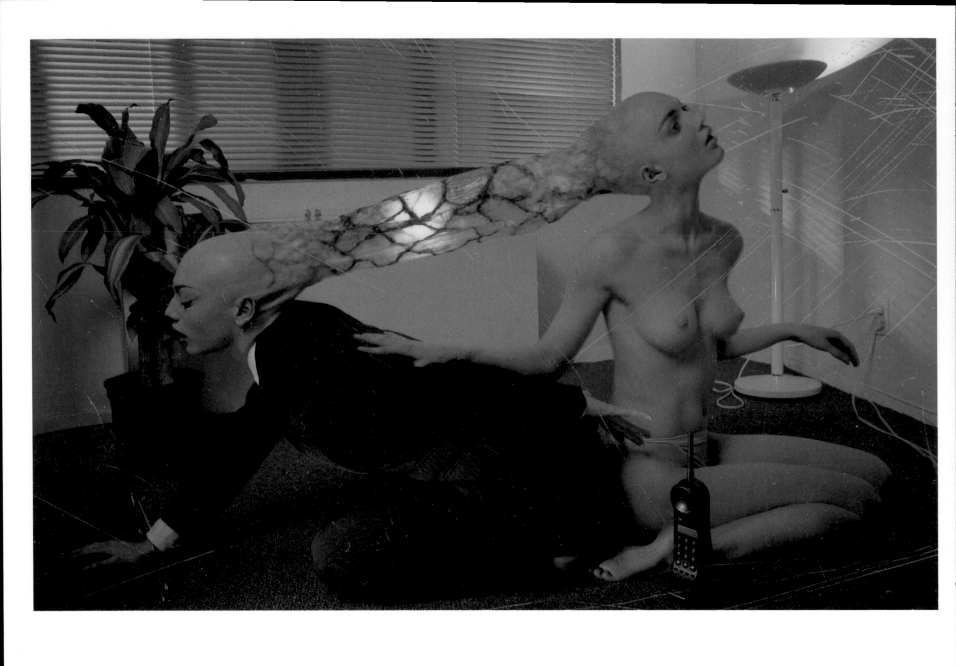

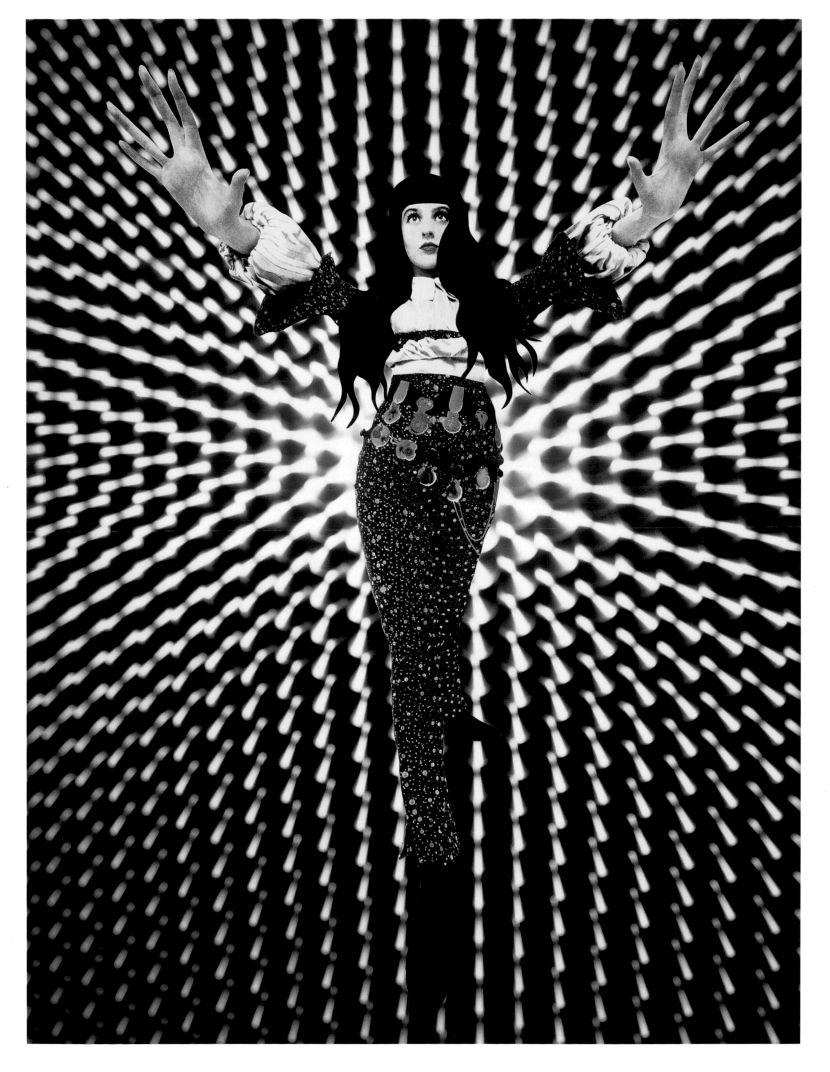

135 . stéphane sednaoui . suzie bick! . the face . 1988

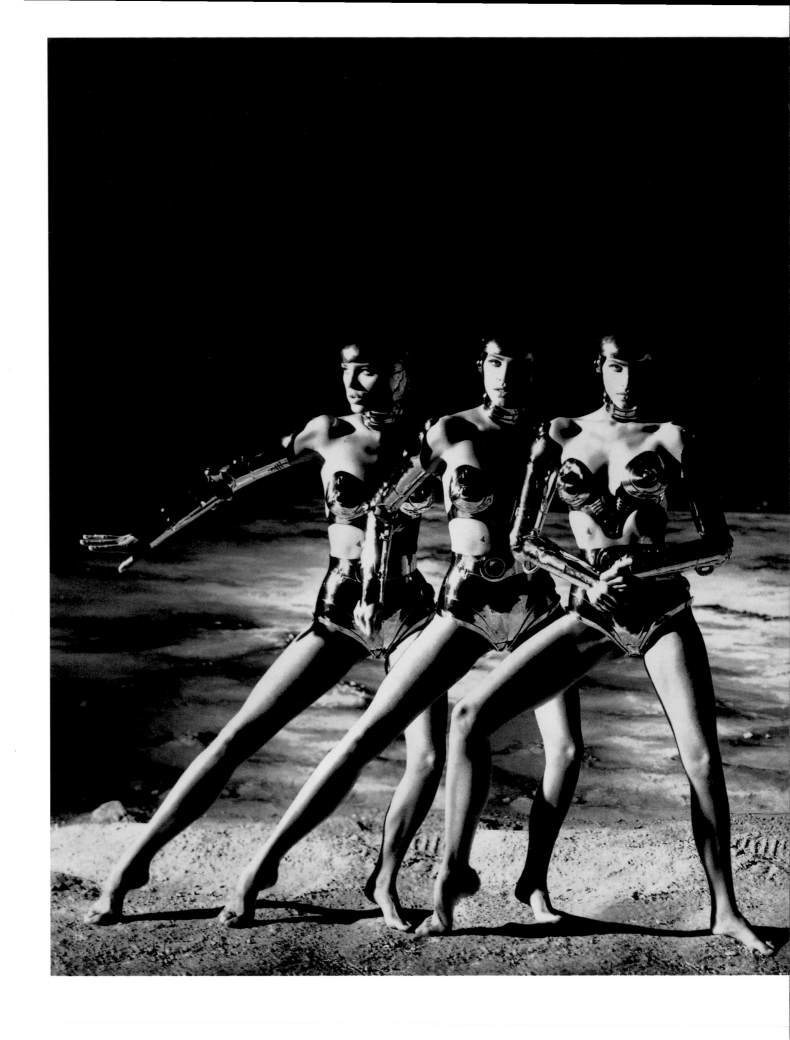

137 . thierry le gouès . robot emma s . glamour france . 1991

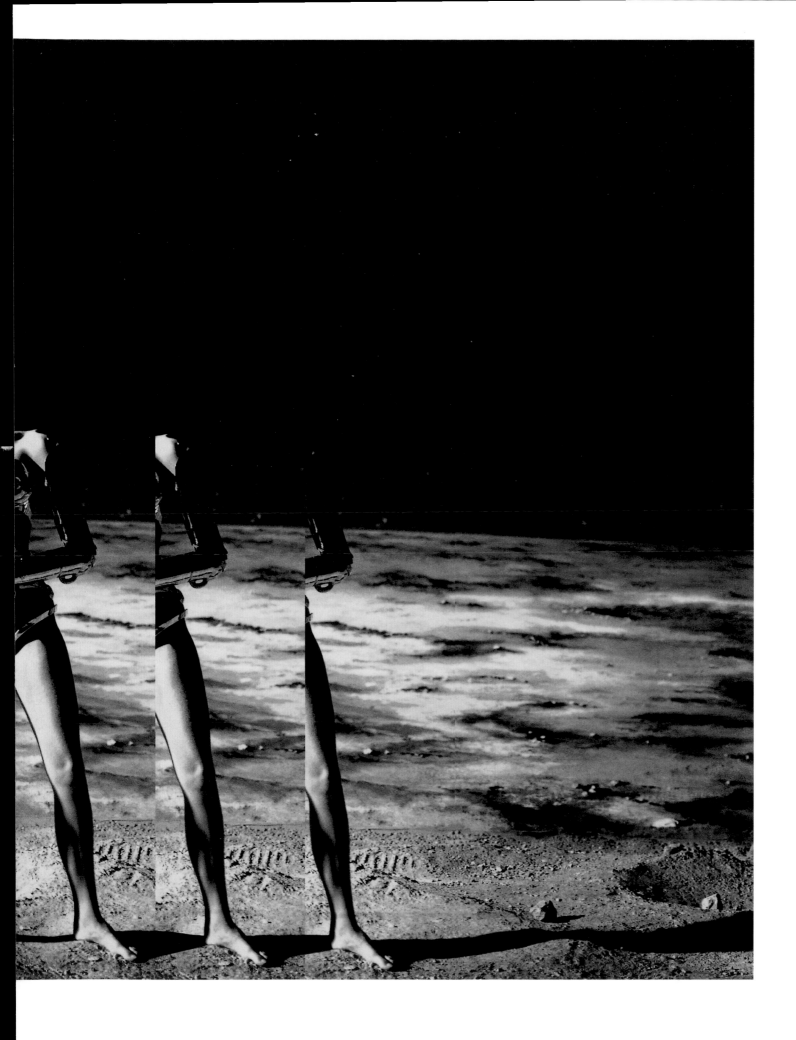

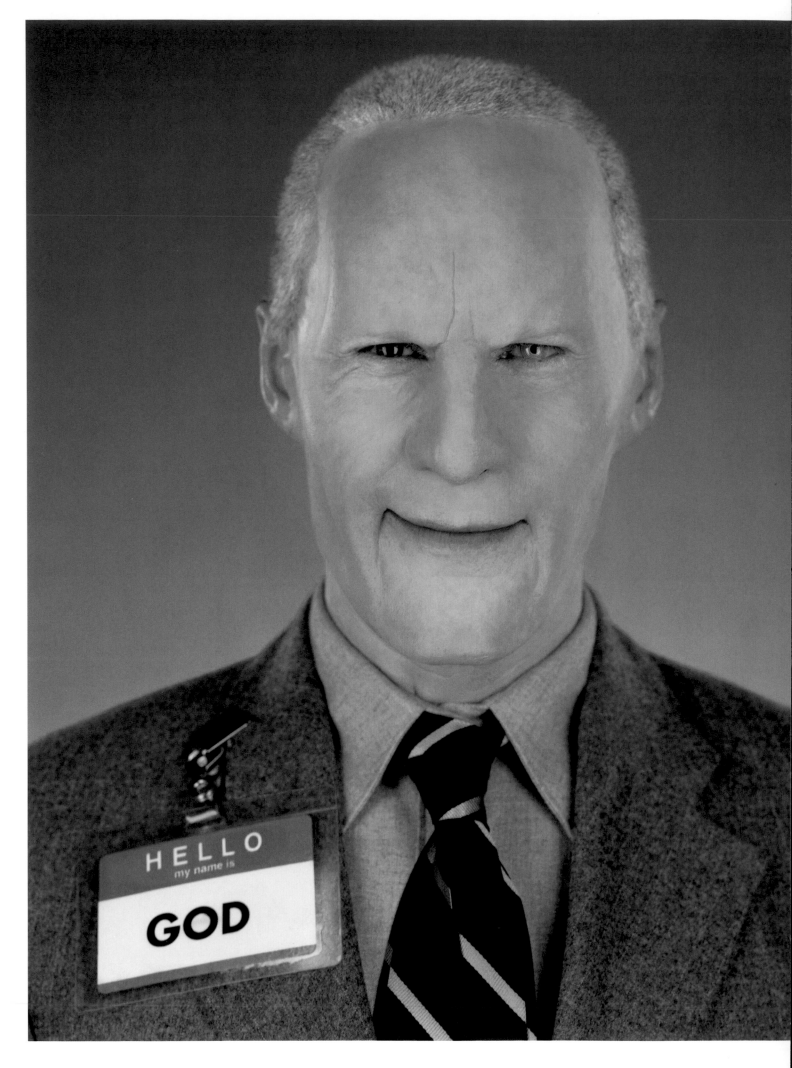

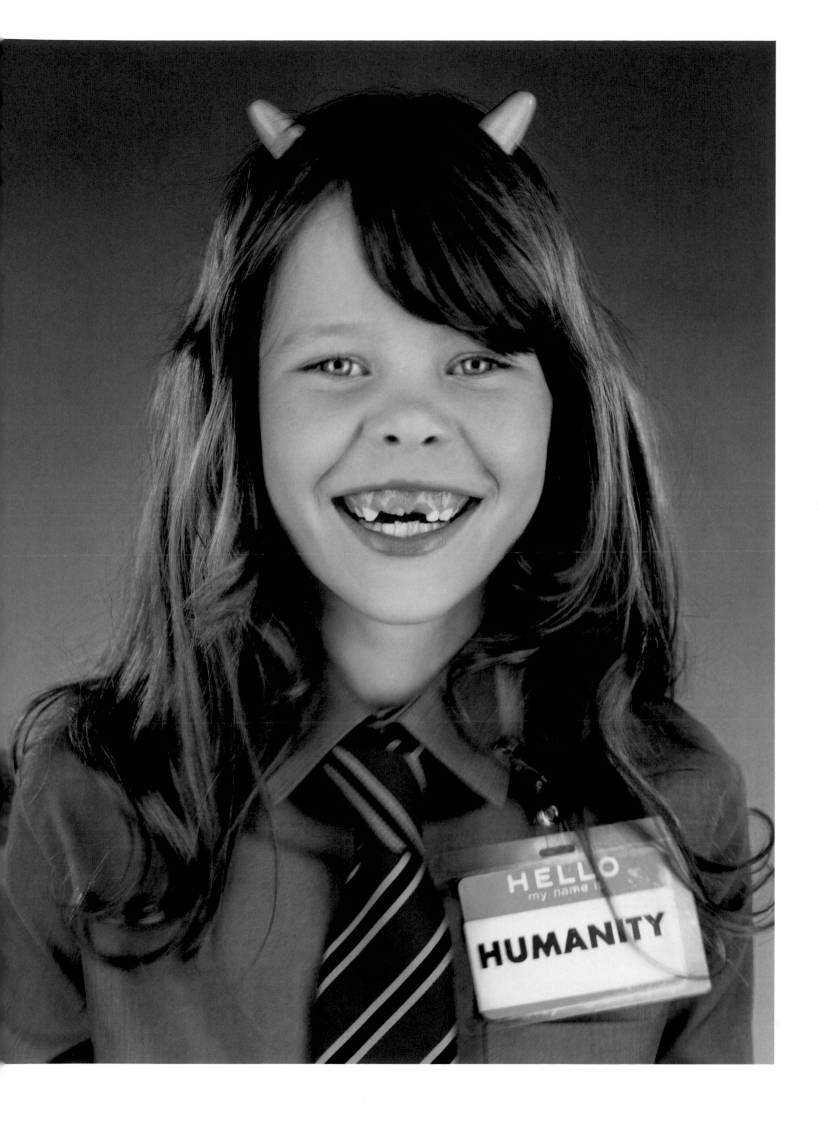

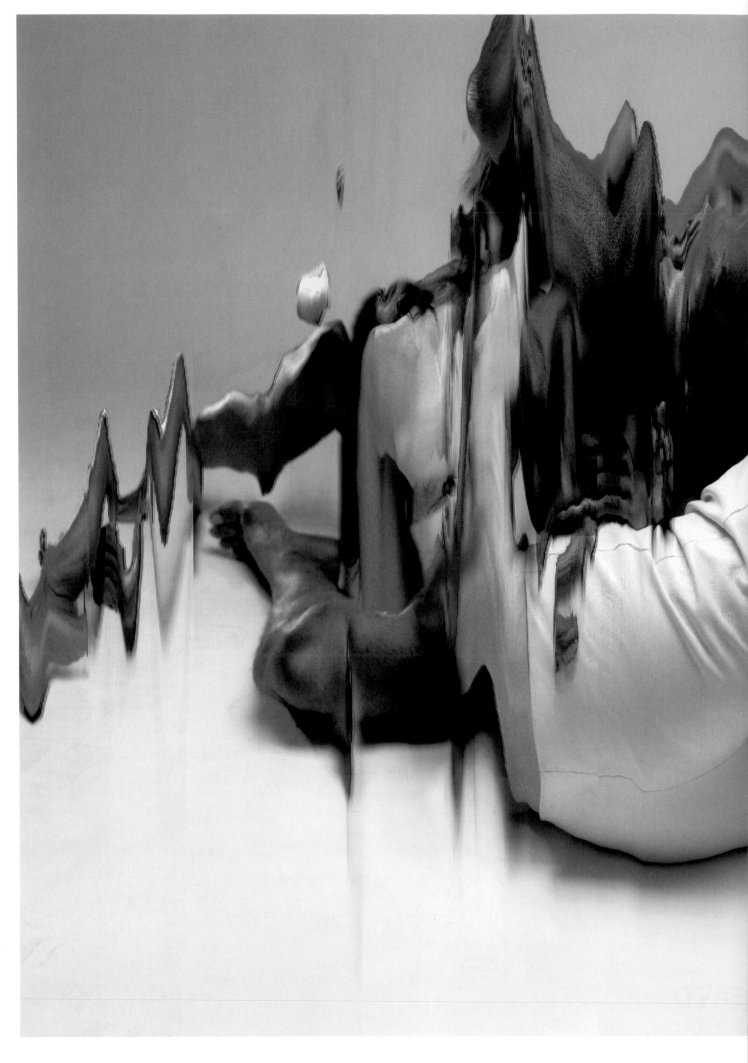

139 . stéphane sednaoui . mary ann . jalouse . 1999

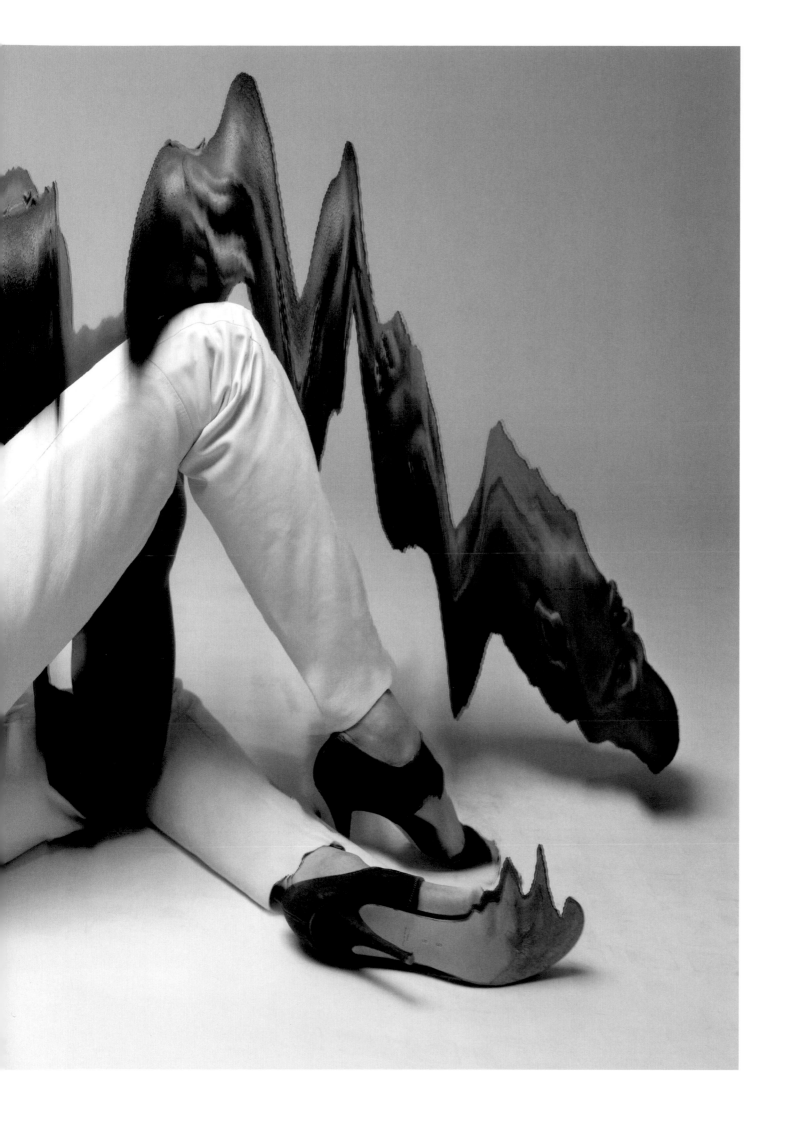

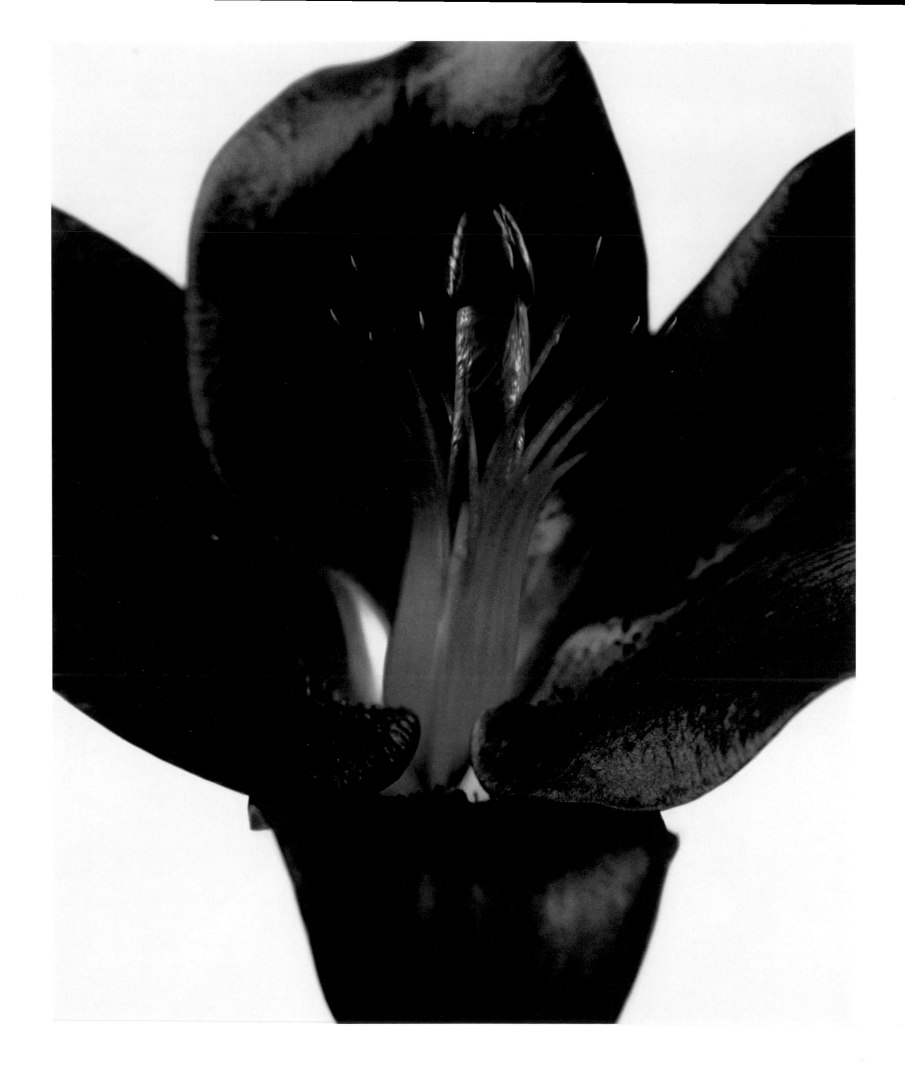

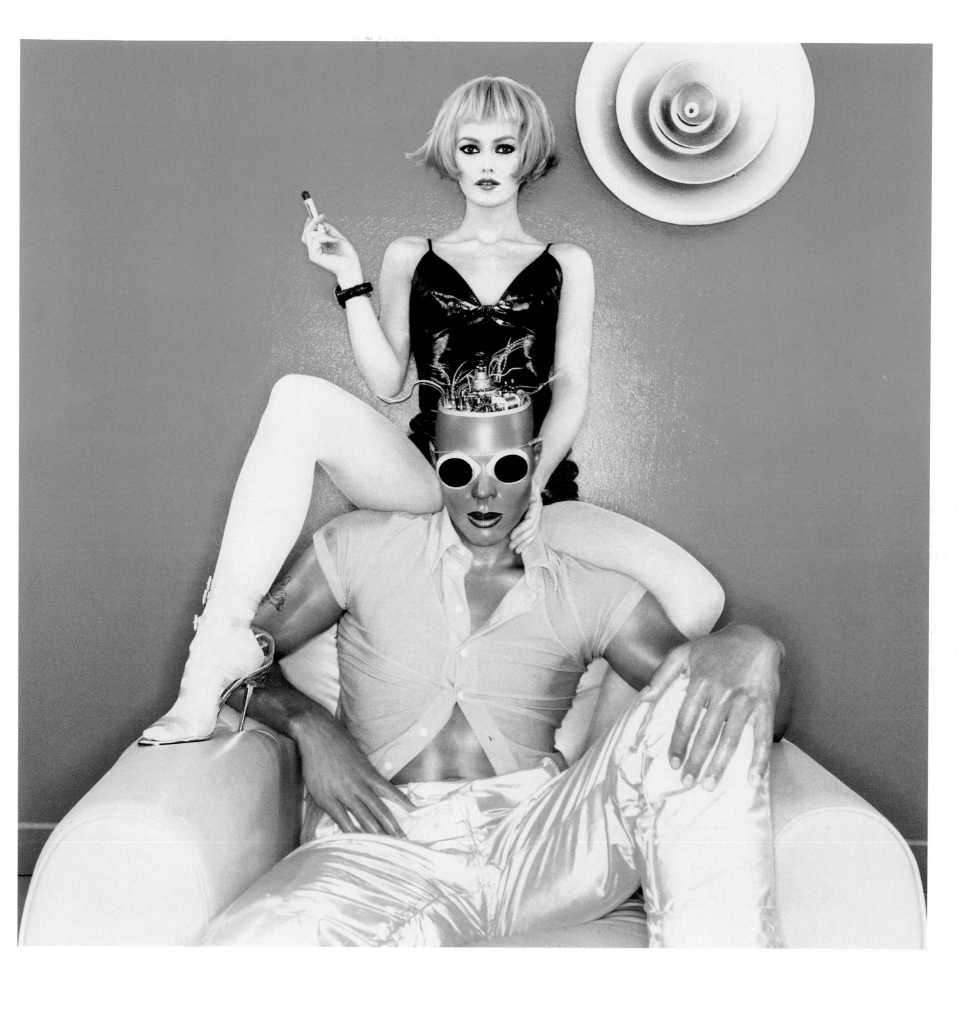

143 . jean-baptiste mondino . vanessa & rankxerox . glamour france . 1994

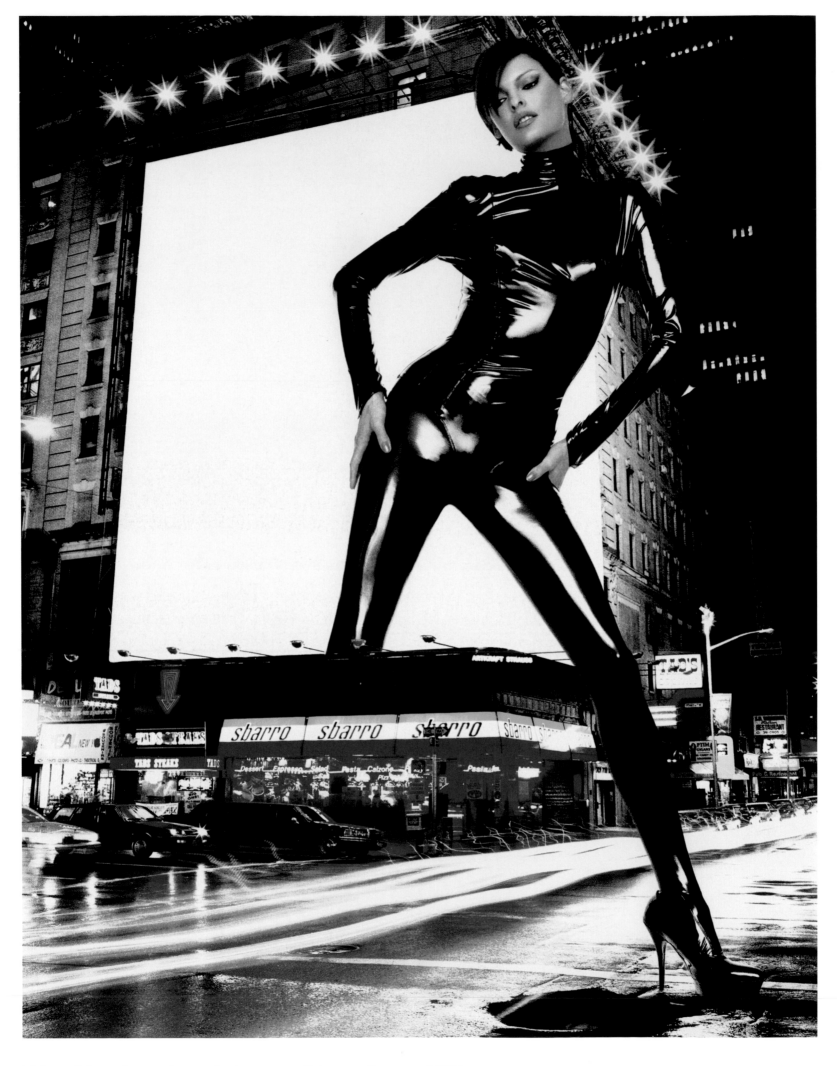

144 . thierry le gouès . linda evangelista . allure . 1995

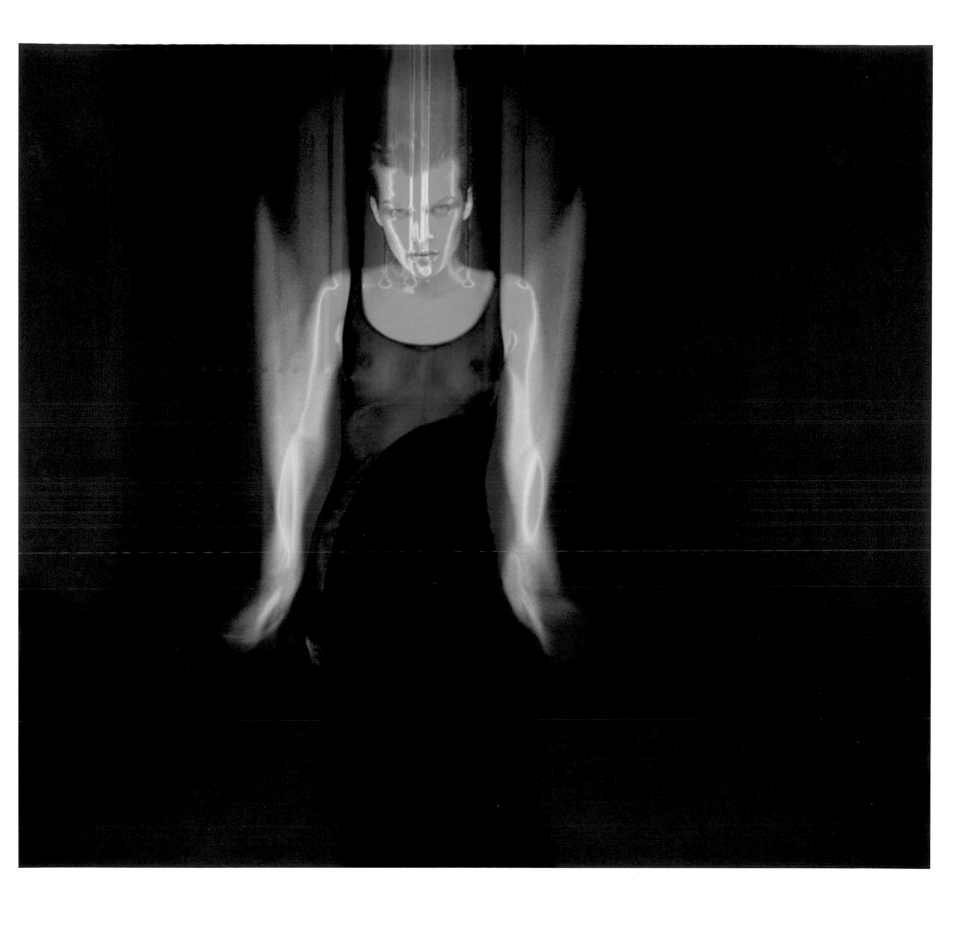

145 . stéphane sednaoui . milla jovovich . campagne plein sud . 1996

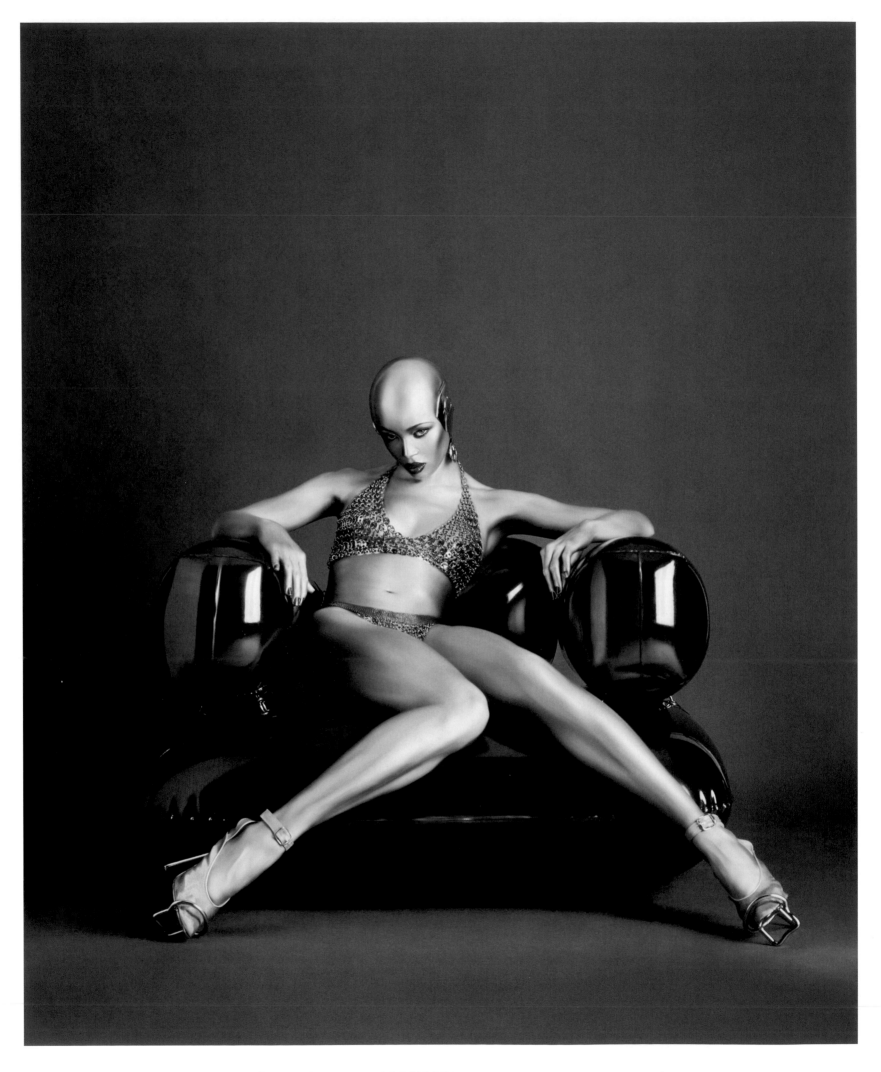

146 ▪ seb janiak ▪ naomi ▪ elle ▪ photo ▪ 1996/1997

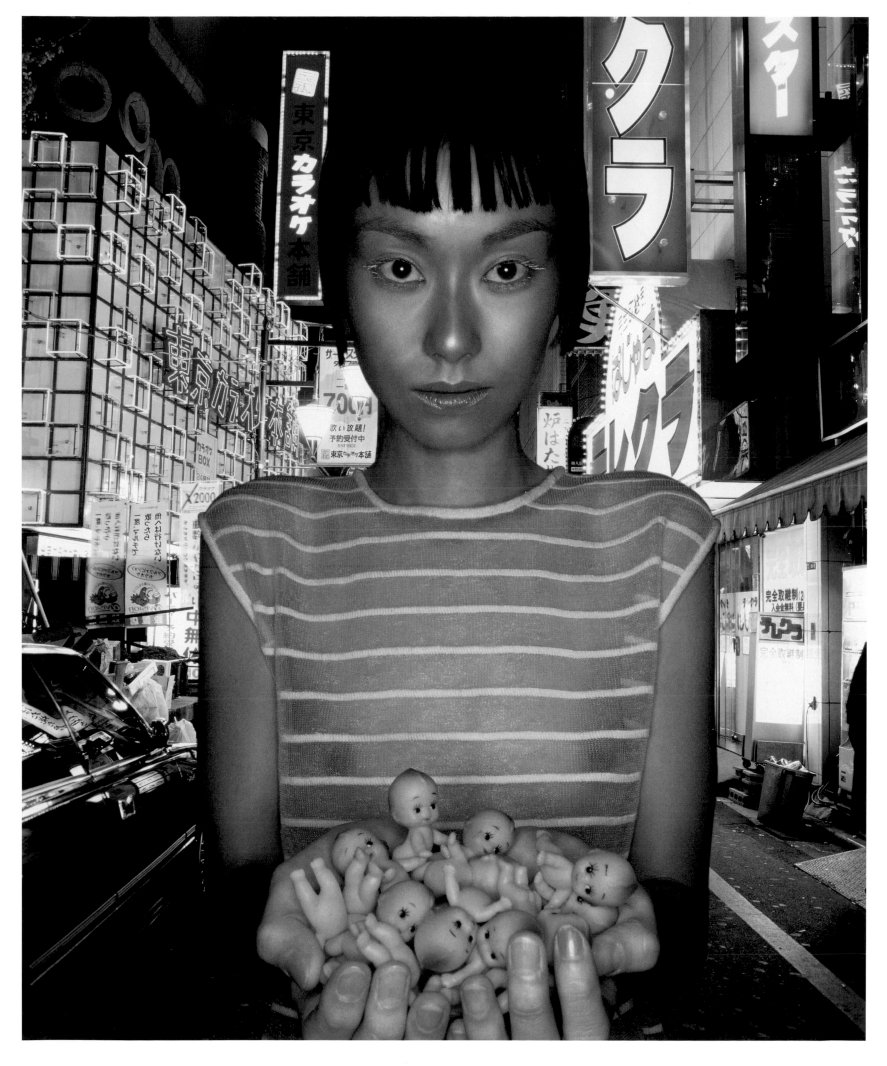

147 . andrea giacobbe . tokyo 1992 . citizen k . 1993

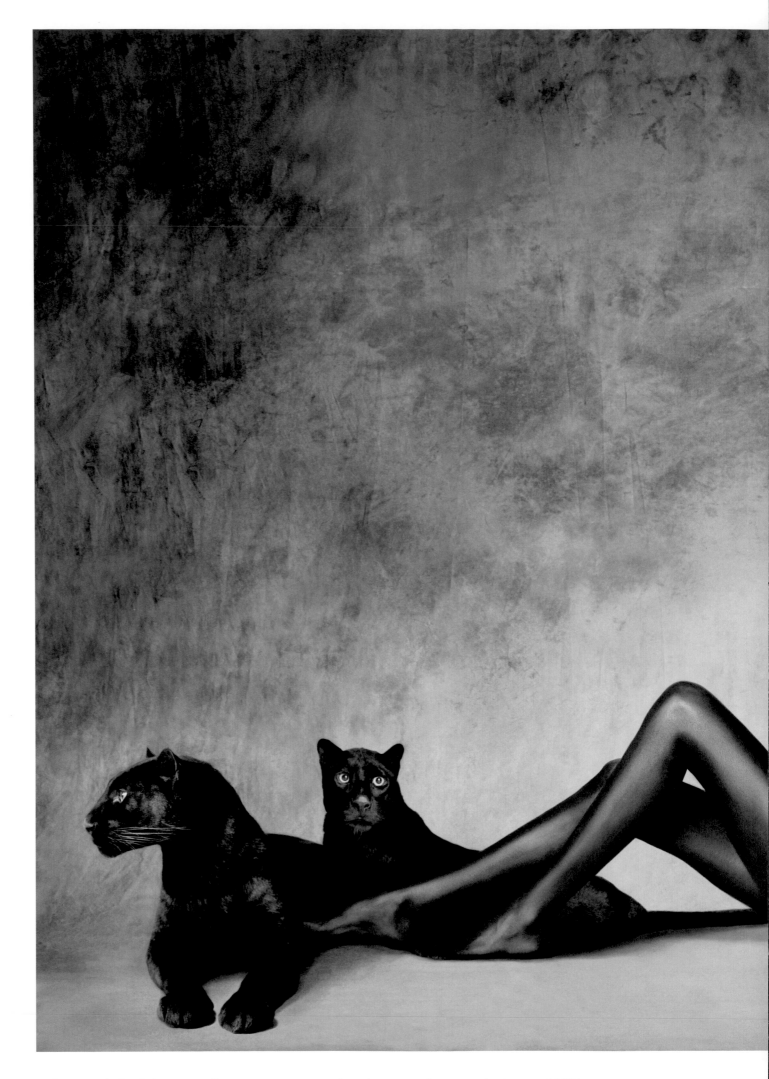

148 . seb janiak . nadja auermann . el país . amica . photo . 1997

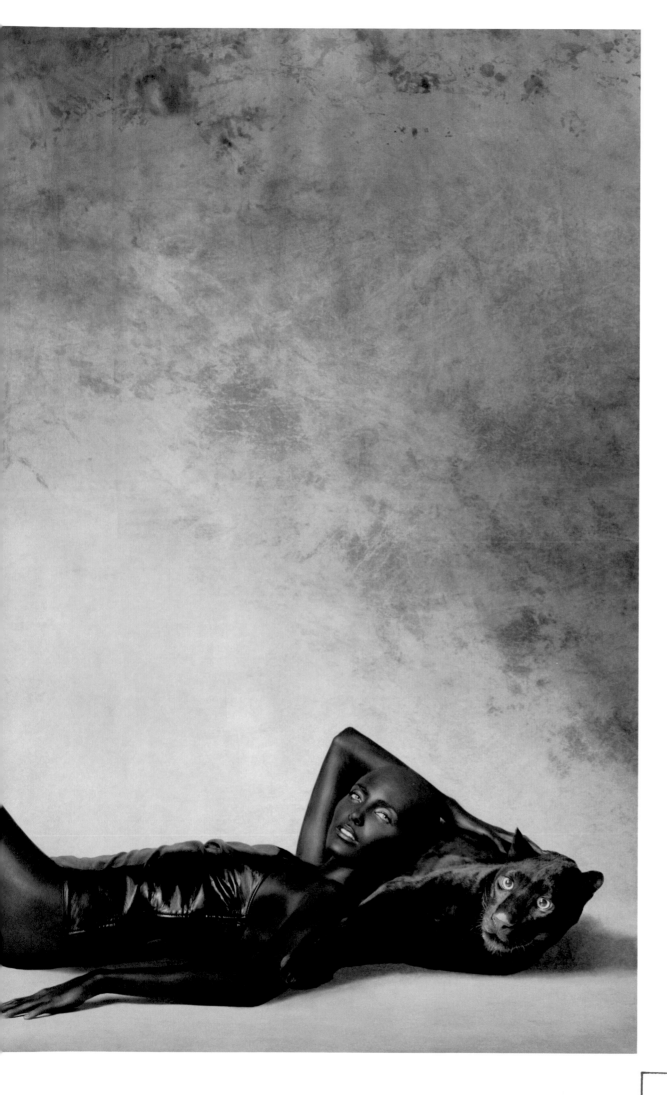

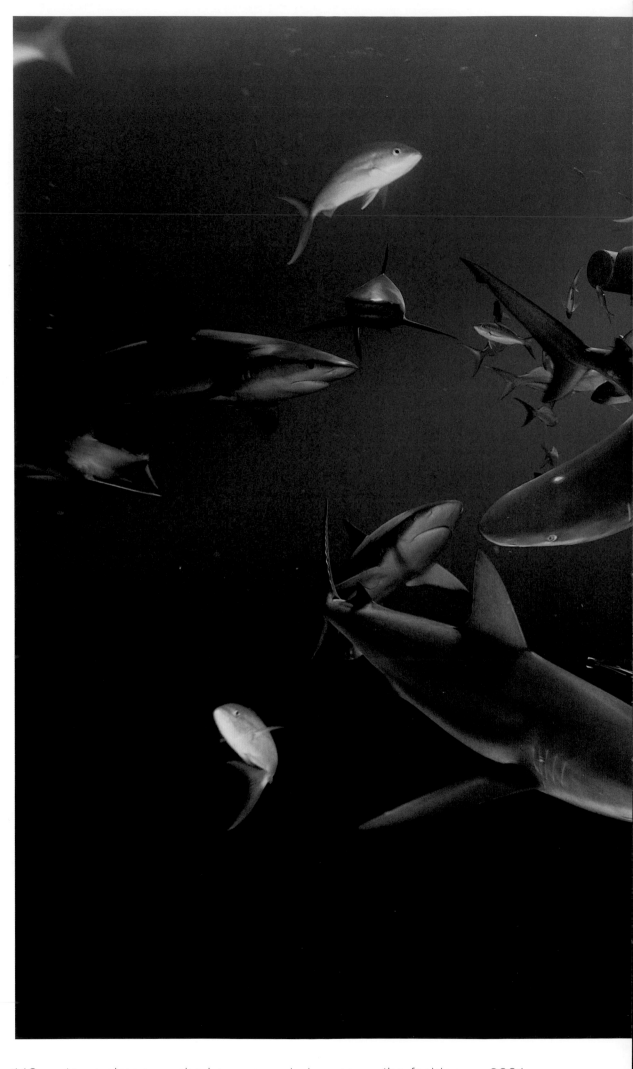

149 . taryn simon . sharks, nassau bahamas . the fashion . 2001

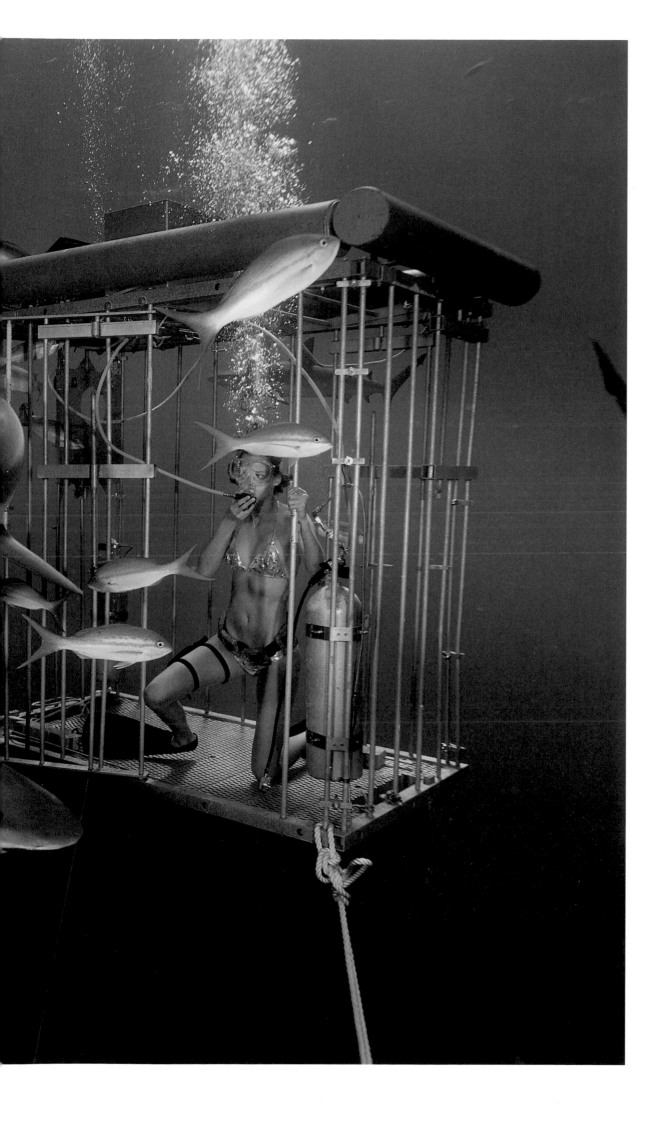

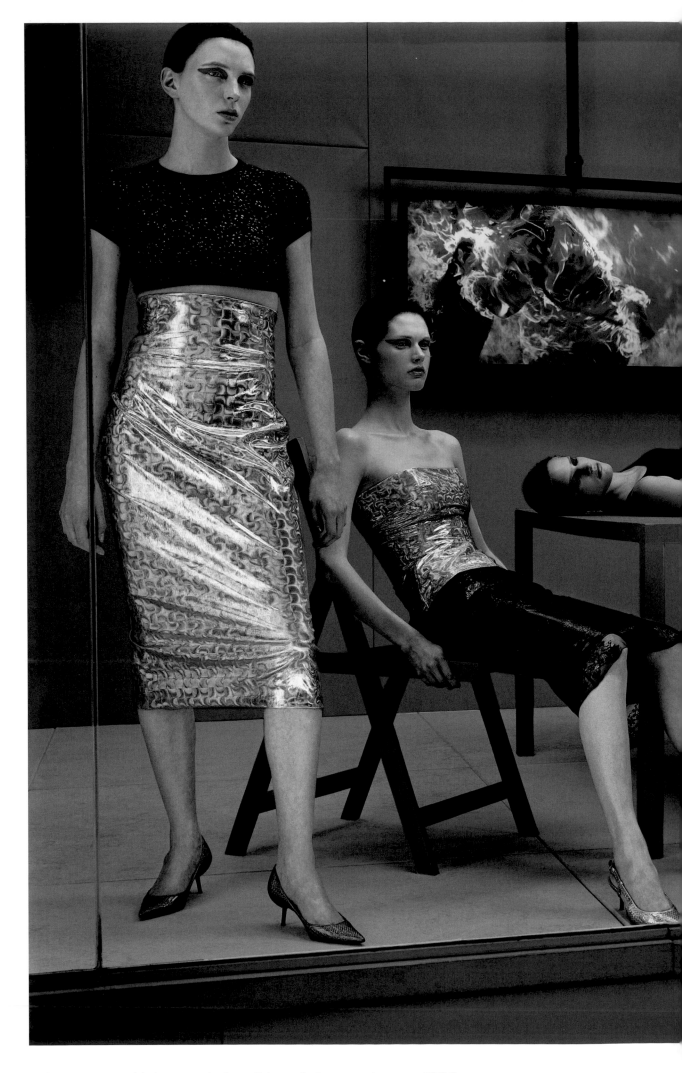

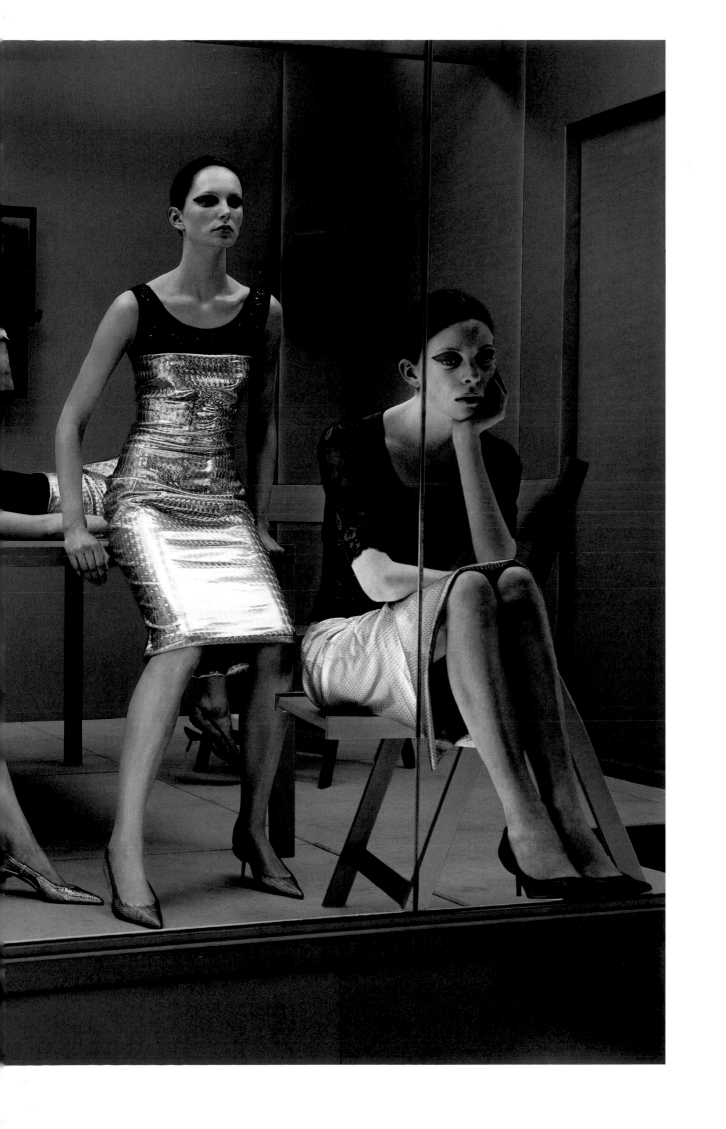

art

Since its invention in the nineteenth century, photography has been art's nightmare, only to become, in the course of the twentieth century, the sensitive part of the liberal arts. The history of photography during the last century has progressed in step with art history. Indeed, in the last two decades of the twentieth century, the overlap between photography construed as art and fashion photography has increased. Less defensively bent on delimitation and instead focusing on an internal pluralist dialogue, fashion photography has developed a relatively bold shamelessness in plundering art history, its holies and its follies.

Art-oriented fashion photography aspires to achieve the greatest possible artificiality. The non-authentic quality of fashion is taken to a higher degree. The hypothetical and the overstaged, exaggeration by stridency, these have all prescribed for photography – a medium formerly considered realistic – a dose of artificiality that impatiently opposes any form of authenticity. When André Breton drew up his First Surrealist Manifesto in 1924, he set it apart from the realist doctrine and its innate positivism as well as from its denial of the imagination. 'Descriptions,' he groaned, 'Nothing can be more vapid.'[21] Logic and rationalism were Breton's bugbears, the destroyers of art and liberty. This Surrealist battle against the heyday of classical Modernism fought out its last skirmishes in photography – a medium of expression defined from the outset as *the* realistic medium, then as *the* realistic art form. The history of Surrealist photography starts with the photographic experiments of Hans Bellmer and Man Ray, who continually subvert the otherwise prevailing 'wakened state' of photography and its perceptual capacities. Surrealist photography endeavours to liberate the medium from its complacent

[21] André Breton, *Manifestes du Surréalisme*, Paris 1946.

self-obstruction, in order to capture dreams that document the surreal beyond all documentation of the real.

Much of the fashion photography of the last twenty years is evidently influenced by art, even quotes and copies it; it resembles a second chance for Surrealist motifs and De Chirico's *pittura metafisica*. The quality of colour film and colour processing that has evolved over the last thirty years affords surrealist photography (hitherto exclusively black-and-white) a new feel and visual idiom. The clear, heady and radiant colours and the new gloss prints change the sensuous feel of the images. The latest photography plays the whole register, whereas classical Modernity had to be satisfied with the abstracting contrasts of black and white – kindling enthusiasm among painters who dripped in colour. 'Photographic imagination; more agile and swifter in finding things than the dark processes of the subconscious,' Dalí cheered in 1927, 'Photography that captures the finest and most uncontrollable of poetry!'[22]

Fashion photography acts like a magnet – all the impressive motifs and mechanisms of constructing images to be found in the more recent arts are imitated, quoted or exaggerated. The seductive originality of Surrealism especially, as well as the subconsciously effective theatre of the absurd, defines the grammar of its iconography. The master of the bizarre was Frenchman Guy Bourdin. A Parisian, fifty-two years old in 1980, he had always drawn and painted, and had trained as a photographer in the army. For Bourdin bringing together painting and photography was a lifetime's project. His first photographs pay homage to Man Ray. Man Ray had emphasized in his texts on photography that it had the ability to visualize what had, prior to the advent of photography,

[22] Salvador Dalí, 'La fotografía pura creatió de l'esperit', *L'Amic de les Arts*, no. 18, 1927, pp. 90–91.

remained in the subconscious without an imago. The work of Bourdin, and that of his most idiosyncratic successor, David LaChapelle, clearly shows how far this subconsciousness has been infiltrated and decomposed by images from the mass media. The contemporary production of films, ads and video art is defined by our familiarity with their images and the shocking confrontation of familiar images. By repeatedly interpreting an infinite number of images from art history, the photos become more readily consumable. A clear distinction is made in photography between archiving and restructuring the mountain of images of Modernity.

The euphoria of Surrealism and *pittura metafisica* has vanished, leaving more modest attempts to introduce poetic structures into photography, in particular into fashion photography. In this context, the grammar of the absurd is largely taken from Surrealist painting (women who hold fish; reclining beauties bleeding, faces in splintered mirrors, men as women, lipsticks as sausages, etc.). However, the painted style and signature are erased and the products of the imagination become all the colder, more lifeless, harder and perhaps less animate in some manner that is easier to consume. Fashion photography slowly but inexorably strips Surrealism and *pittura metafisica* of its rebellious, humanist thrust. Yet it was precisely that character for which Walter Benjamin held Surrealist photography in such high regard: that the world does not seem lonely, but bereft of atmosphere, emptied 'like an apartment which does not yet have a tenant'.[23] Surrealist photography, or so Benjamin claimed, prepares 'a healthy alienation between man and his surroundings'. Surreal fashion photography does this deliberately in order to create the final impression of an exceptionally high-brow and

23 Benjamin, 'Kleine Geschichte der Photographie (1931)', *Gesammelte Schriften*, p. 379.

of image shown, but instead by re-creating them in the studio or the lab. Alongside the Surrealist genres, Dadaist motifs, Fluxus and Arte Povera's heaps of clothes, Bellmer's dolls are all given a new interpretation, re-issued by Mario Sorrenti and Jean-Pierre Khazem; constructivist architectural drawings are sampled by Serge Lutens and Claude Cahuns' gender-specific deconstructing collages are brusquely touched by Jean-François Lepage. Young and old photographers alike skim off a veritable tub of art history, in order to place its images – as shameless as they are inspiring – in new barrels. The quotations become especially exciting where the art cited is itself an echo of photography's threat to art. For example, the photo realism of painting is quoted in the disturbingly stiff photographs of Taryn Simon. Photography apes a type of painting that itself suffered as a stigmatized form of art at the hands of the dominance of photography. Here, visual culture enters an echo chamber in which all the impressions and resonances interfere so much that at the end they are synchronized and superimposed in a striking multi-layered entity. Precisely these fine allusions to art show that synergies can be tapped not only at the iconographical level, but that syntheses are de rigueur: the idioms of art and photography must intermingle to such an extent that a new art idiom emerges that over-arches the different media. Even if photography has apparently effortlessly shed any claim to producing something exclusive of its own, it is precisely its relativized authorship given the seemingly effortless and non-academic nature of its reference that constitutes the new quality in plundering art history.

Here, again David LaChapelle is a past master, arranging his surreal worlds of images with a baroque sense of enjoyment. Like dolls' houses

crammed with perverse fantasies, one picture blends with the next to form an architectural labyrinth in which there are no linking roads. *Hotel LaChapelle* was the title of the second of his monographs, published in 1999. Hotel rooms are places where people are guests only for a while and analogously his photographs were intended to make the viewer feel at home for a moment in an alien world. His pictures are not fully defined by the discourse of fashion but themselves create fashion, for everything in and about them is fashionable: the type of make-up, the colour, the light. They act with models who are exaggeratedly artificial, embedded in the settings as if to become part of an allegory. In the age of decomposing old linguistic systems of communication and the emergence of new systems of understanding each other, the signification of things becomes a slippery matter. Semantics becomes a black hole. And LaChapelle and his colleagues Nick Knight or Mark Borthwick place their allegories directly within this uncertainty of meaning. Allegory by definition has something abstract about it, and in fashion photography it becomes an attitude rendering abstractions that are conceivable and imaginable, without the ability to specify them any more closely. In other words, the level of abstraction is only simulated. Here, again, fashion is a successful model for what are now only simulated processes of signification: be it noisy message T-shirts or the incunabula of fetishes or polit-radicalism – all the meanings used are wired up in a black box that is not actually powered. Everything remains a game of form and colour.

The way in which still lives are seized is equally a matter of simulation. *Natura morte* is taken on as a form from art: De Chirico defined still life as a peaceful life devoid of noise or motion, an existence expressed by

volume, form and three-dimensional qualities. The *memento mori* of skulls and wine carafes is brought up to date in the form of the models' rigid shrouded legs or torsos, and the melancholy rags of contemporary design especially uphold this heavy-hearted trait of classical still lives culled from painting.

In Pop culture, the New Wave movement peaked in the early 1980s. Its central message was to declare the entire world and all life to be a still life or – to put it dynamically – a sequence of still lives. By exaggerating ennui and resorting to stylistic extravagance, in New Wave everything became a rigid, cool arrangement intended to illustrate the artificial nature of existence in general and of all friends of fashion in particular.

New Wave was, if not the end of all desire, then at least its decadent trivializiation. Yearning was misunderstood as a craving for visions. Since it was impossible to be happy, the misery of existence had at the very least to look nice. This was the battle plan of New Wave, and many photographers of the last twenty years underwent their socialization exposed to its styles. The melancholy thus promulgated, and narcissistic paranoia, again thrived on the images of fashion magazines such as *Vogue*, where the photos by Guy Bourdin also inspired musicians such as Bryan Ferry of Roxy Music or Debbie Harry of Blondie. In the mid-1970s, Ferry's love song to a plastic doll that floats in his swimming pool was quite trailblazing in its forced affirmation of the artificial and ahuman. It was not until much later that this attitude reached the visual and aesthetic mainstream, only to slide back immediately into the opaque world of ambitious postcards and wall calendars.

The surreal alienation effect becomes the tool of a visual culture of kitsch. And it is precisely with this that contemporary fashion photo-

graphy interacts, whereby the latter is relatively sure of itself in terms of style. In other words, the photographer's sensory array enables him to pick out those elements of kitsch that evolve new traits and evoke the current zeitgeist. The result is a camp strategy for reclaiming the most beautiful stereotypes that had been lost to kitsch.

Glamour and art meet in the estrangement between representation and reality. In his Versace campaigns Steven Meisel so overdoes the realism and glamour that in the end the arrangements seem surreal and self-contradictory in their opulent glory even though they were shot at *real* showcases of luxury. Be it in North Italian palazzi or in Los Angeles – wherever Meisel combines models and real surroundings, the representation of luxury becomes an unreal totality whose ghastly wholeness seems robbed of alternatives. The world is, in both senses of the word, finished, left to its own devices, lost. The women's gestures and expressions are resigned. How things will continue is both unclear and not yet considered. The figures become dolls, the houses stages, the hyperrealism of a seemingly endless depth in focus and the brilliance of colours in the prints gives this luxury that touch of unreality which identifies the Surrealism of decadence. All beauty becomes mysterious.

Aragon once spoke of the enemies of order who spread the magic potion of the absurd; now they are the ones who are paid as image-makers to glorify that order who make use of the absurdity of the real. This occurs less obviously than in the overly clear unreal or surreal scenes. Granting the abstract real presence is not the task of the glamour photograph but a generous by-product. Breton termed the dissolution of dream and reality in Surrealism a kind of 'absolute reality'.[26] Here, the dream was the agent of political and social rebellion – it embodies

26 Breton, *Manifestes du Surréalisme.*

an unredeemed emancipation, a tangible utopia. Modern glamour photography is the dissolution of nightmares and reality in a kind of sur-reality that depicts estrangement – that cannot be pinpointed on behalf of the bourgeoisie using the categories of social-documentary photo-graphy but, in line with bourgeois categories of distinction, only by visualizing bourgeois material dreams and hopes. In other words, the Romantic element of Surrealism has disappeared and has been replaced by a capitalistic eschatology. The dreams are not the expres-sion of some individual subconscious, but of society's consciousness. The new surreality functions analogously.

Fashion photography professed to be art and equally the liberal arts professed to be fashionable. Both US art of the 1980s and 1990s as well as British art of the 1990s flirted with fashion or allied with it. Fash-ion, art and photography give rise to a mixture as attractive as it is repul-sive. The fact that photography purports to be so masterful and casual in the process stems often from the laborious endeavours of fashionably affected artworks and artists. The modish semi-cultured nature of these artists makes many of the works only interesting in a gallery and only rarely in settings where fashion experts and fashion victims spend time. The poverty of the radical chic in which the art of fashion dresses itself goes unrewarded. A glance in an issue of Italian *Vogue* of the time, with its wide-ranging ads and editorial sections, shows just how paradise-like the blossoming radiant garden of ideas is that fashion cultivates. As an artist, trying to top it or cast it into question, to sample it or reinterpret it, could mean running the risk of falling from a great height.

art

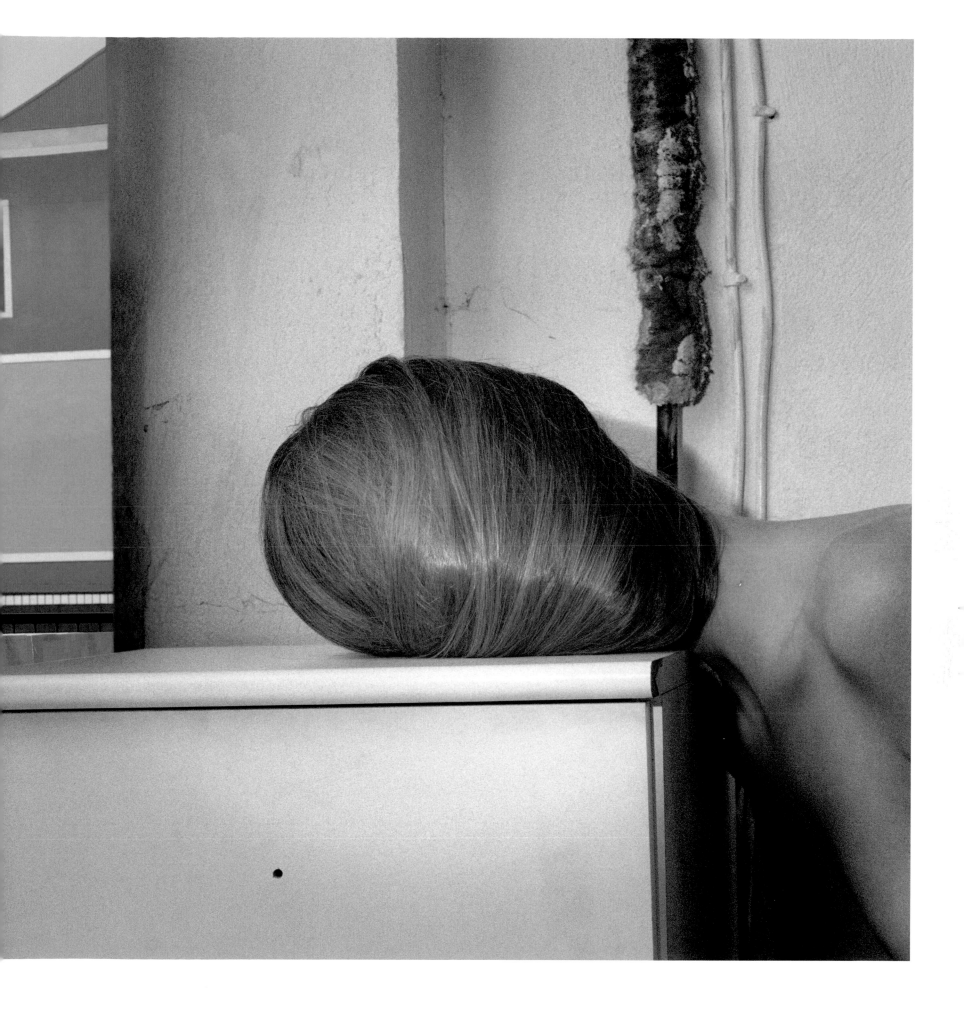

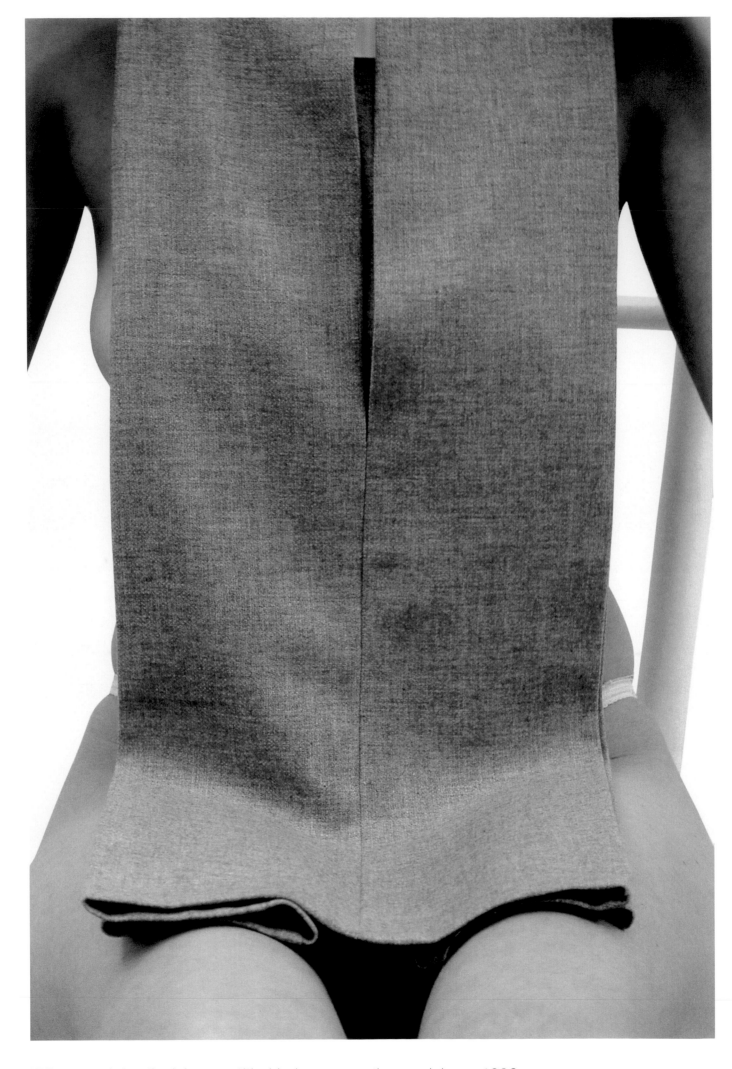

158 . mark borthwick . untitled helen . martin margiela . 1999

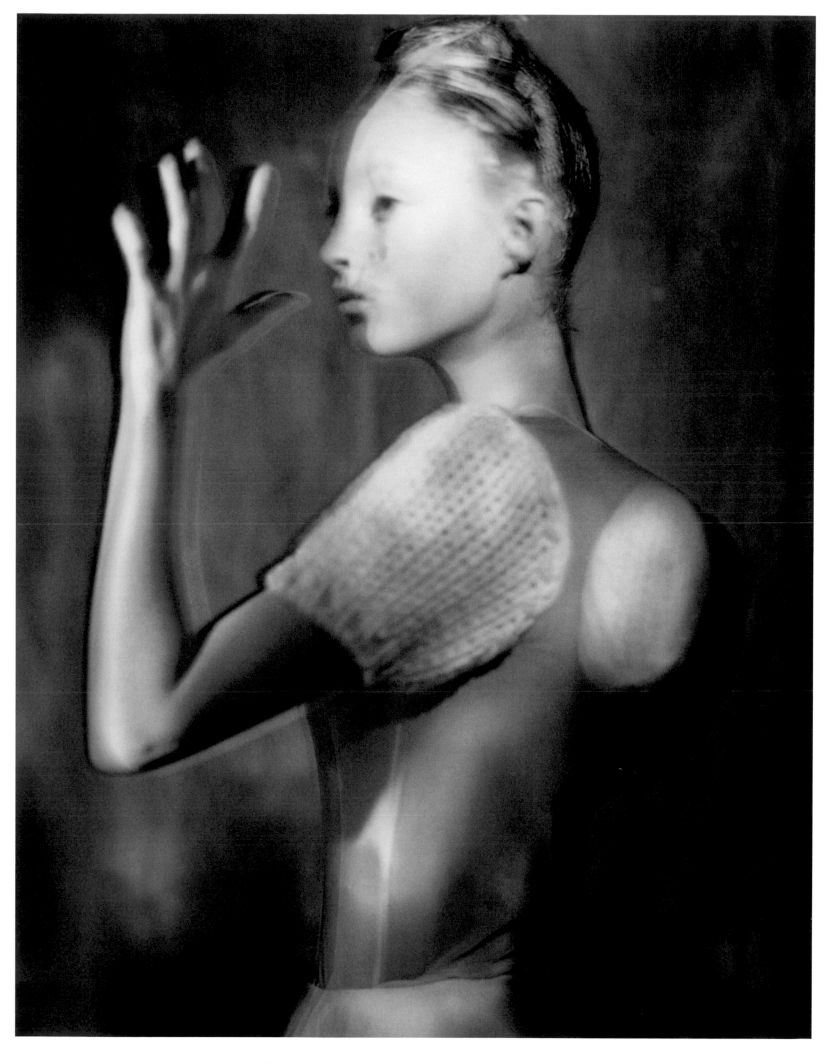

159 . paolo roversi . audrey . libretto . 1996

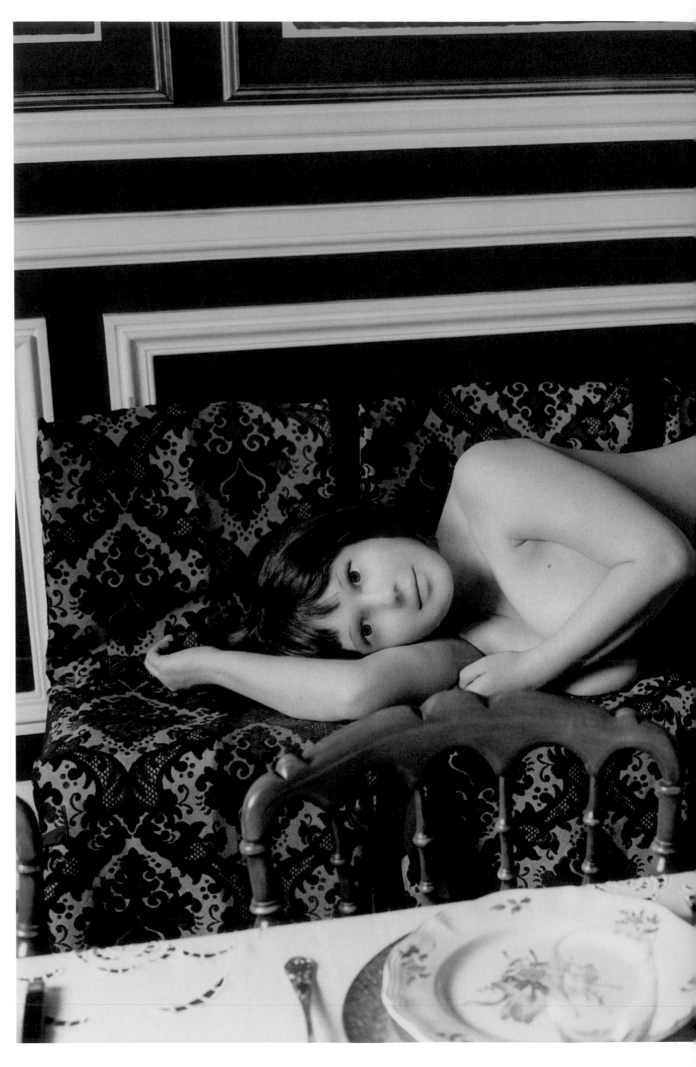

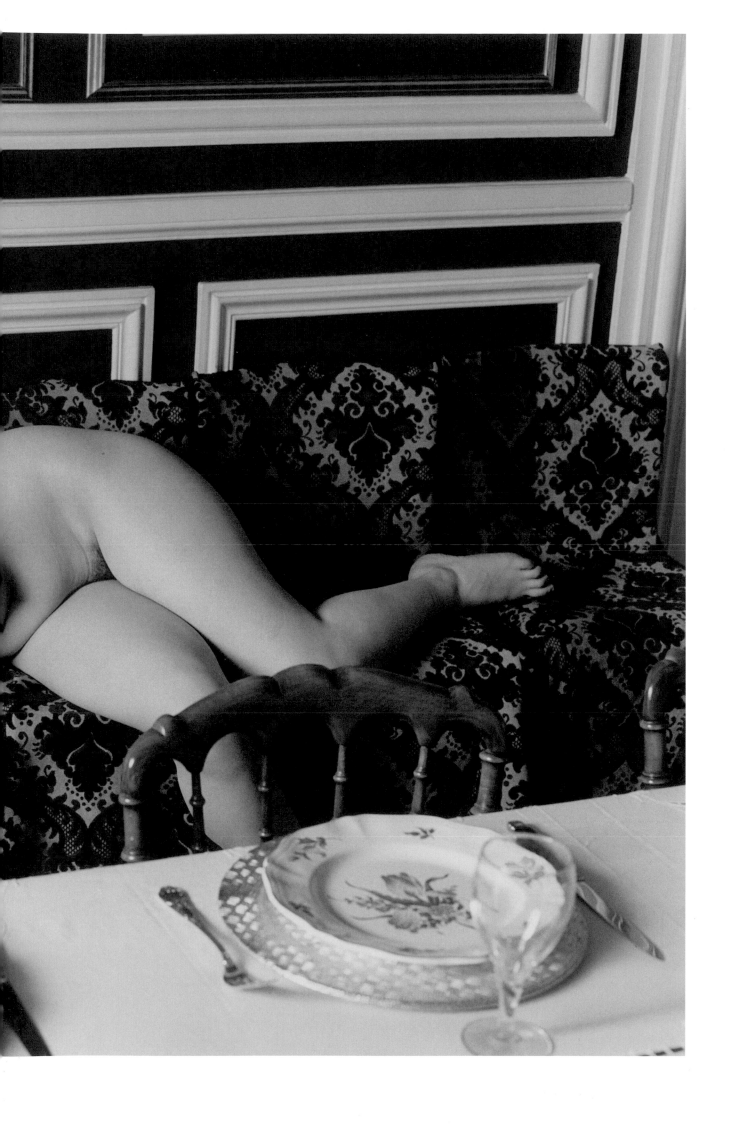

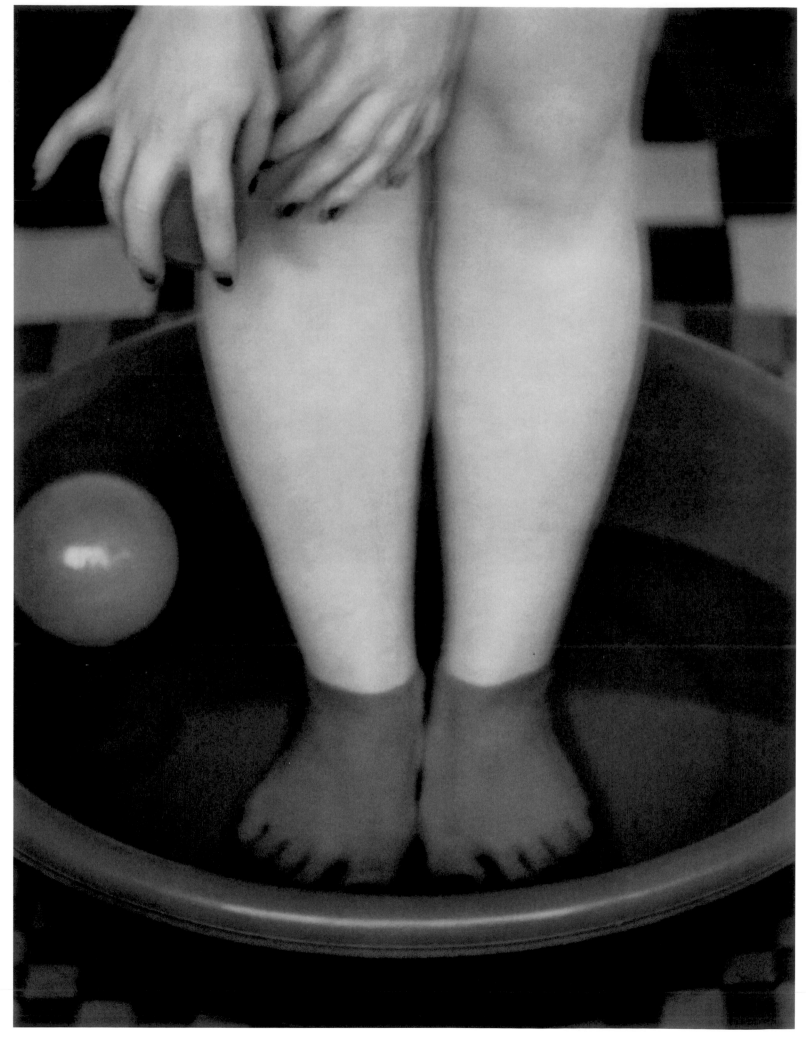

161 . sarah moon . le bain de pied . 1998

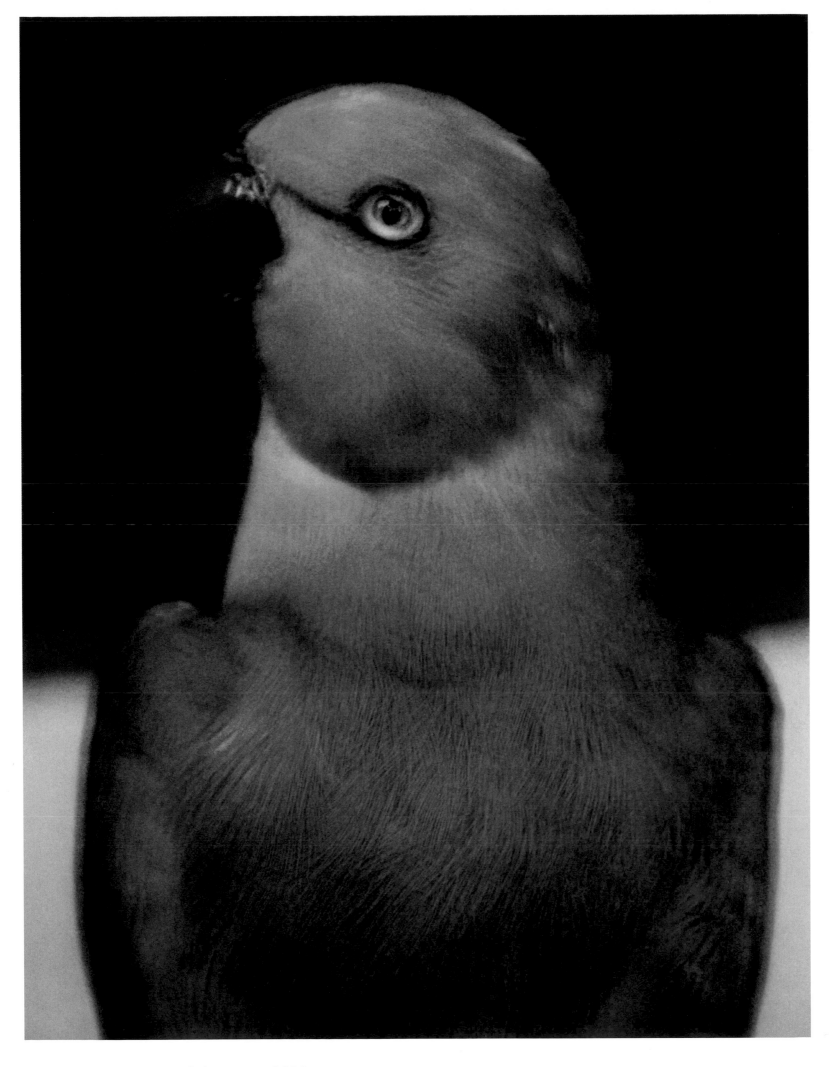

162 . sarah moon . l'oiseau . 2000

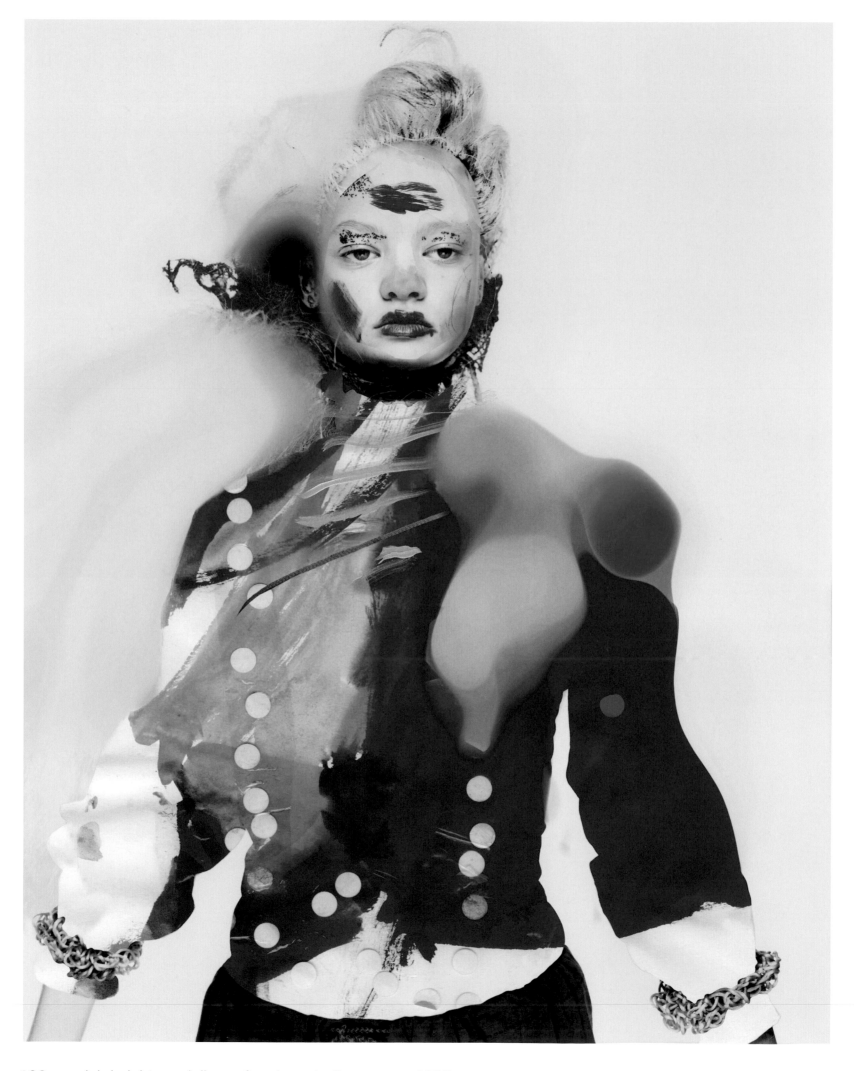

163 . nick knight . dolls . for showstudio.com . 1998

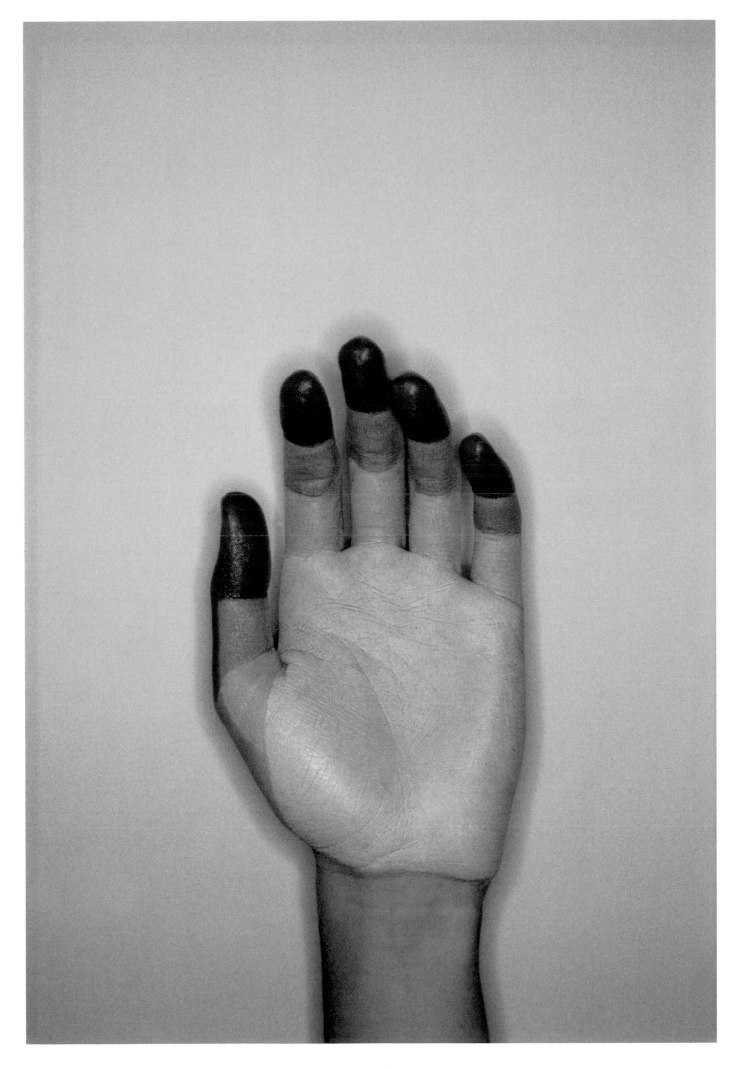

164 . camille vivier . untitled . libération supplément n° 2 . 1999

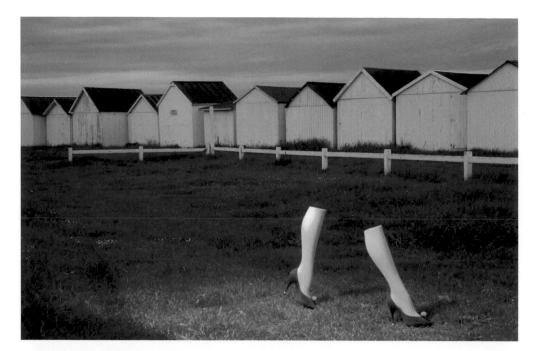

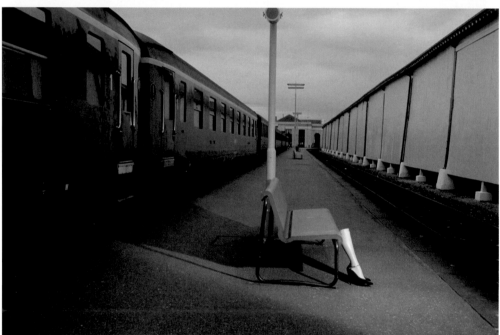

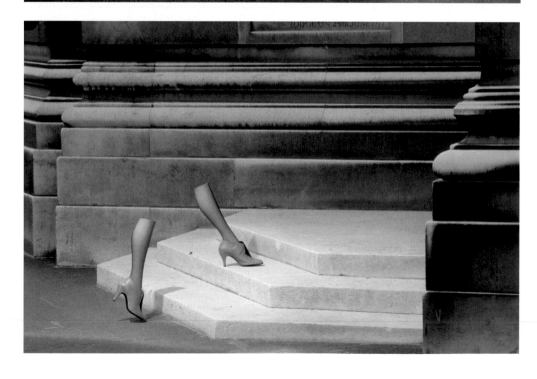

165 ▪ guy bourdin ▪ charles jourdan ▪ 1979

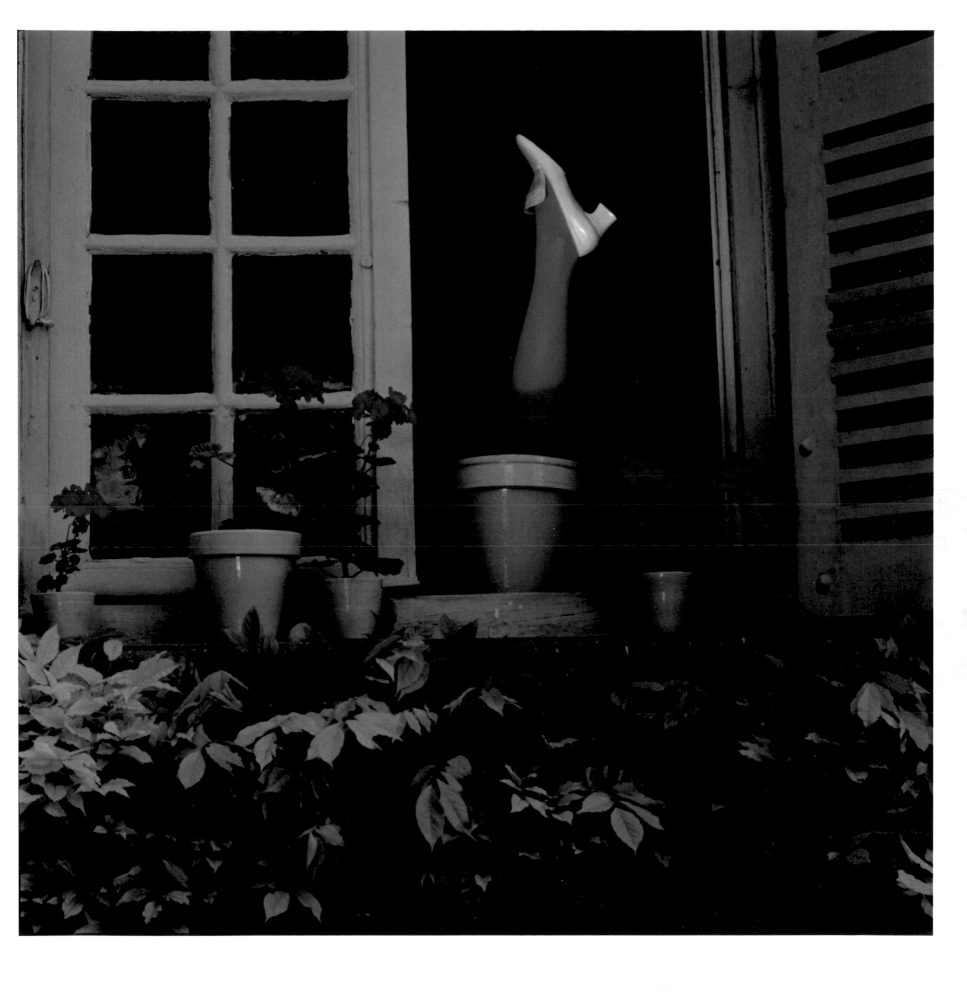

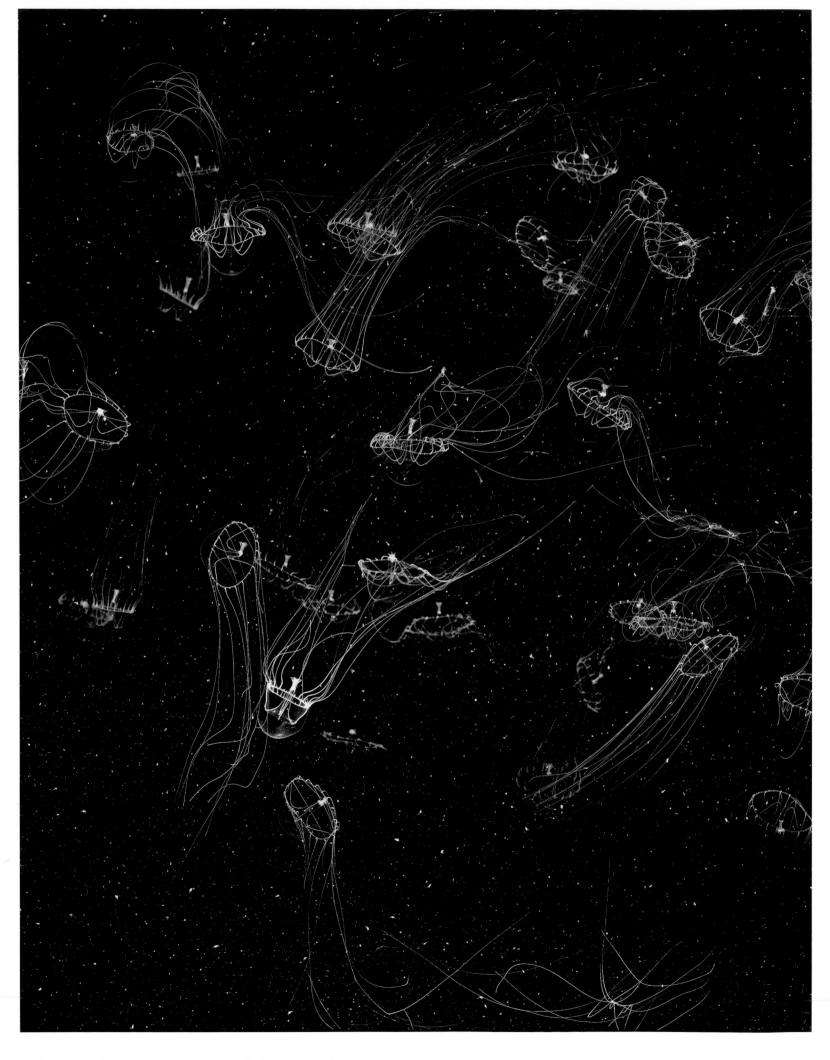

167 . guido mocafico . jelly fish . tina formosa . 2000

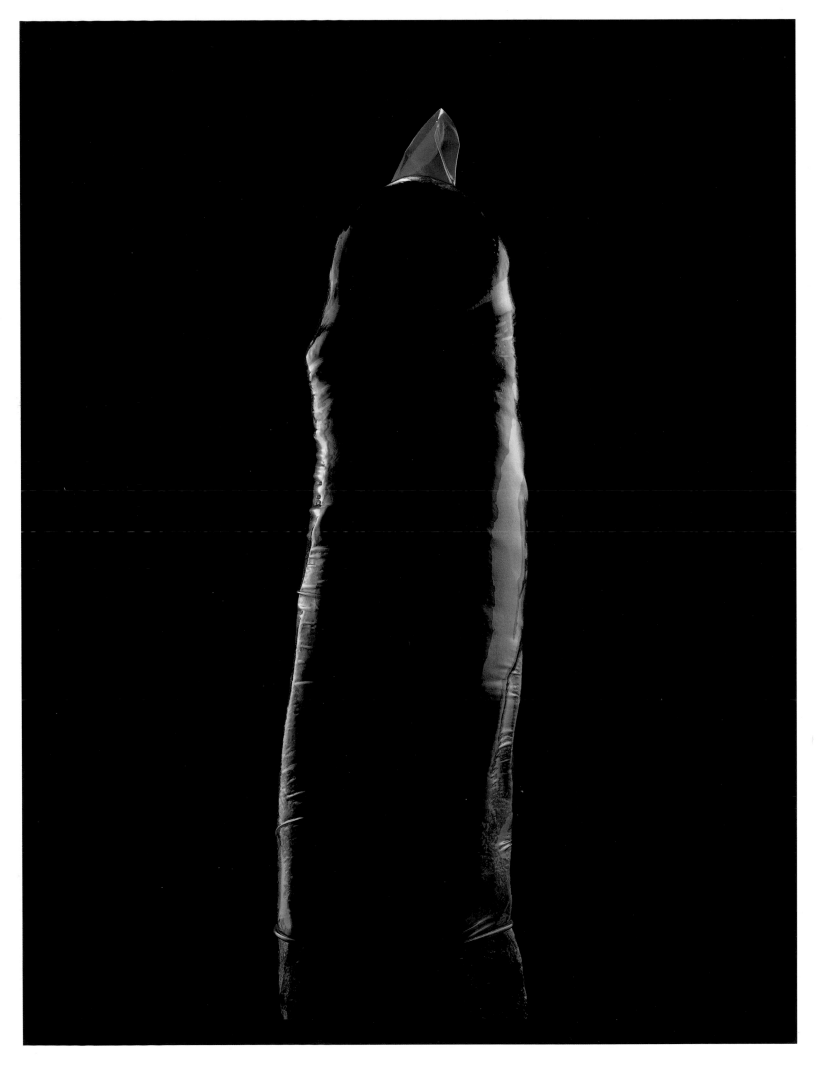

168 ▪ guido mocafico ▪ condom, manix ▪ têtu ▪ 2001

174 . nick knight . sister honey . dazed & confused . 2000

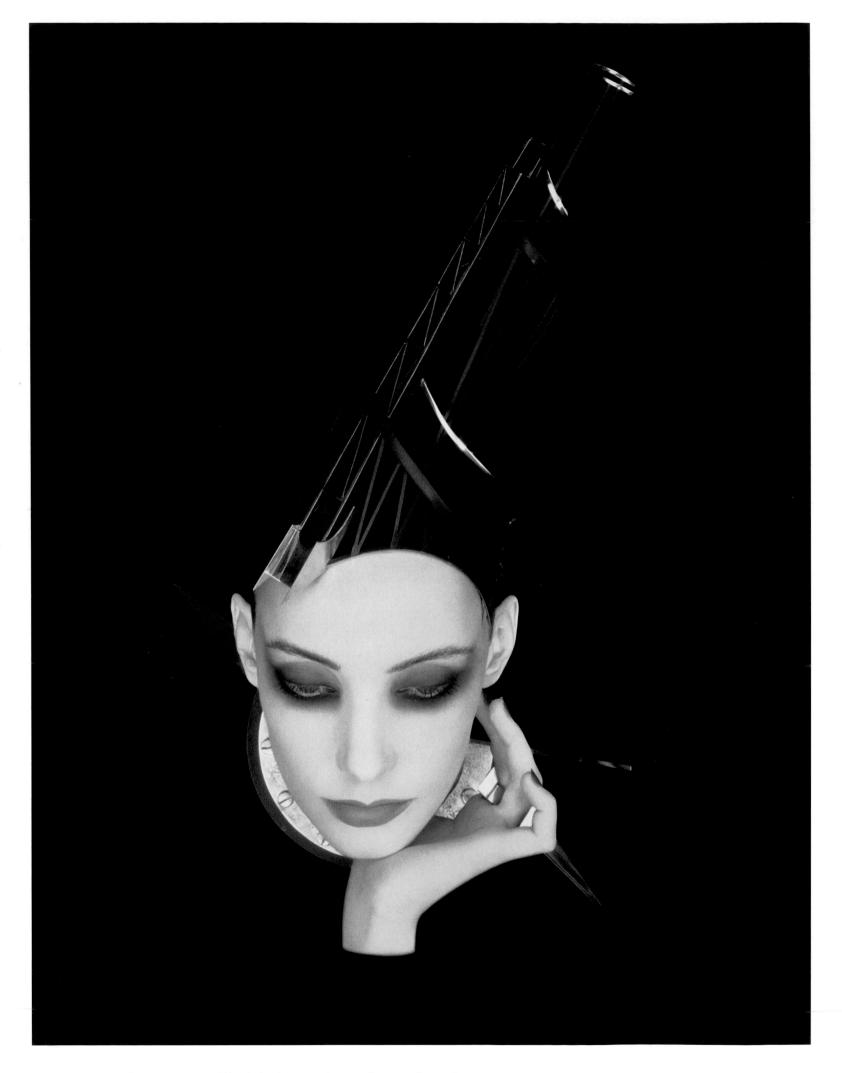

175 . serge lutens . coiffe à la façon de "tatlin tour", cathy . 1989

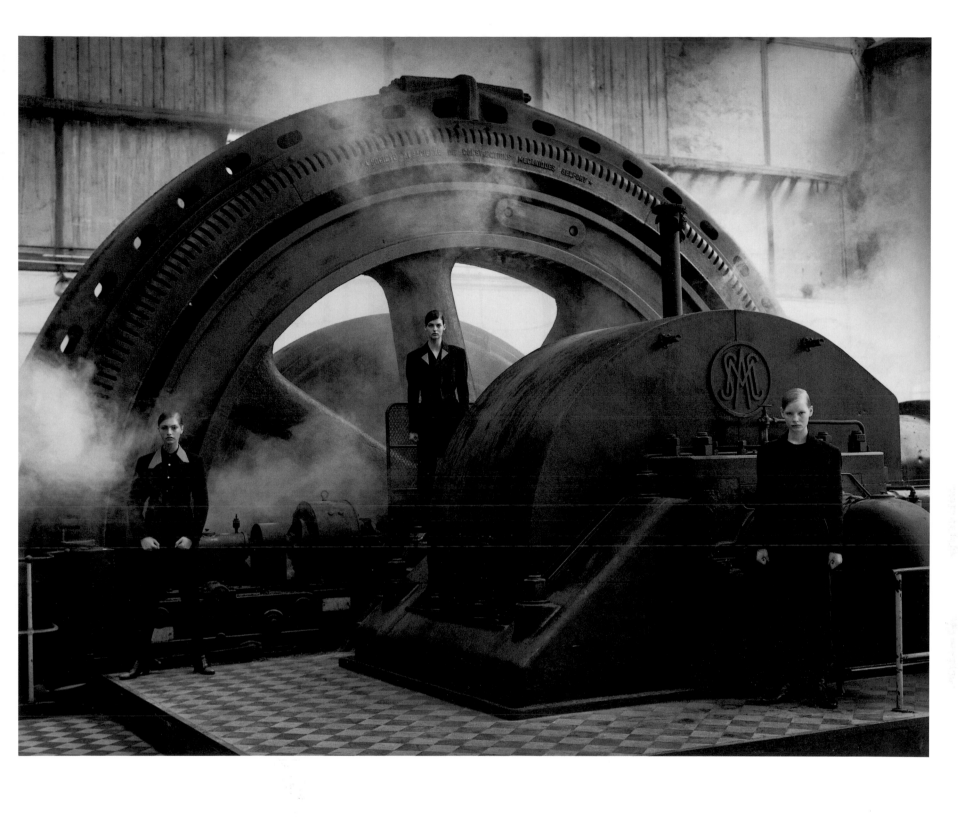

176 . peter lindbergh . kirsten owen, michaela berko & linda evangelista . comme des garçons . 1988

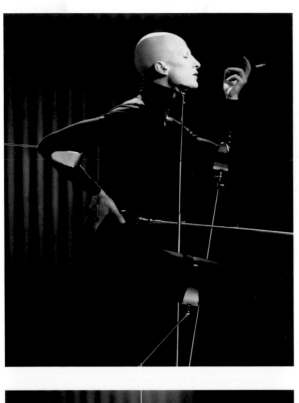
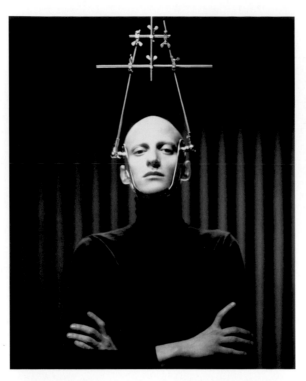
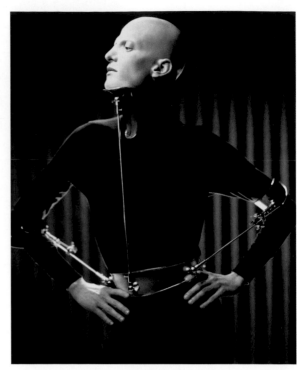
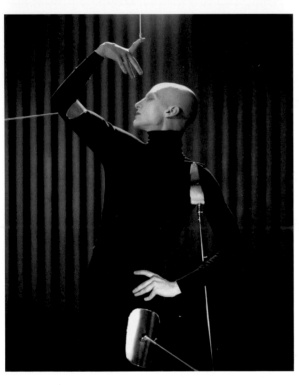
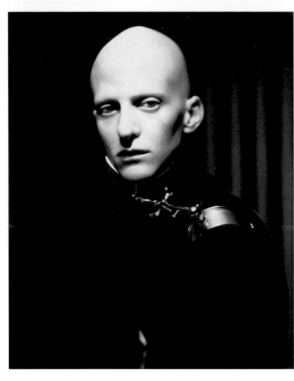
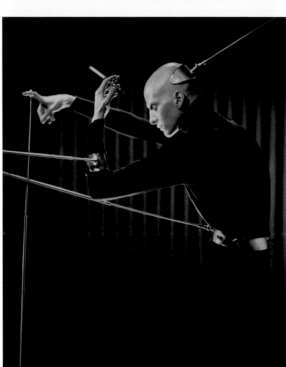

177 . ali mahdavi . as you desire me . 2000

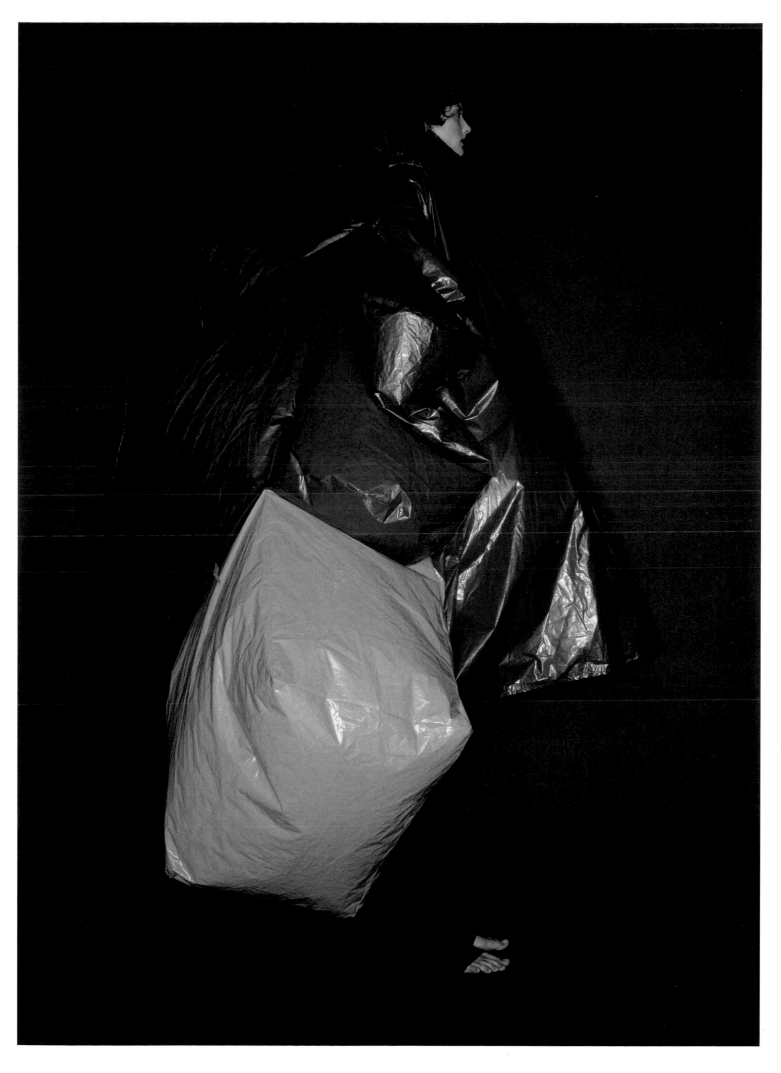

178 . camille vivier . untitled . zoo . 1999

180 . toby mcfarlan pond . work for yohji . 2000

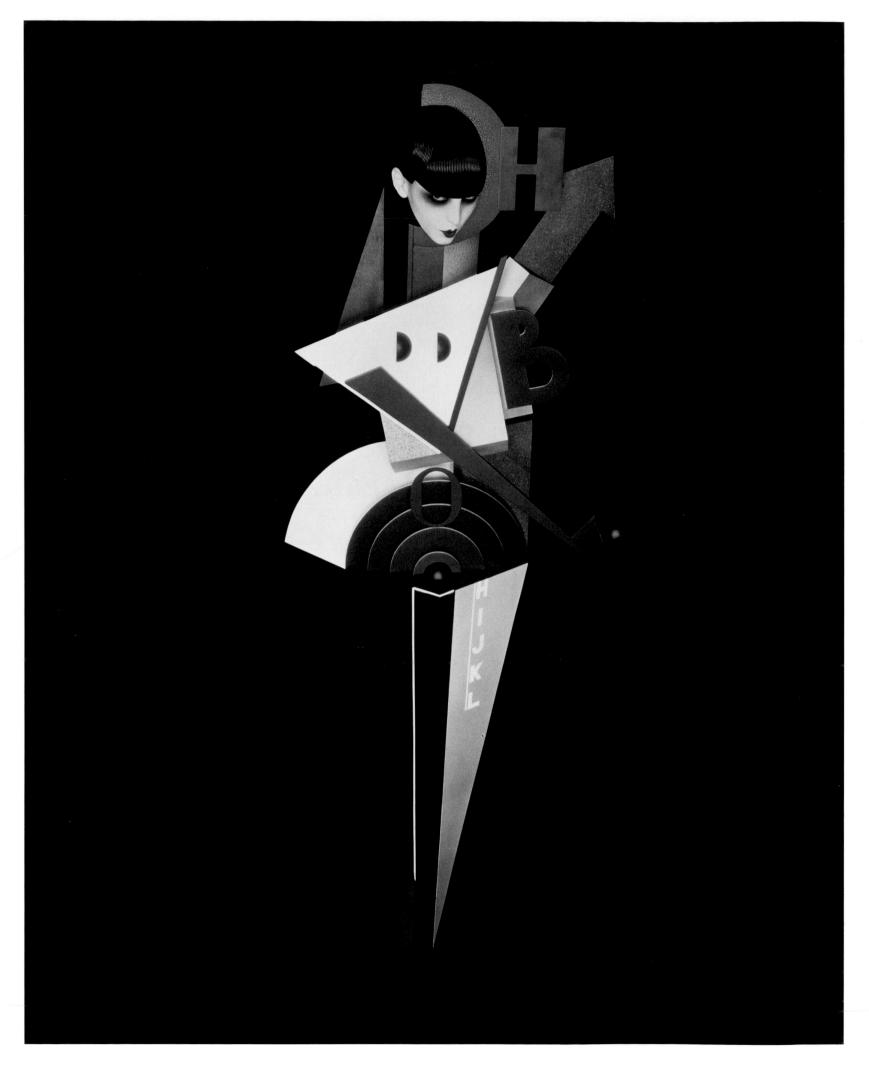

181 . serge lutens . composition lettriste noir, rouge & blanc, louise . 1989

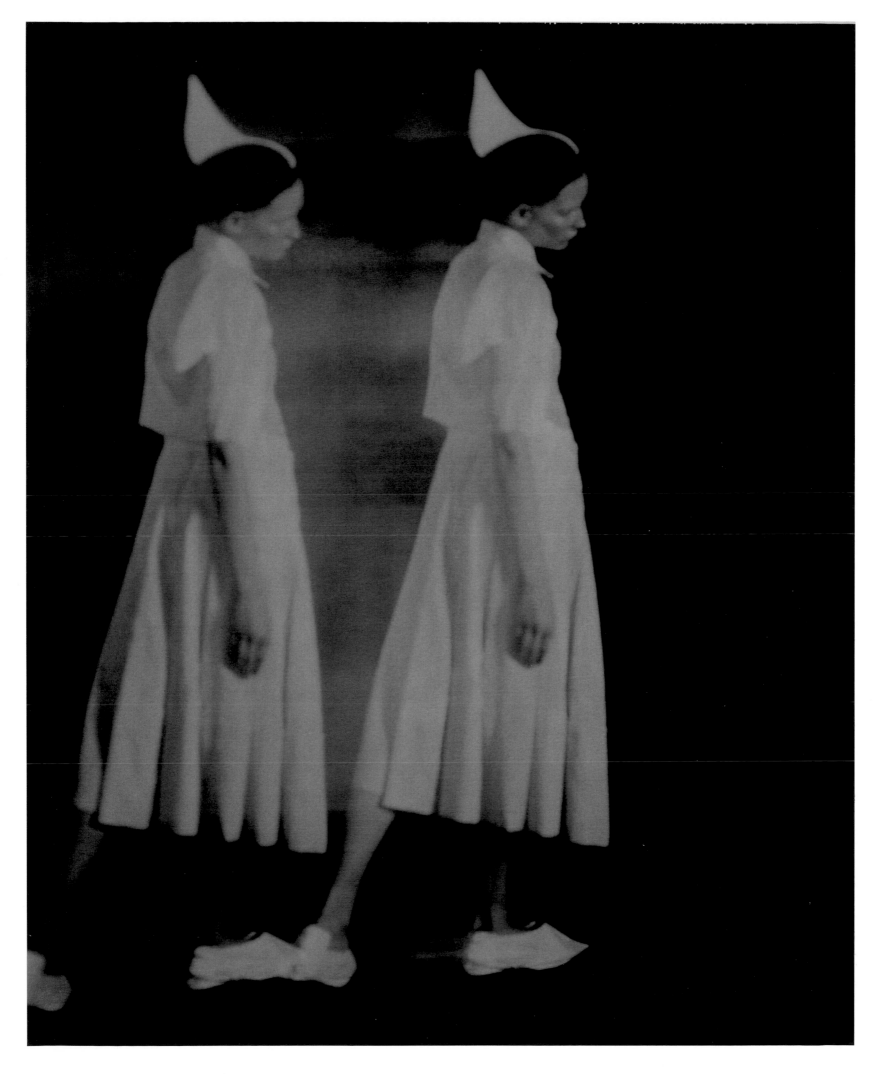

182 . paolo roversi . sasha, paris . english vogue . 1985

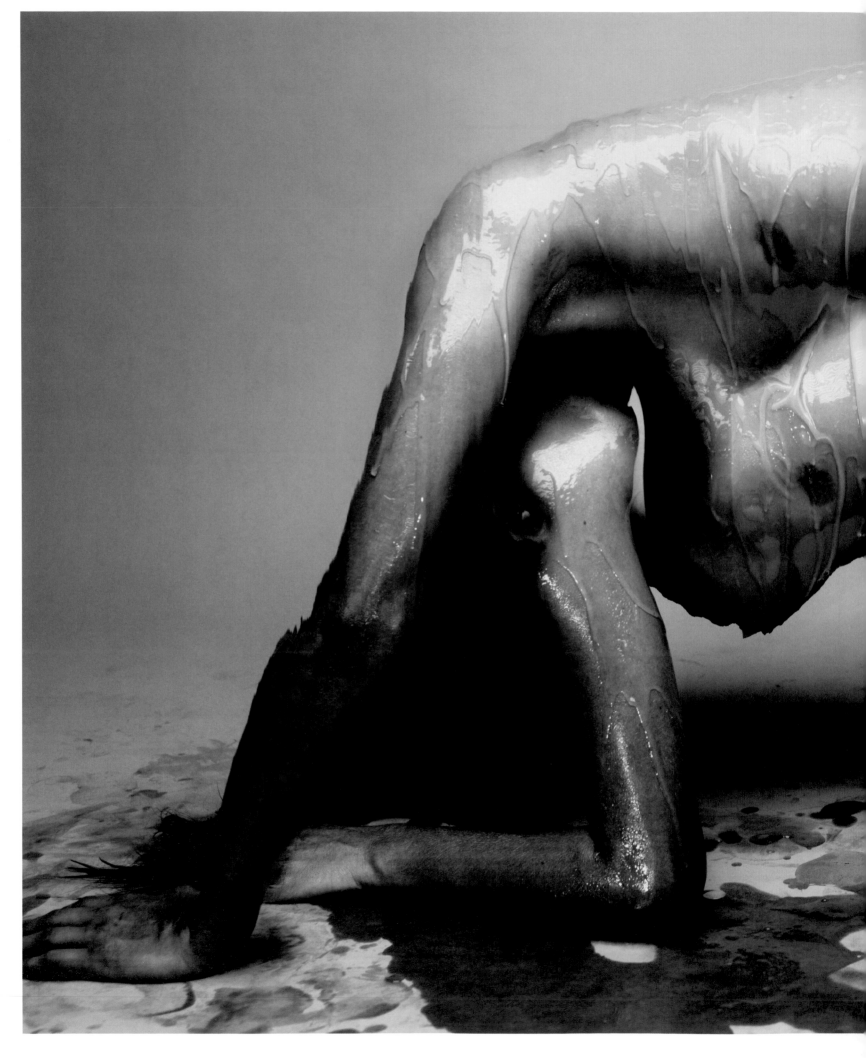

183 . stéphane sednaoui . daniela urzi . black book . 2000

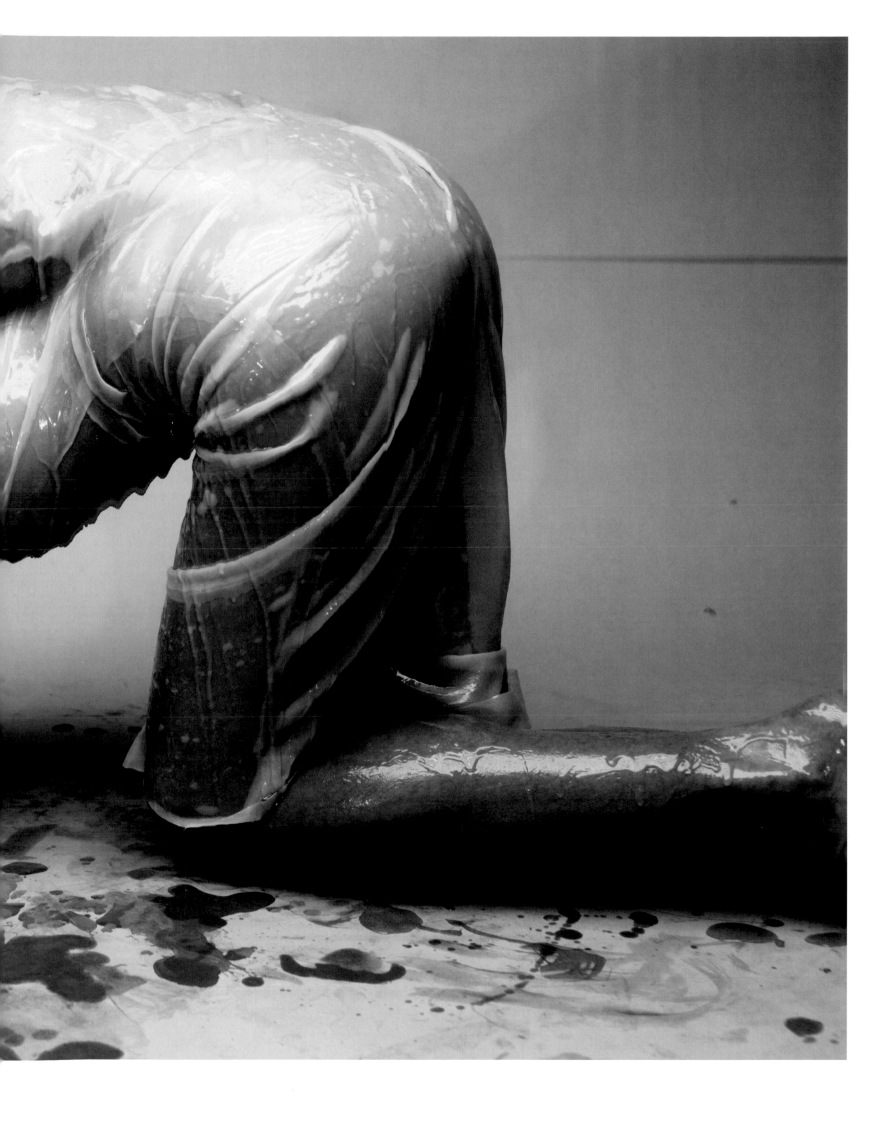

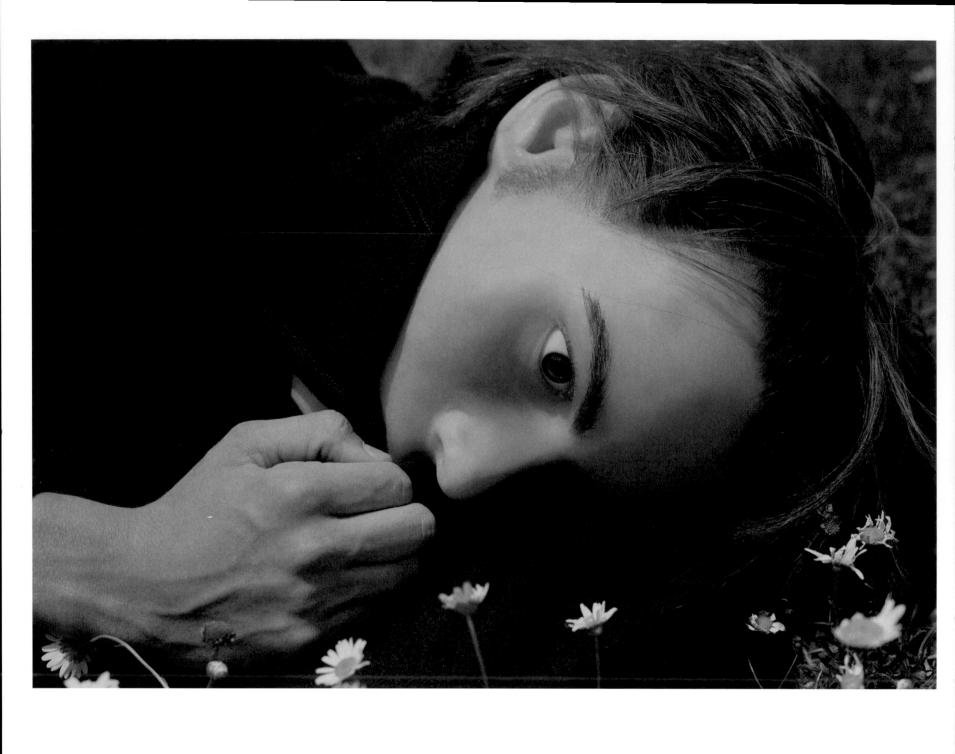

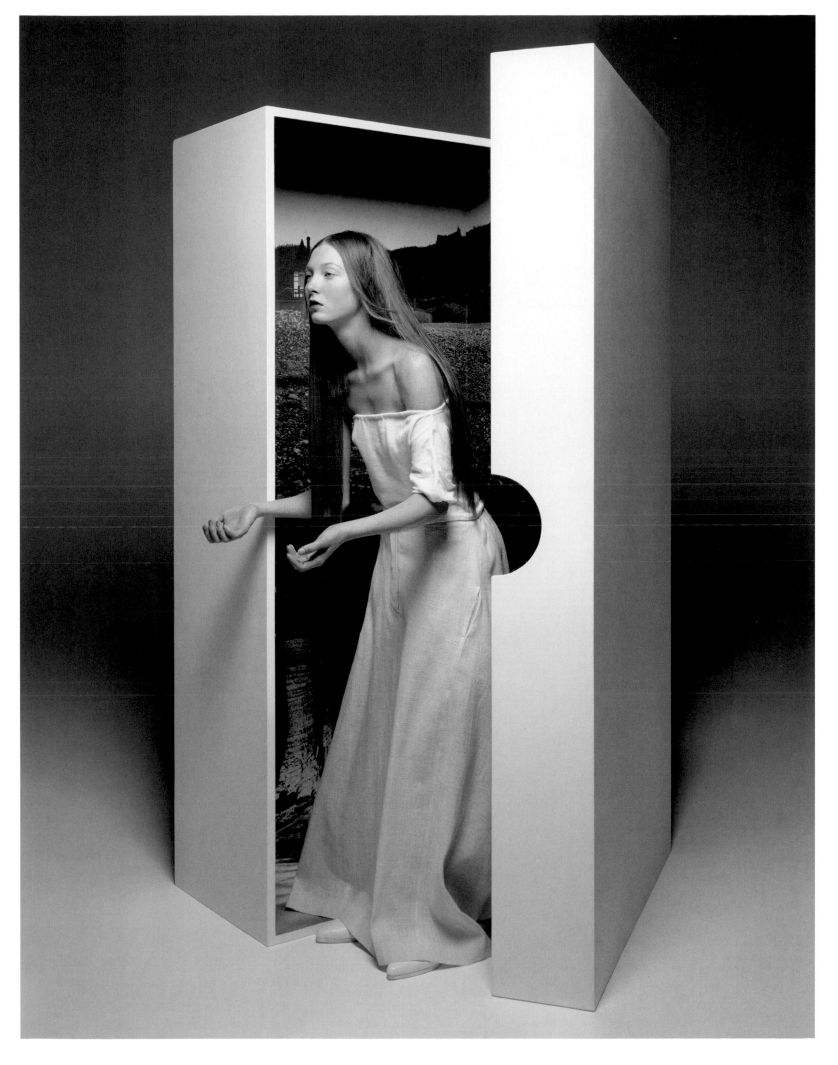

185 . inez van lamsweerde & vinoodh matadin . yamamoto, maggie's box . 1997

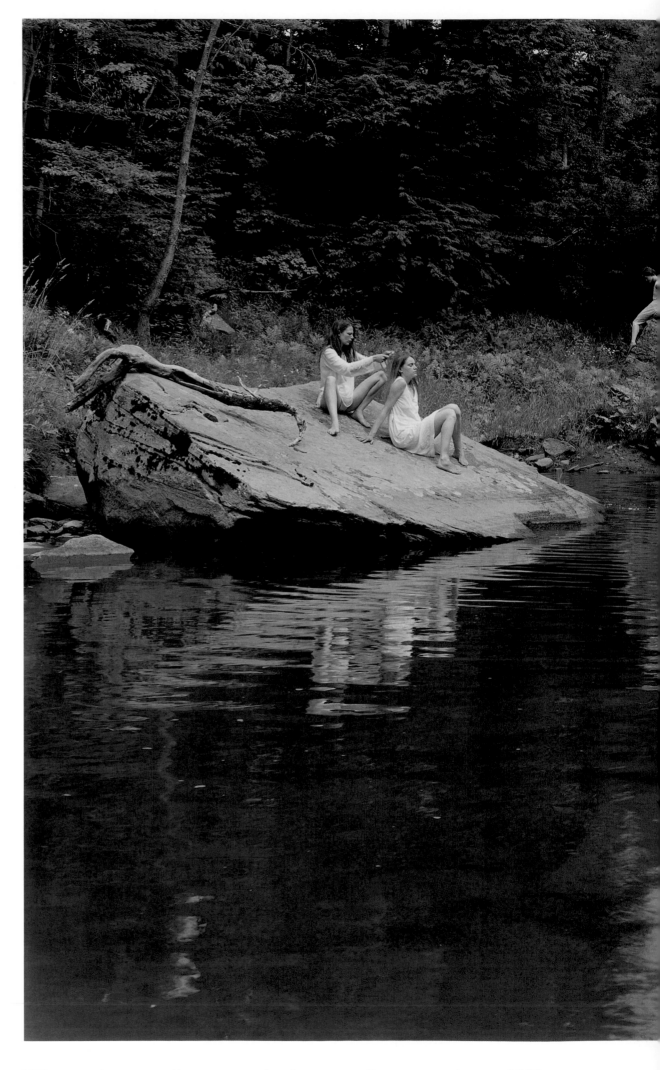

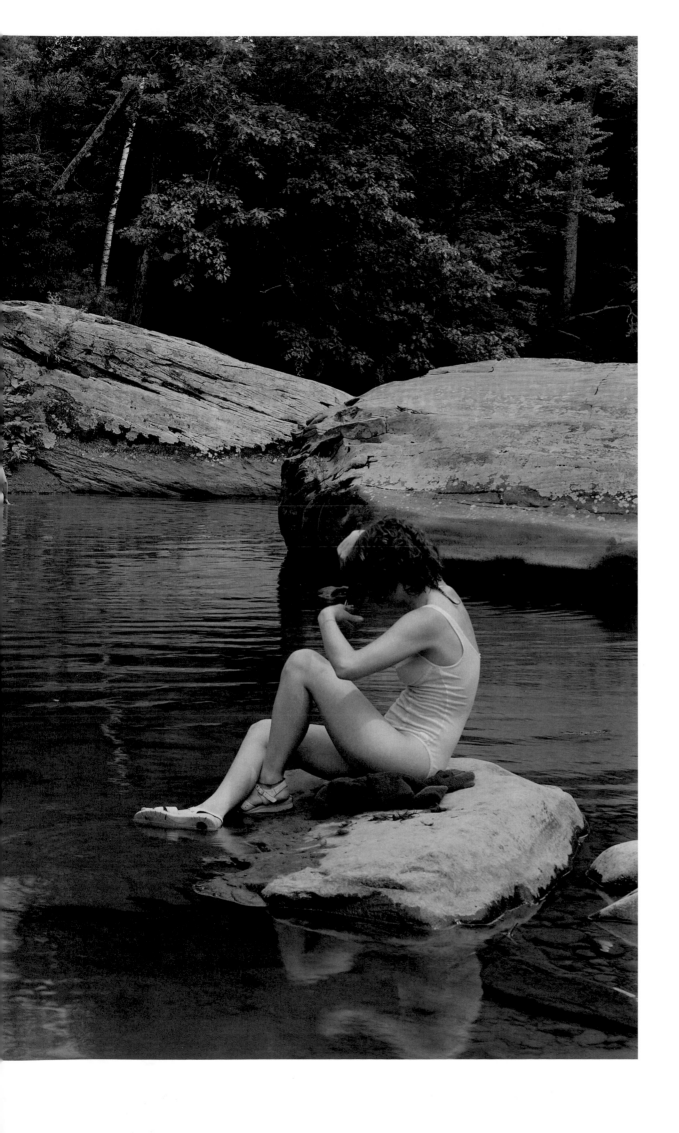

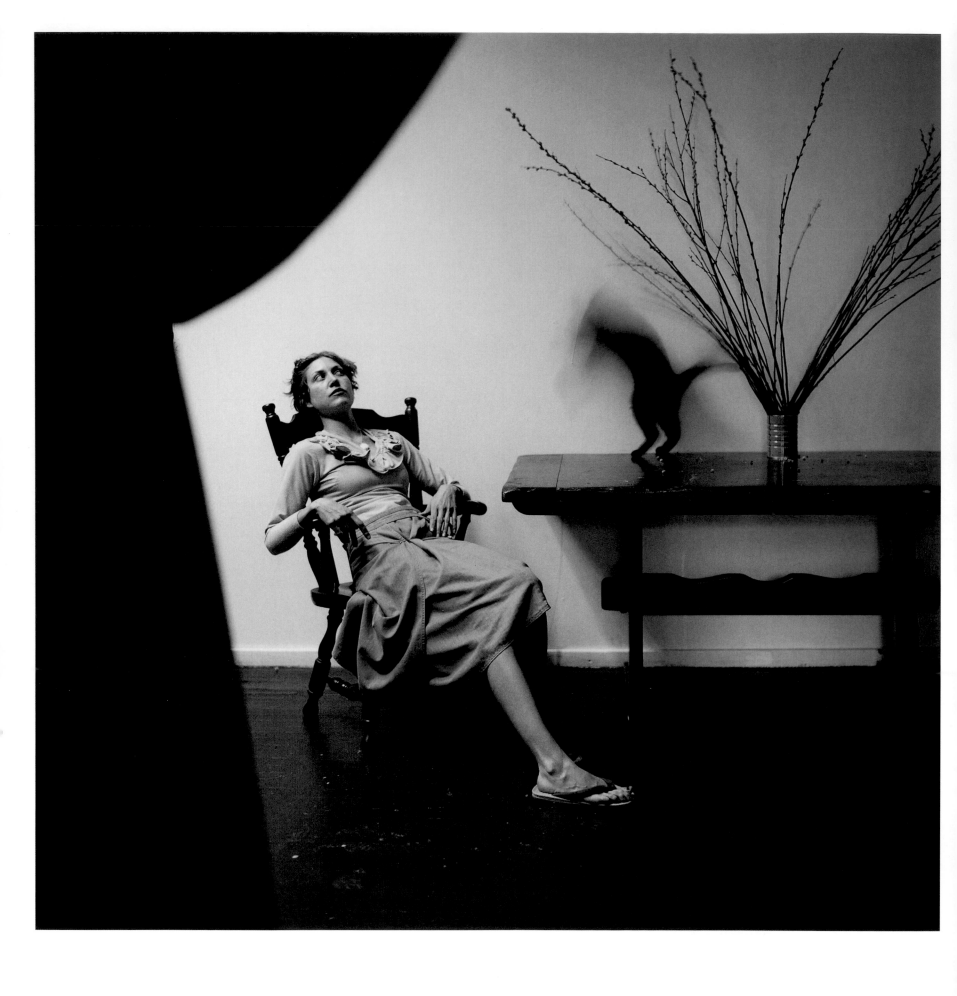

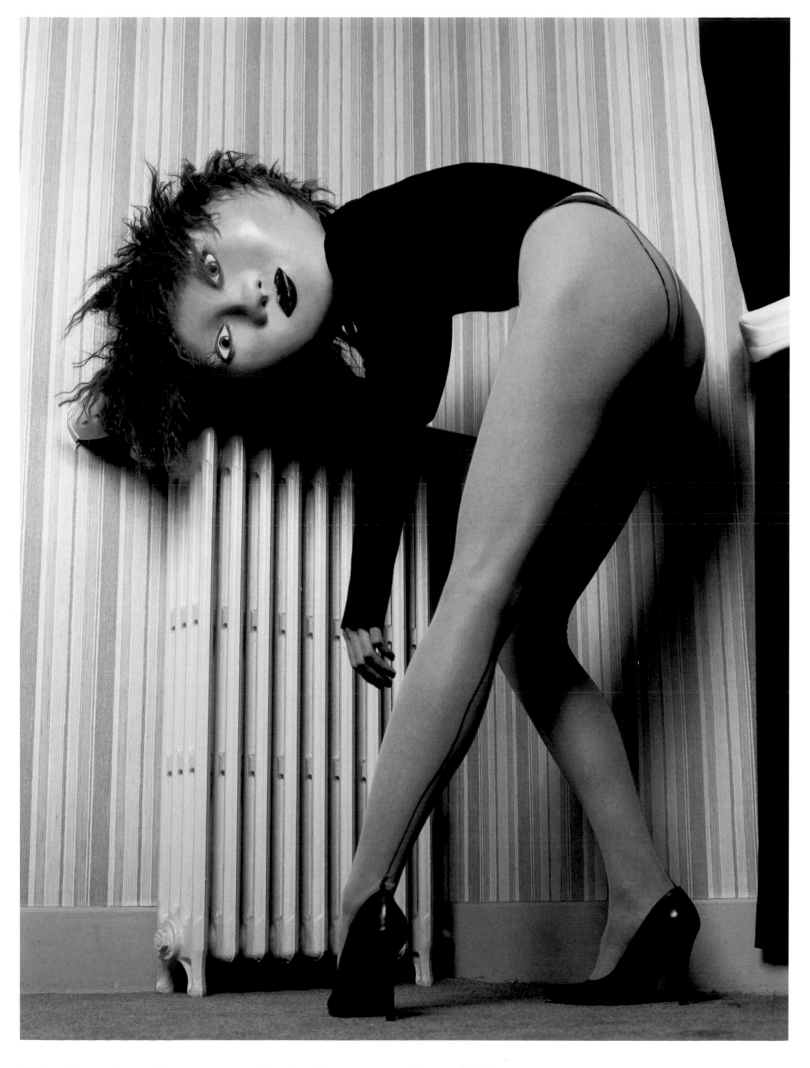

188 . jean-pierre khazem . radiator's girl . composite . 1997

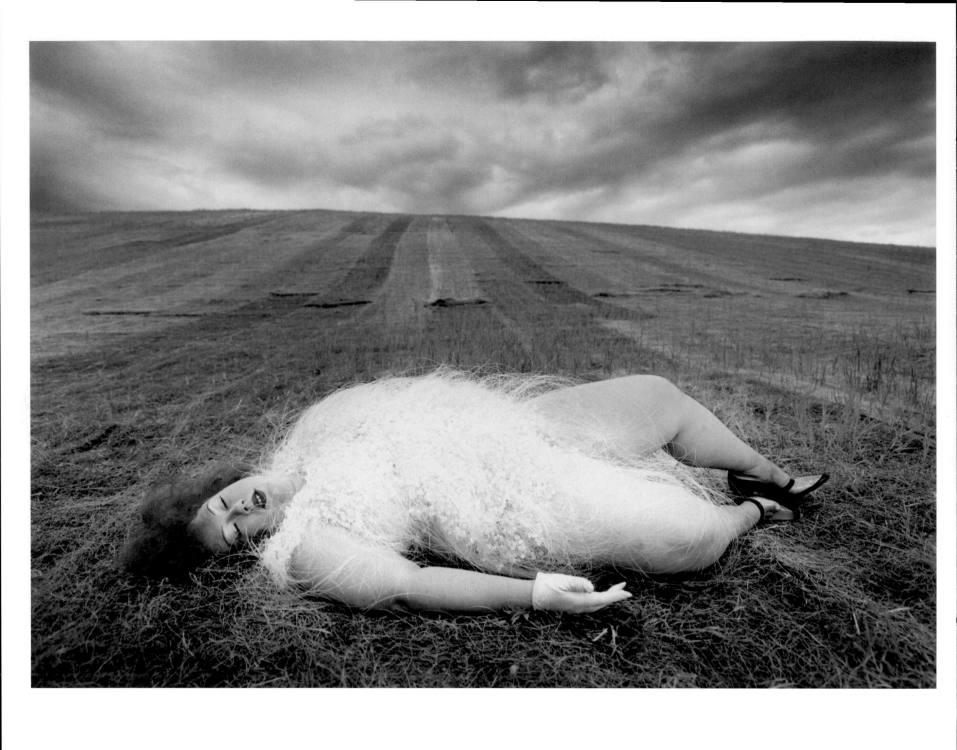

189 . david lachapelle . lonely doll 1 . i-d magazine . 1998

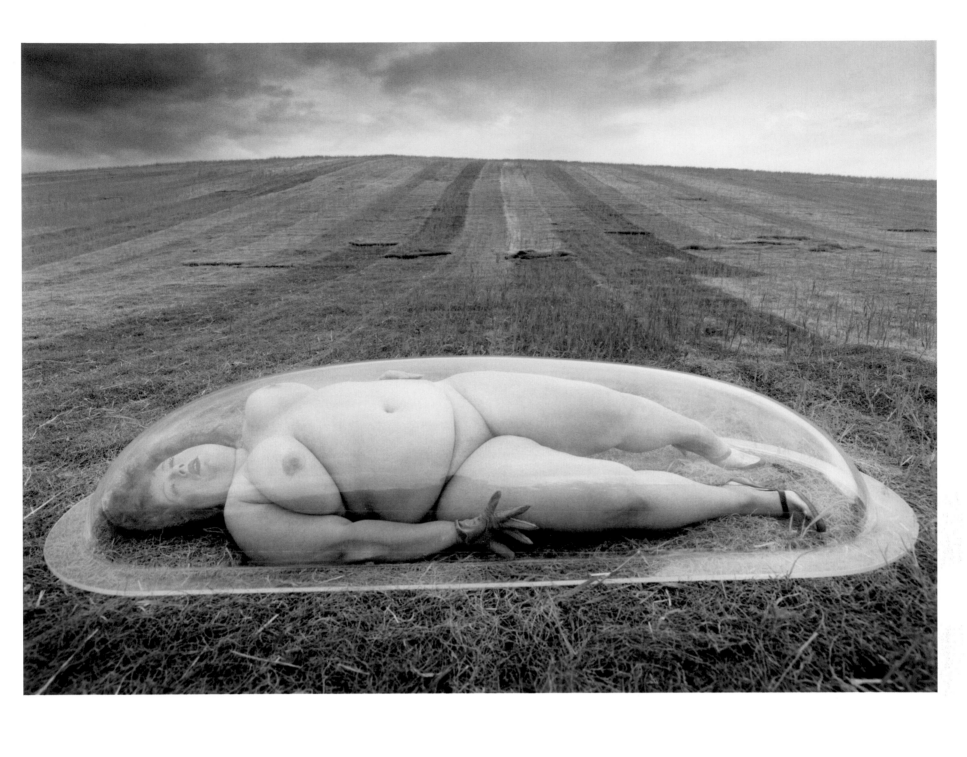

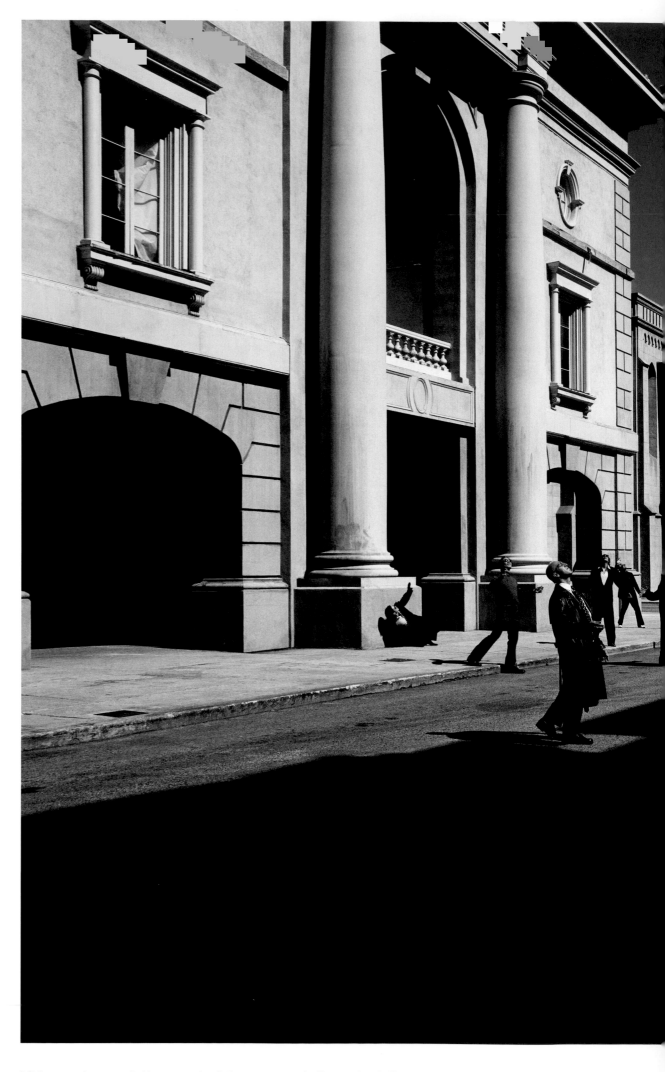

191 . pierre winther . holiday on earth II . dunhill . 2001

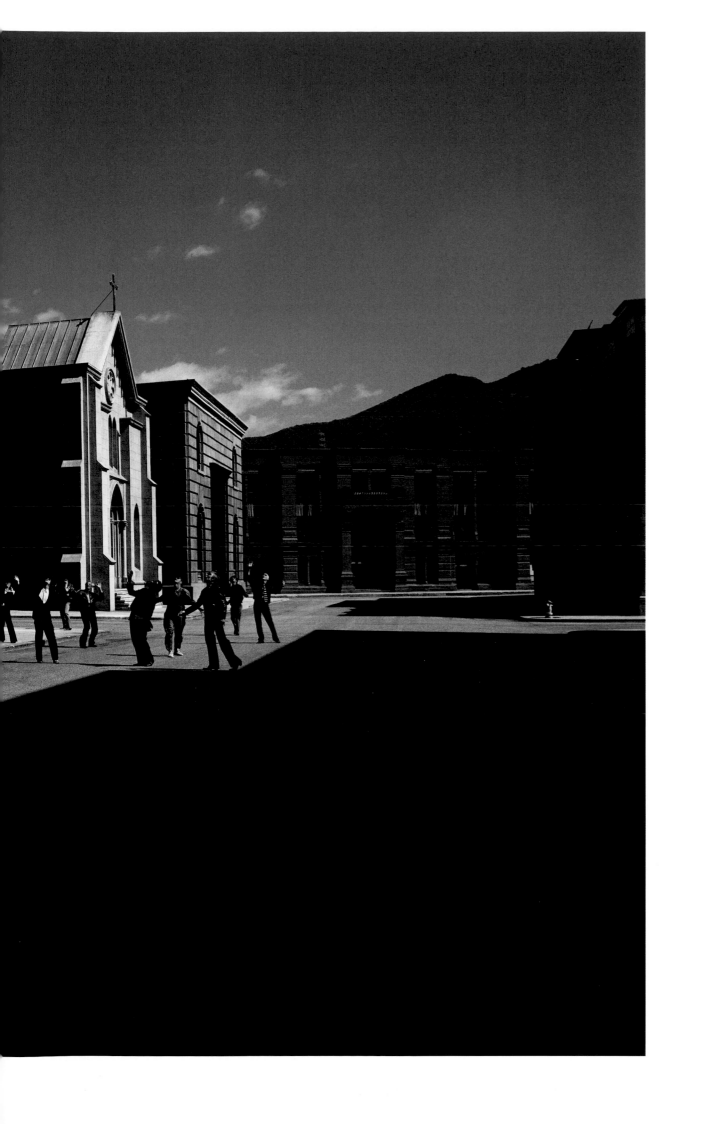

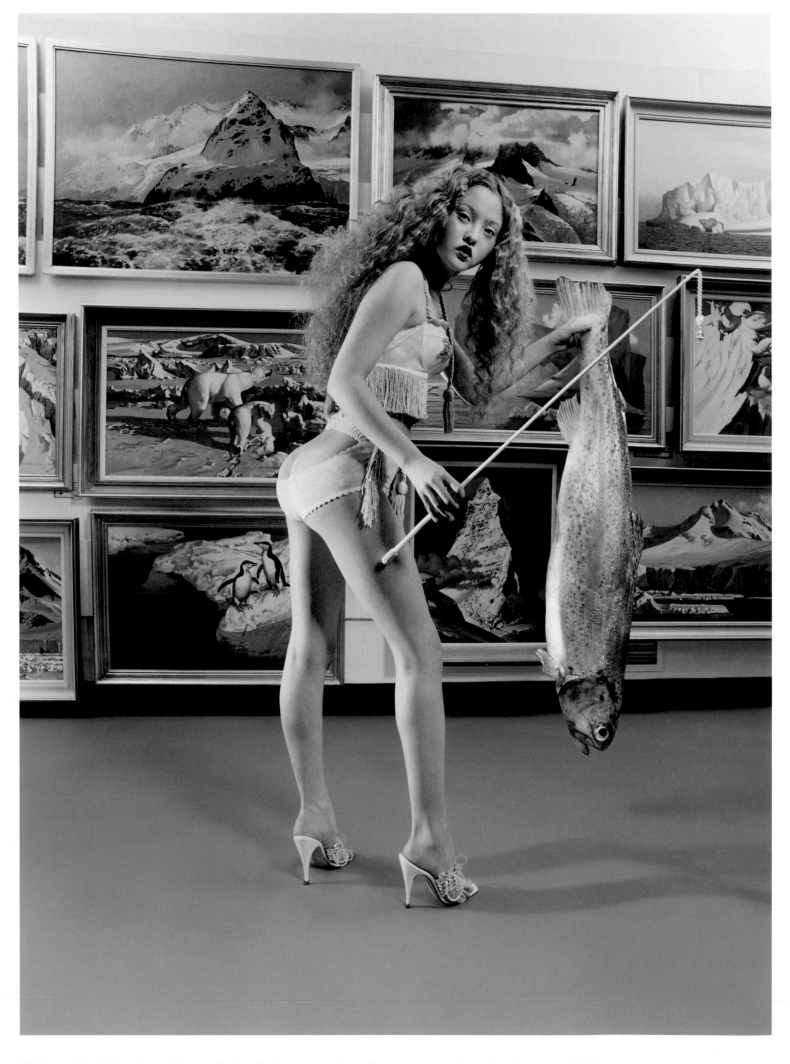

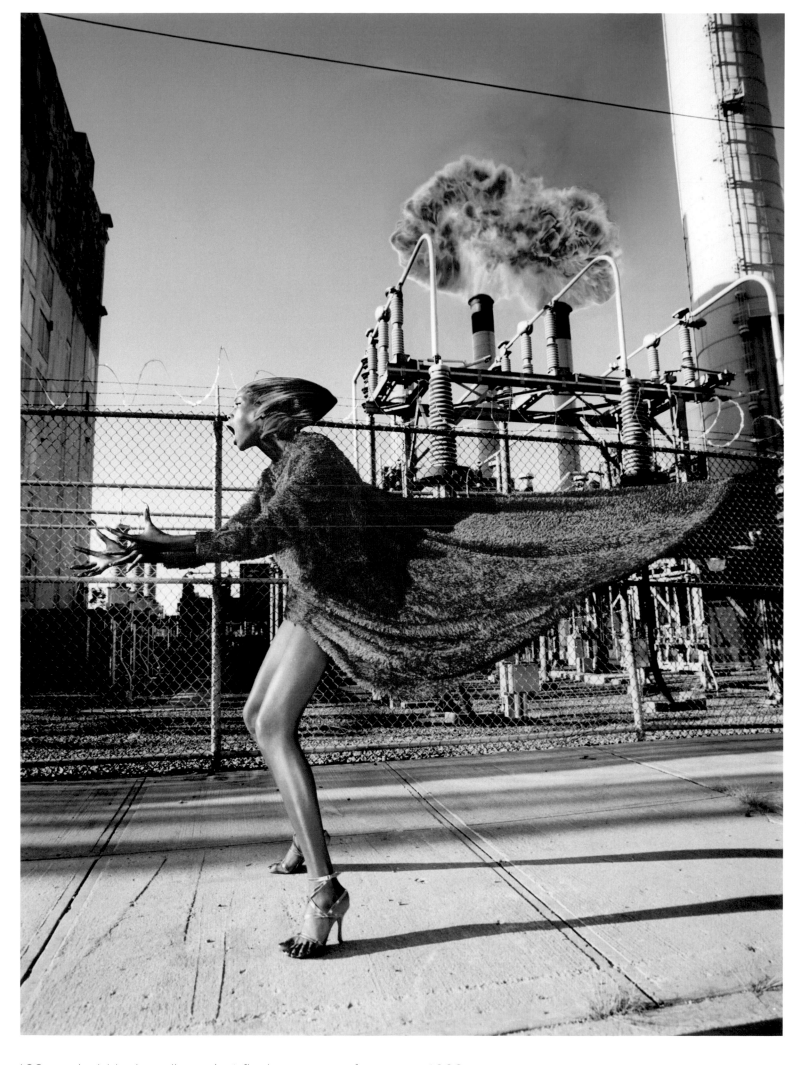

193 . david lachapelle . hot flash . vogue france . 1998

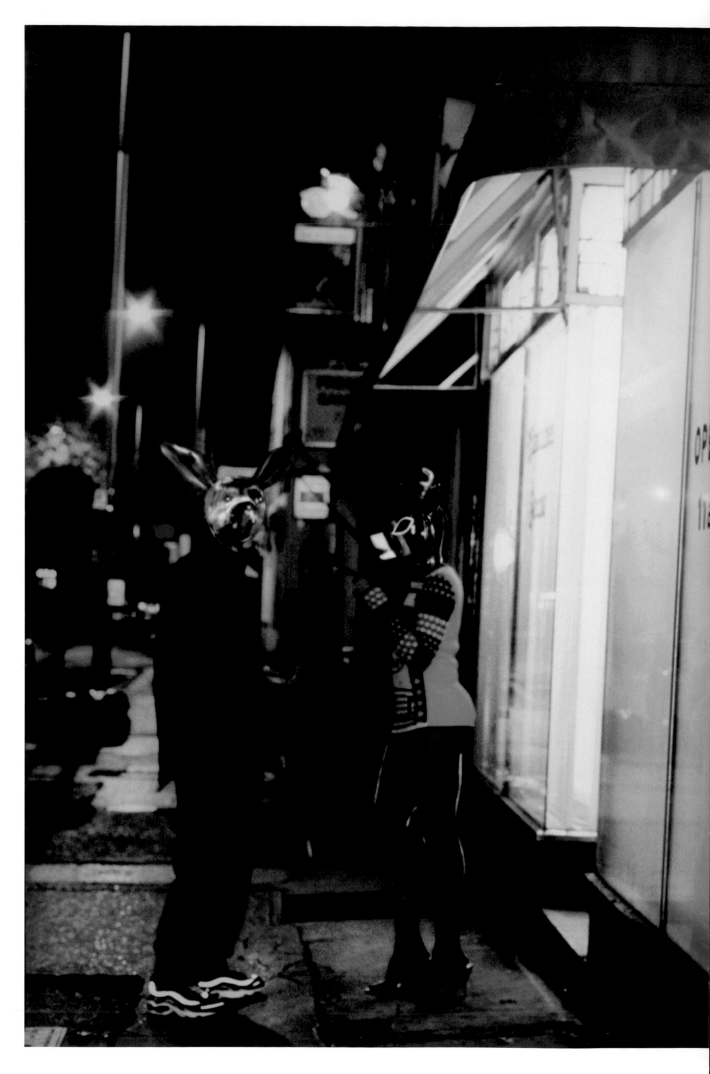

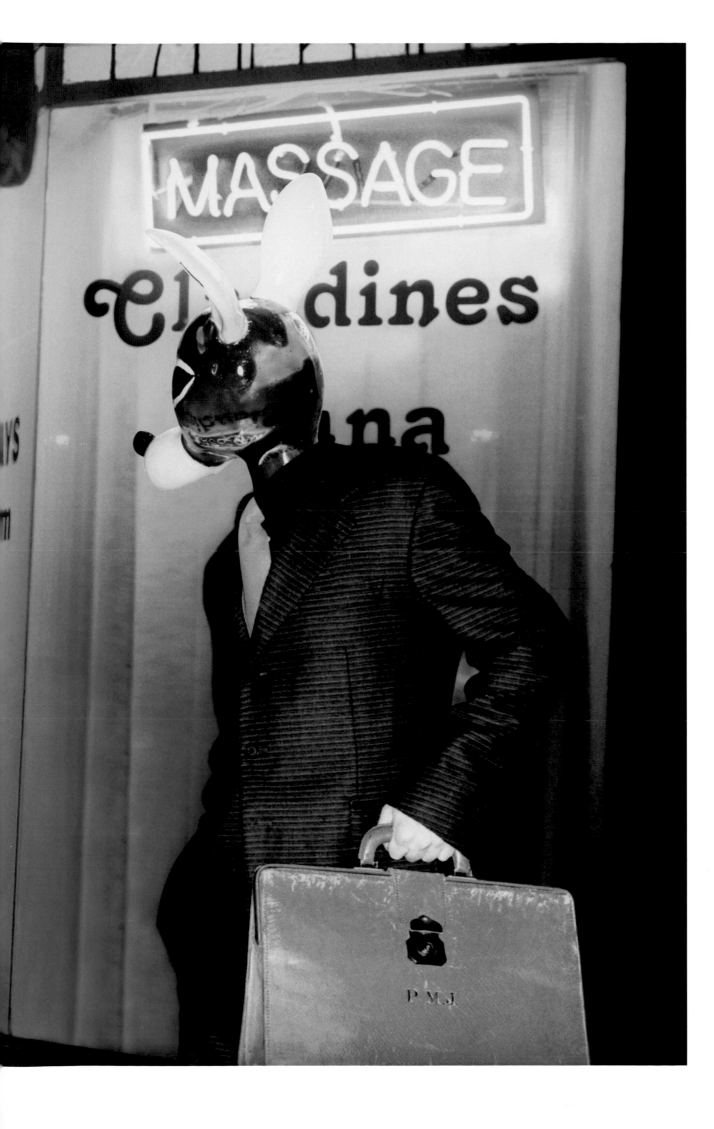

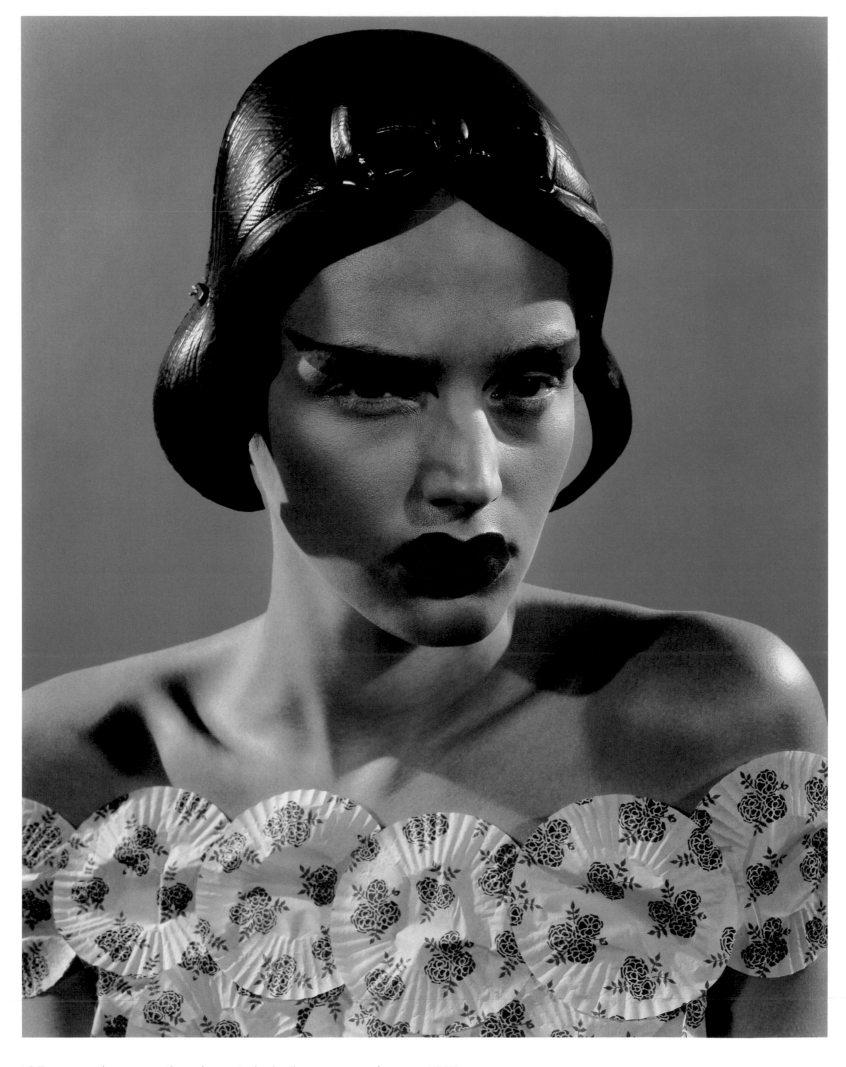

195 . mario sorrenti . beauty hair, lips . numéro . 1999

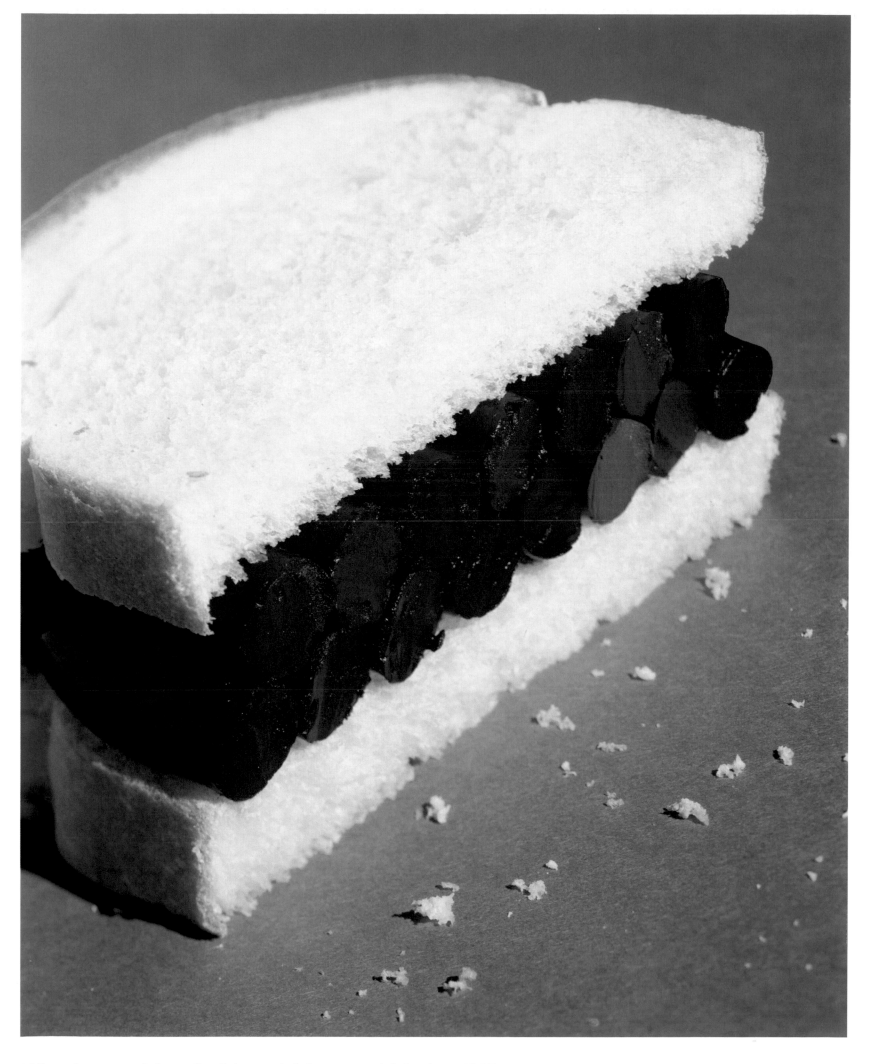

196 . james wojcik . lipstick sandwich . unpublished . 1995

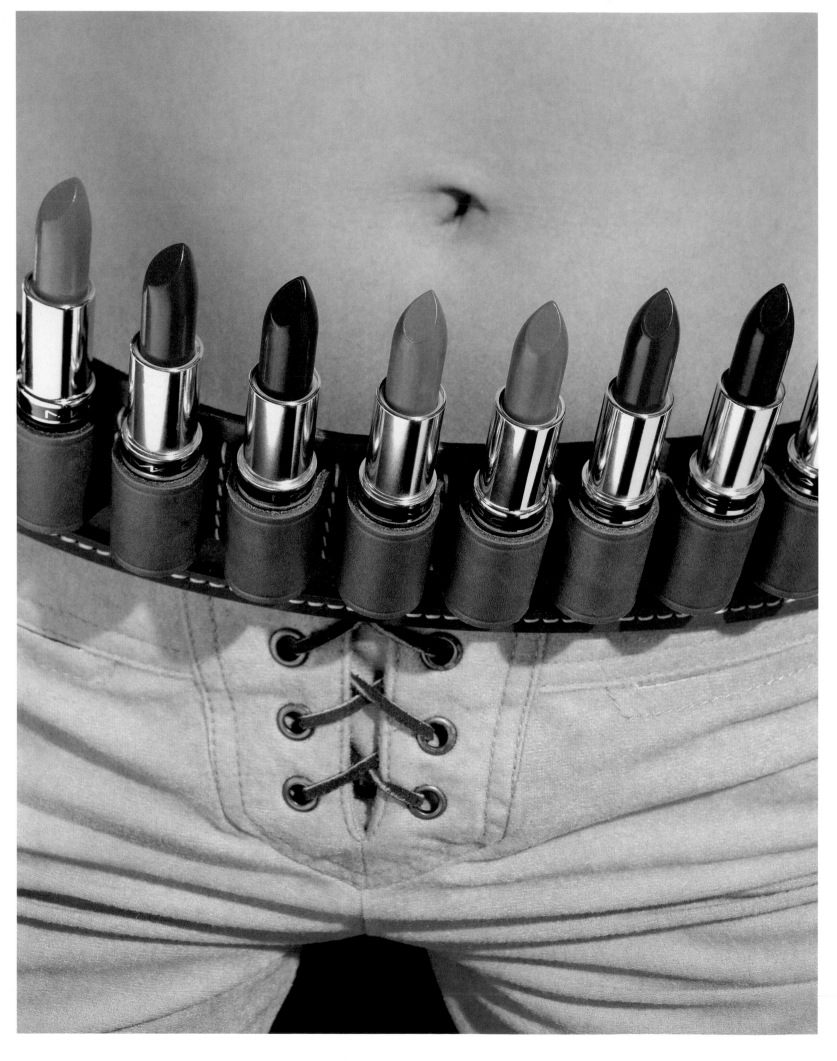

197 . james wojcik . lipstick belt . i-d magazine . 1997

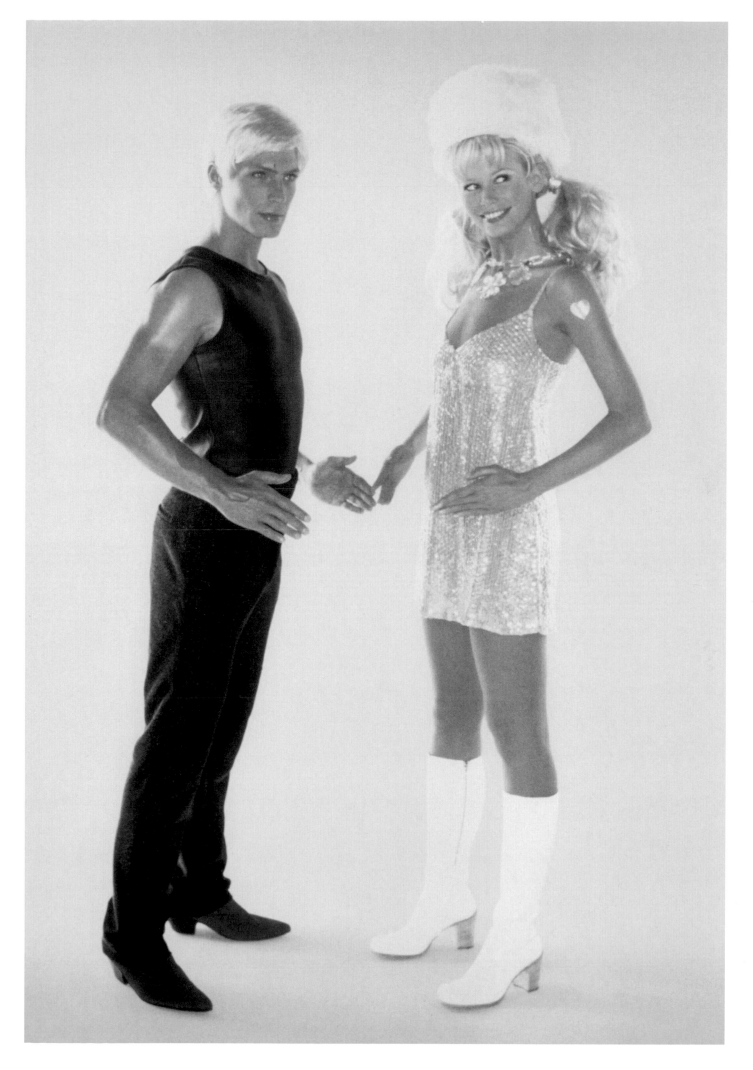

198 . ellen von unwerth . barbie and ken, new york . 1994

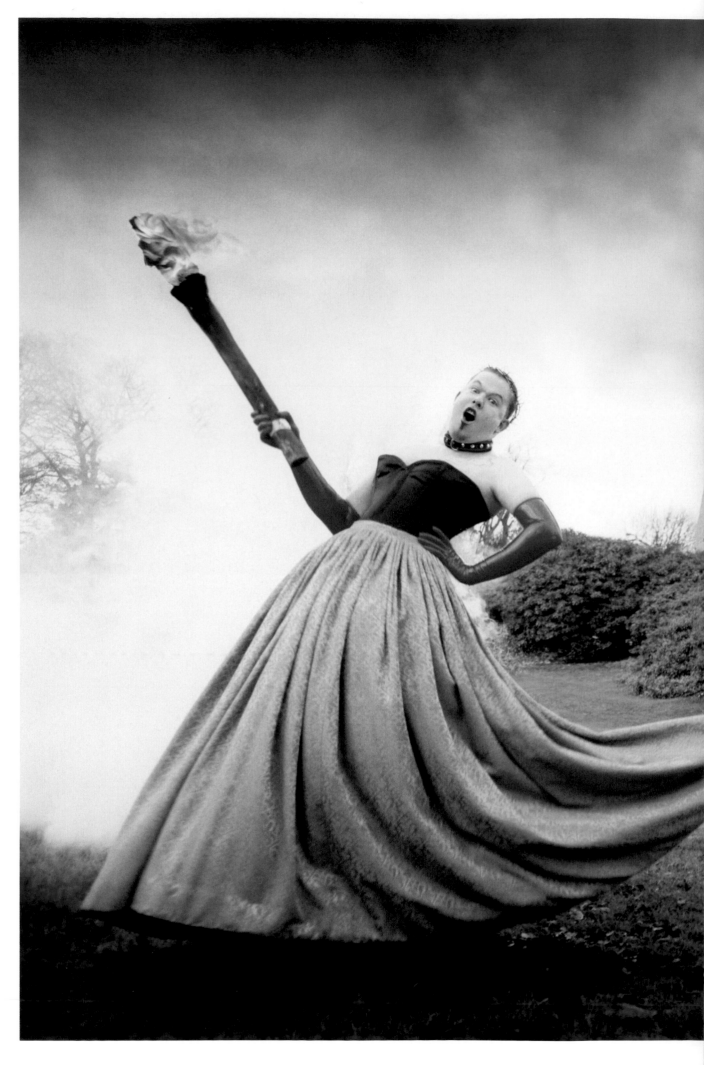

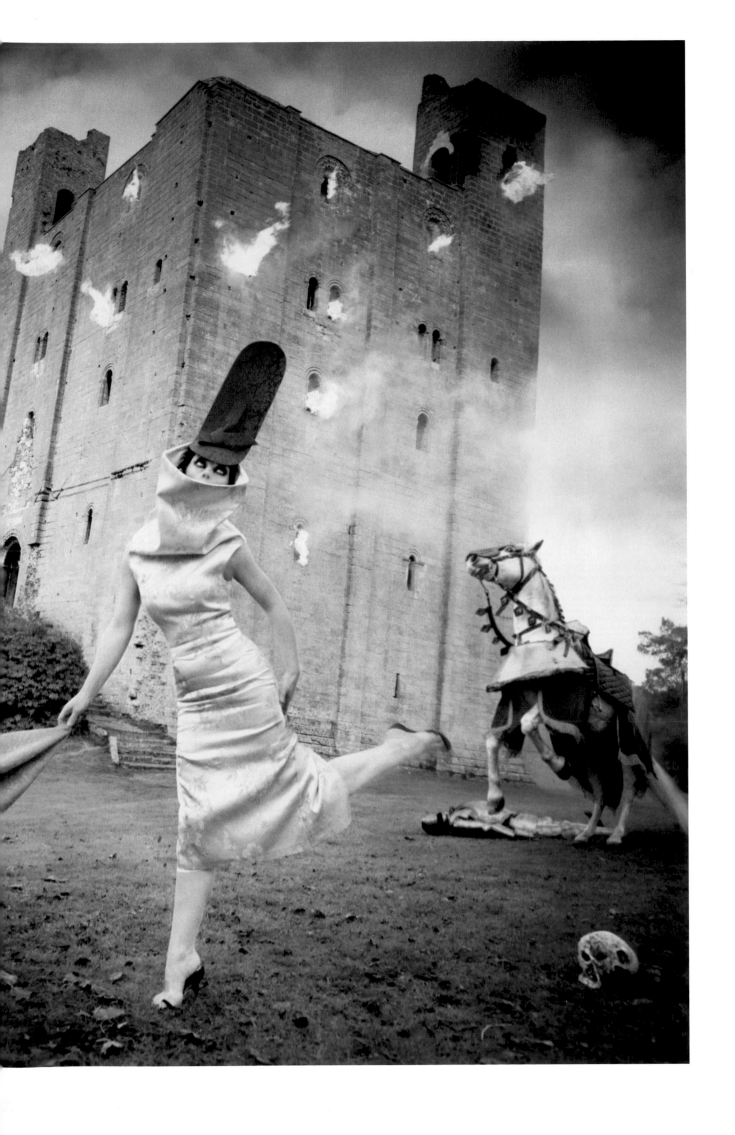

200 . norbert schoerner . constable's line up . 2000

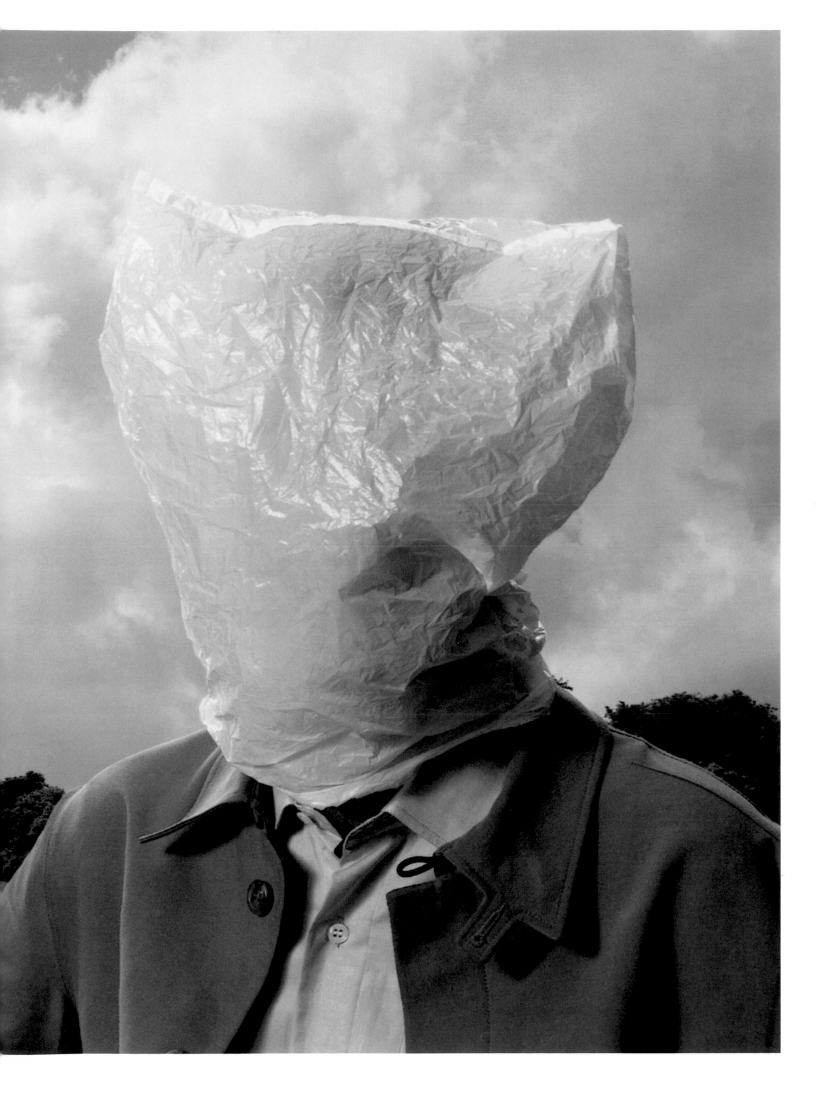

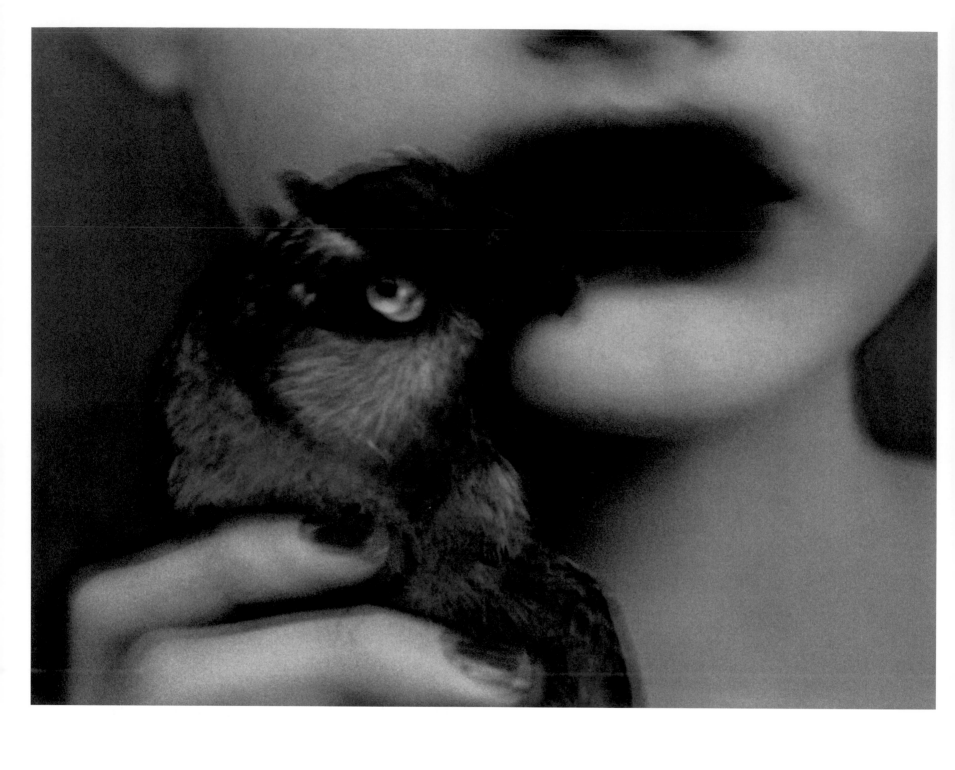

201 . sarah moon . à bouche perdue . 2000

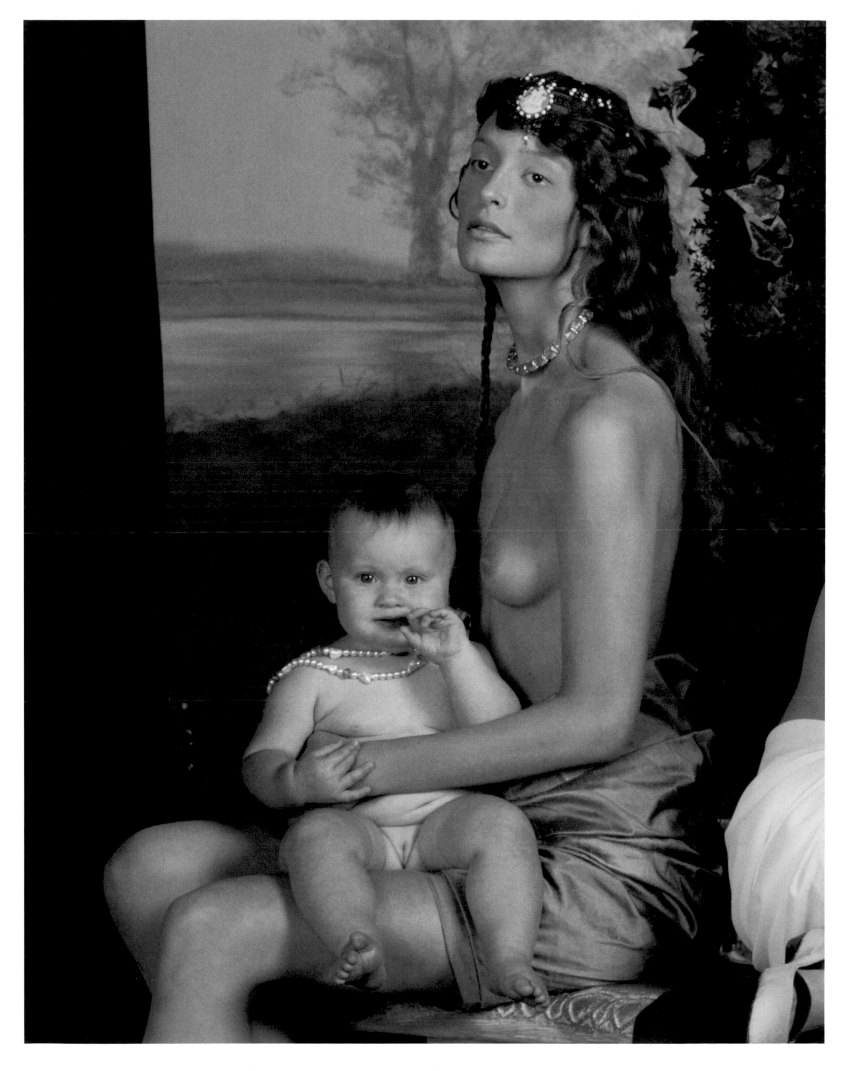

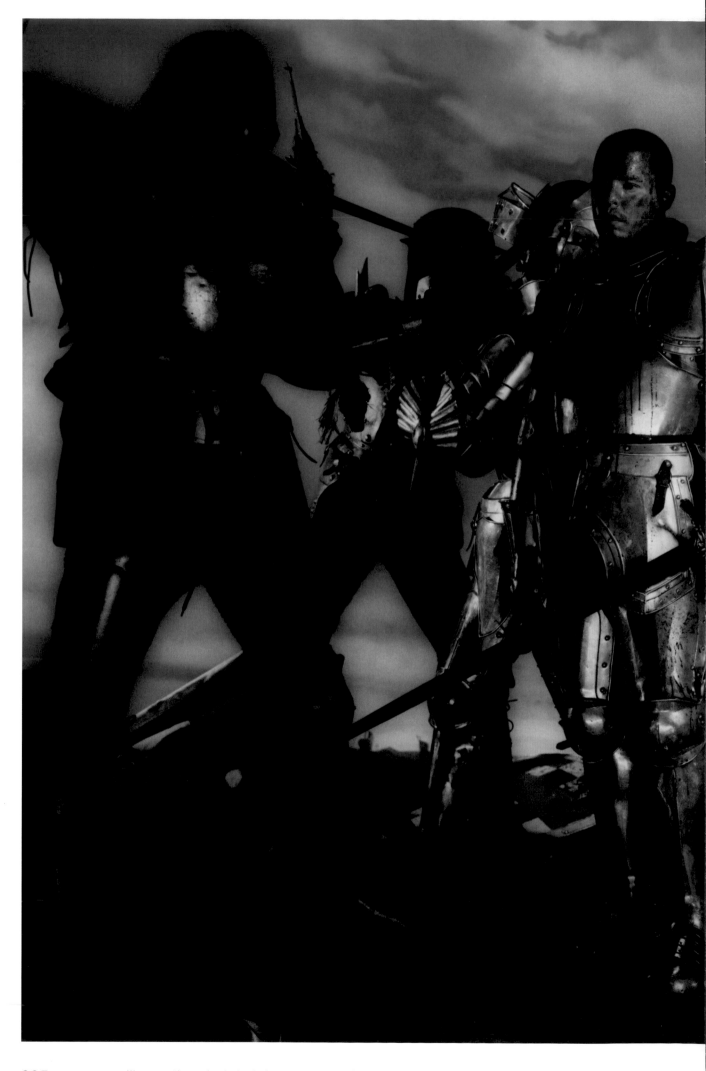

205 ▪ sean ellis ▪ the dark knight returns, alexander mcqueen ▪ the face ▪ 1998

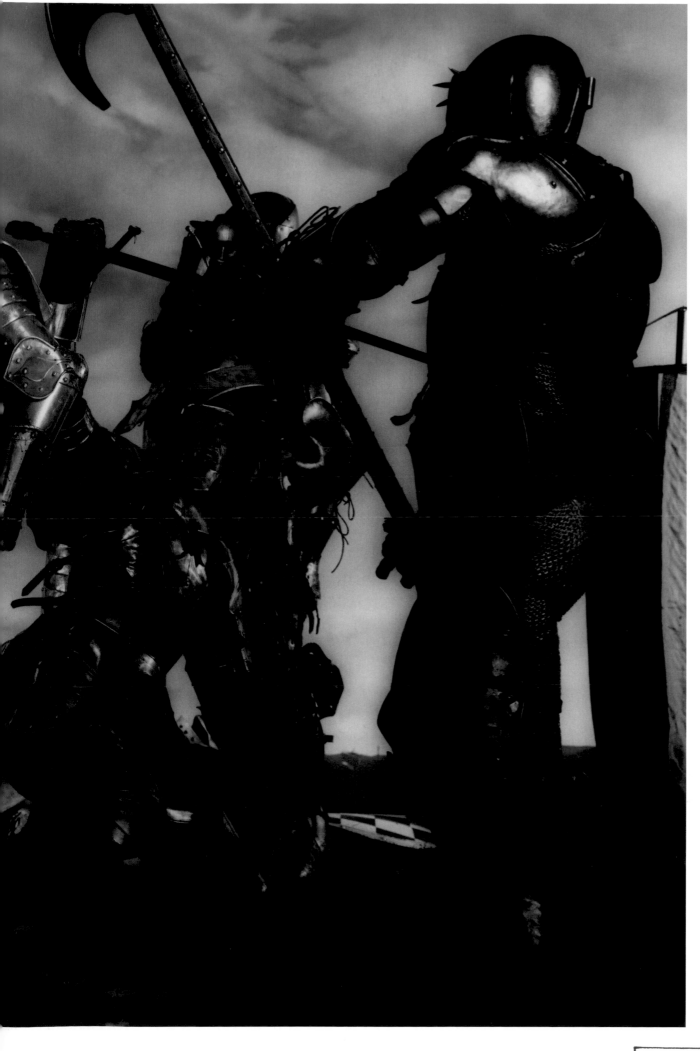

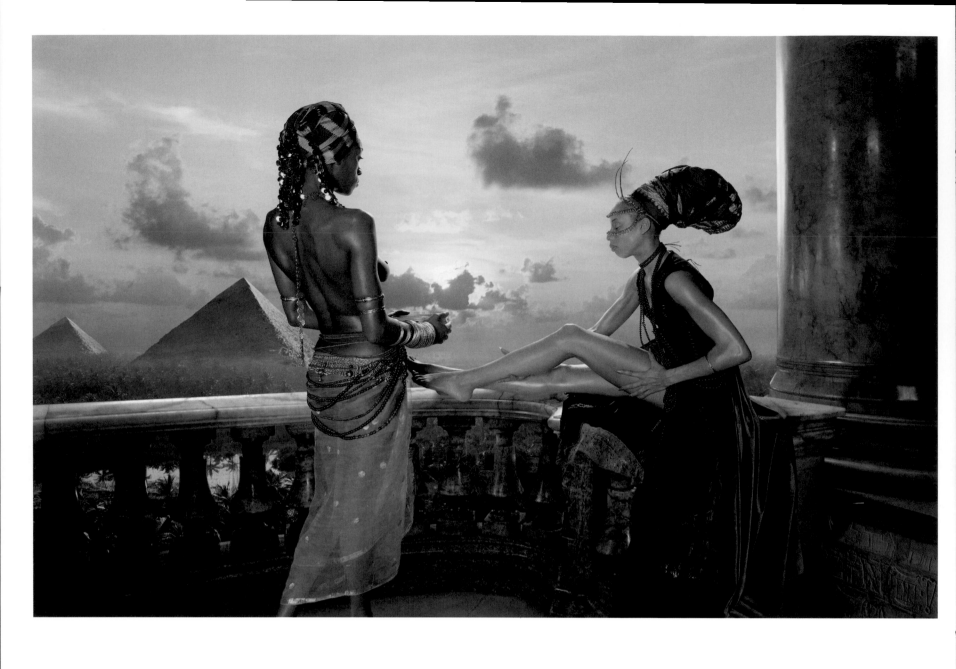

206 . seb janiak . egypt . the face . photo . 1993

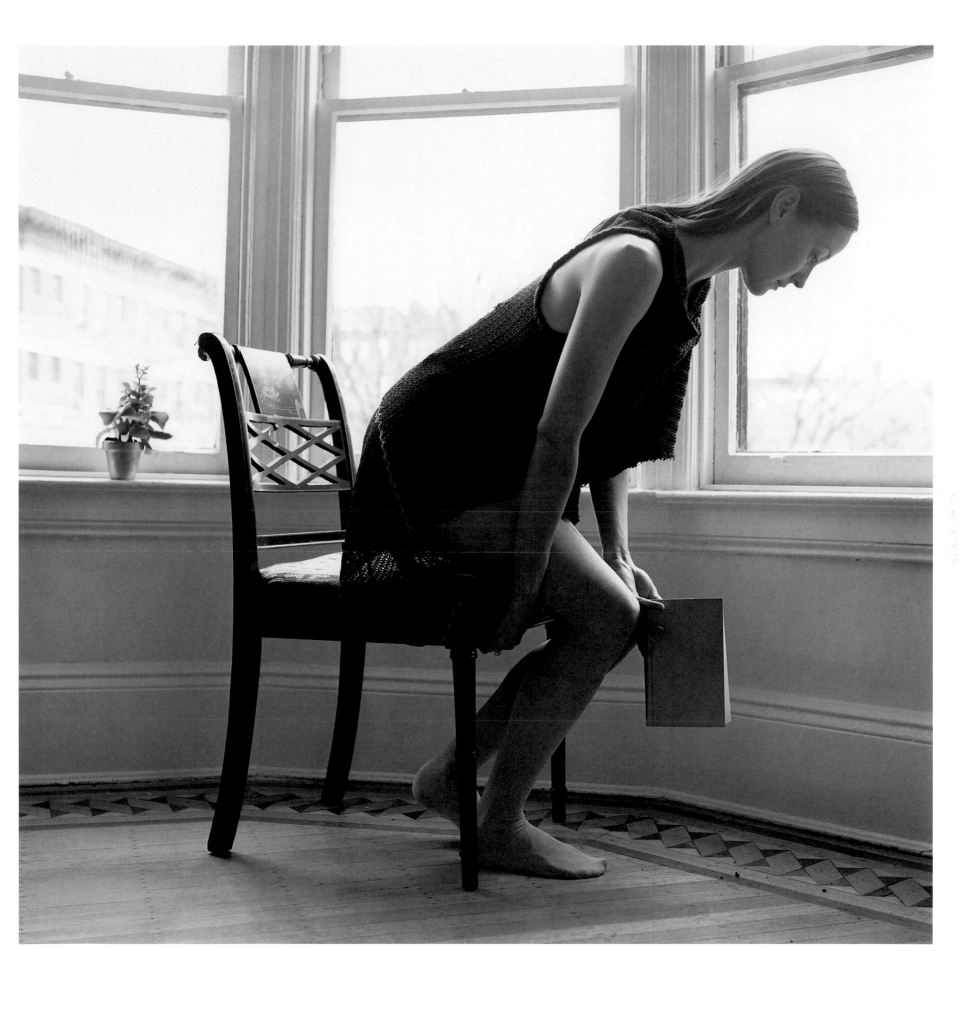

207 . vanina sorrenti . mahoney rising from chair (profile) . *surface magazine . 1998

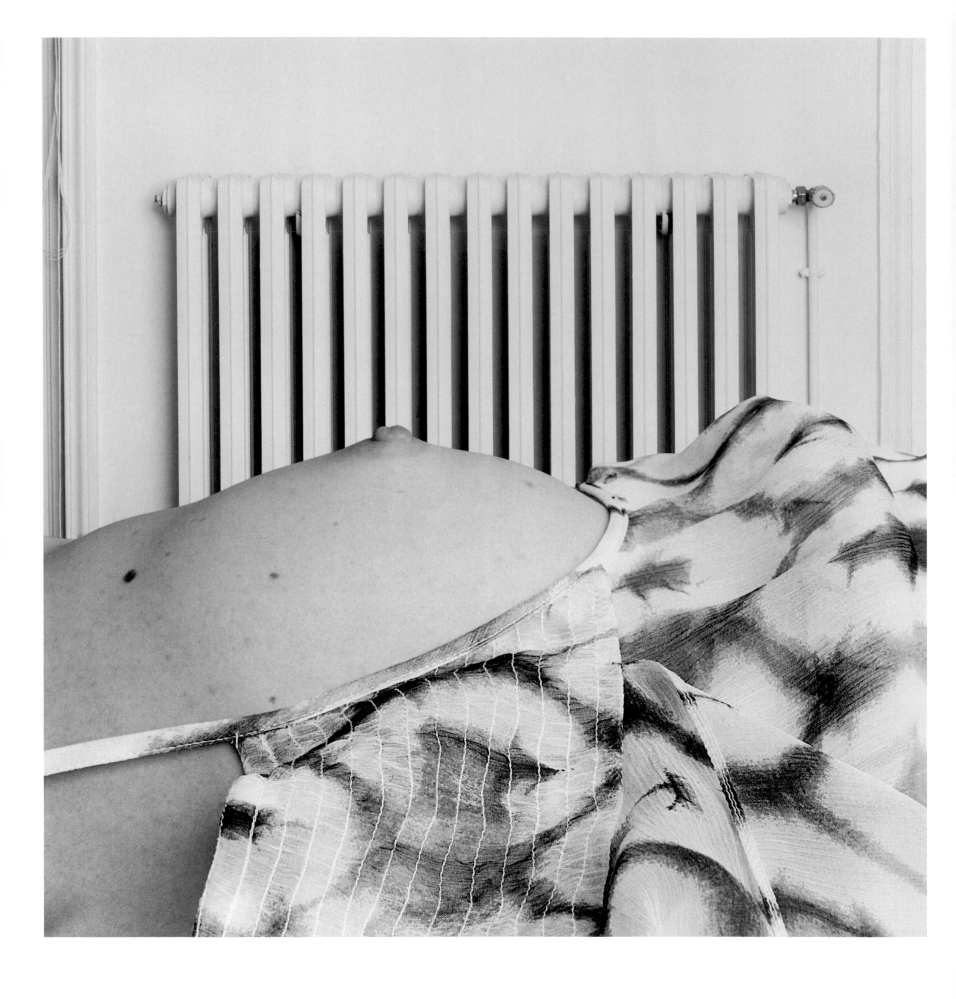

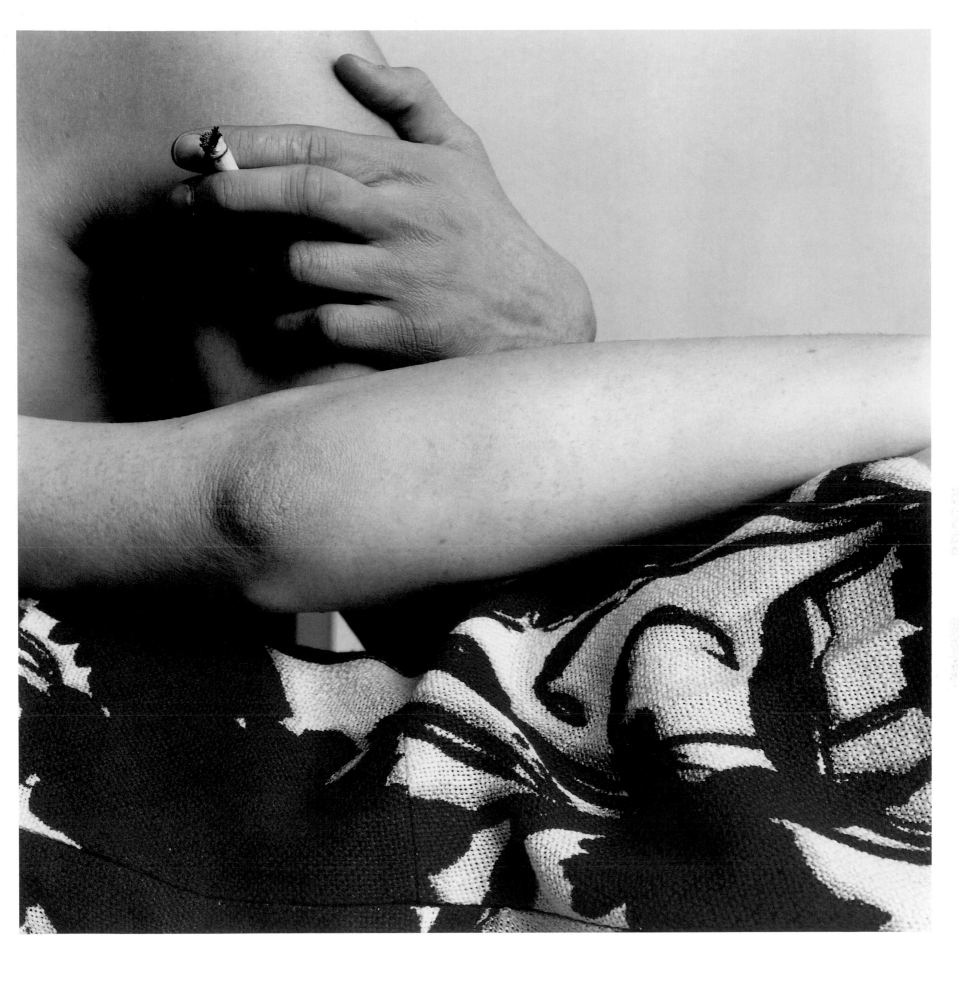

209 . nathaniel goldberg . 5ᵉᵐᵉ étage gauche II . numéro . 2001

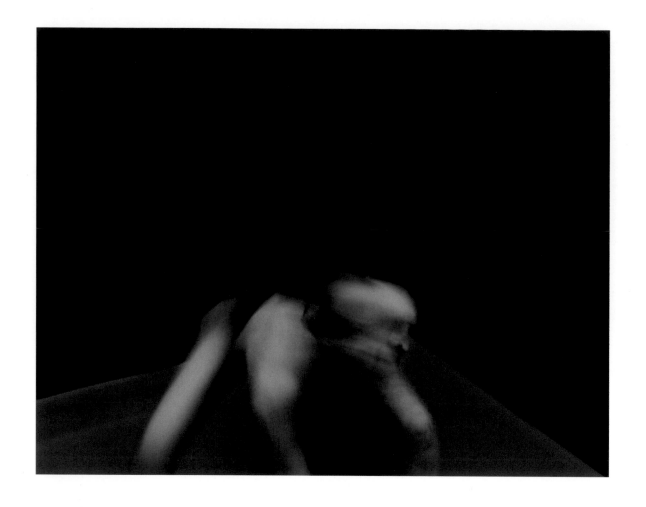

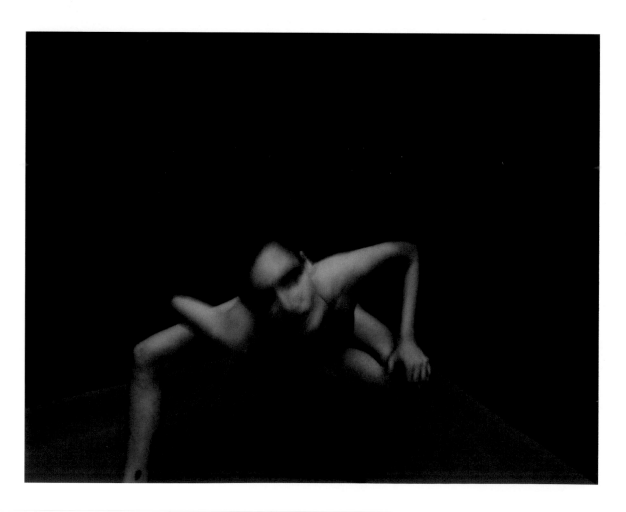

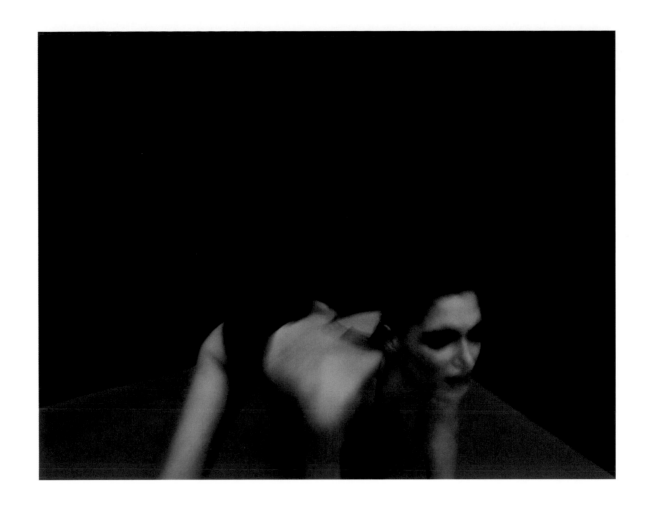

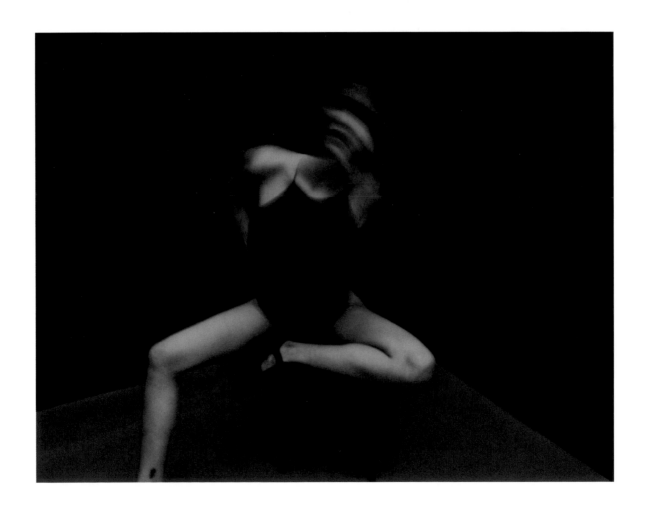

211 . mario sorrenti . francis bacon III, IV . w magazine . 1997

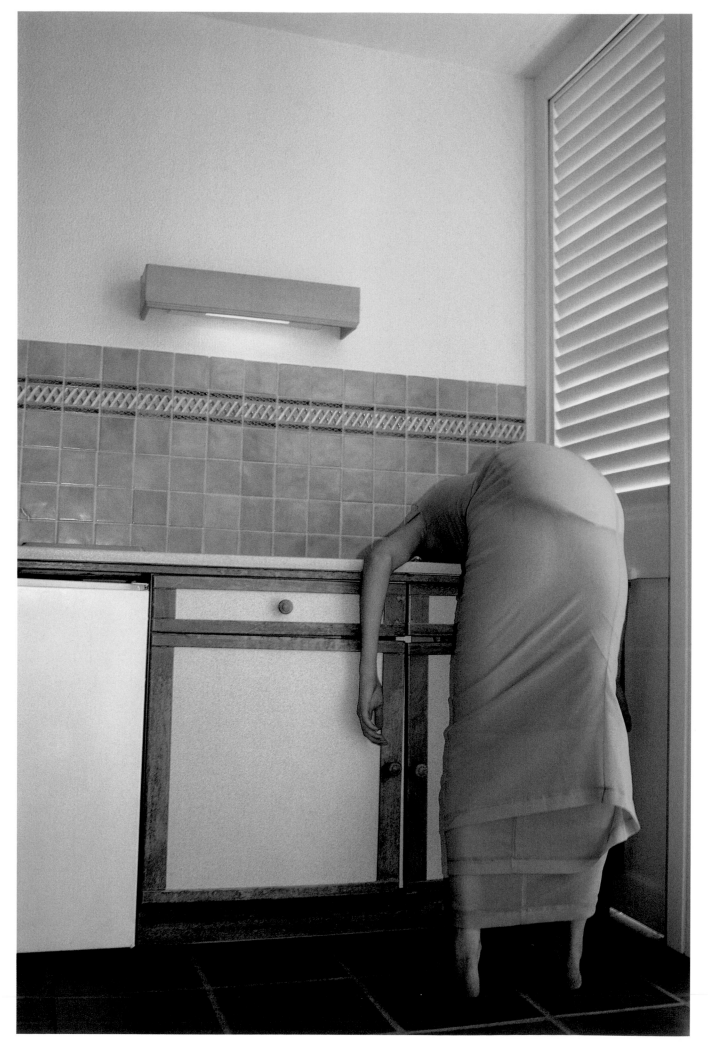

212 . mark borthwick . untitled zora, comme des garçons . big . 1997

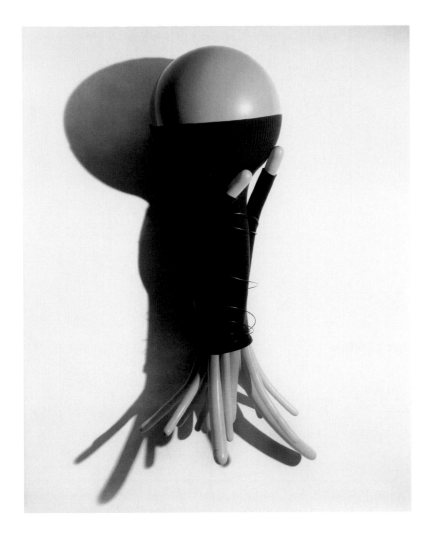
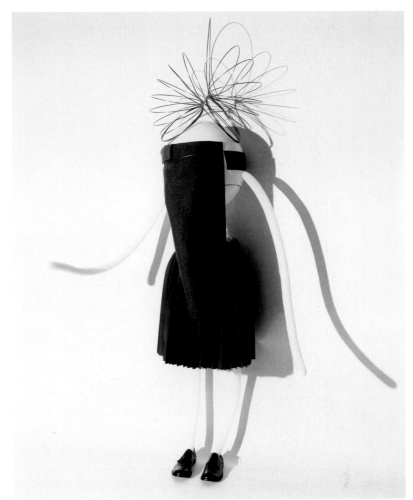
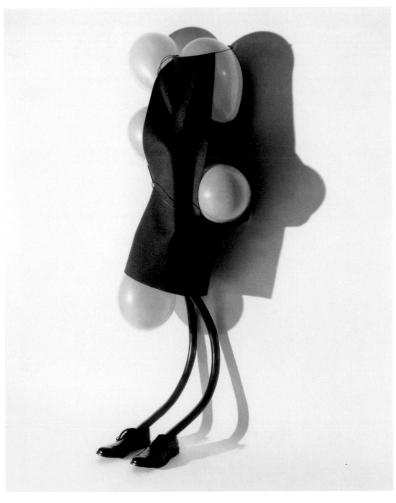
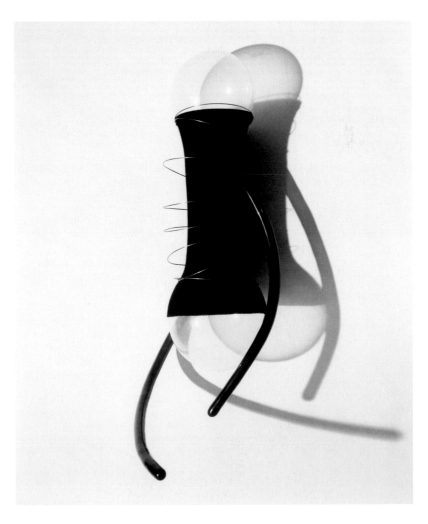

213 **.** mario sorrenti **.** comme des garçons I–IV **.** visionaire **.** 1998

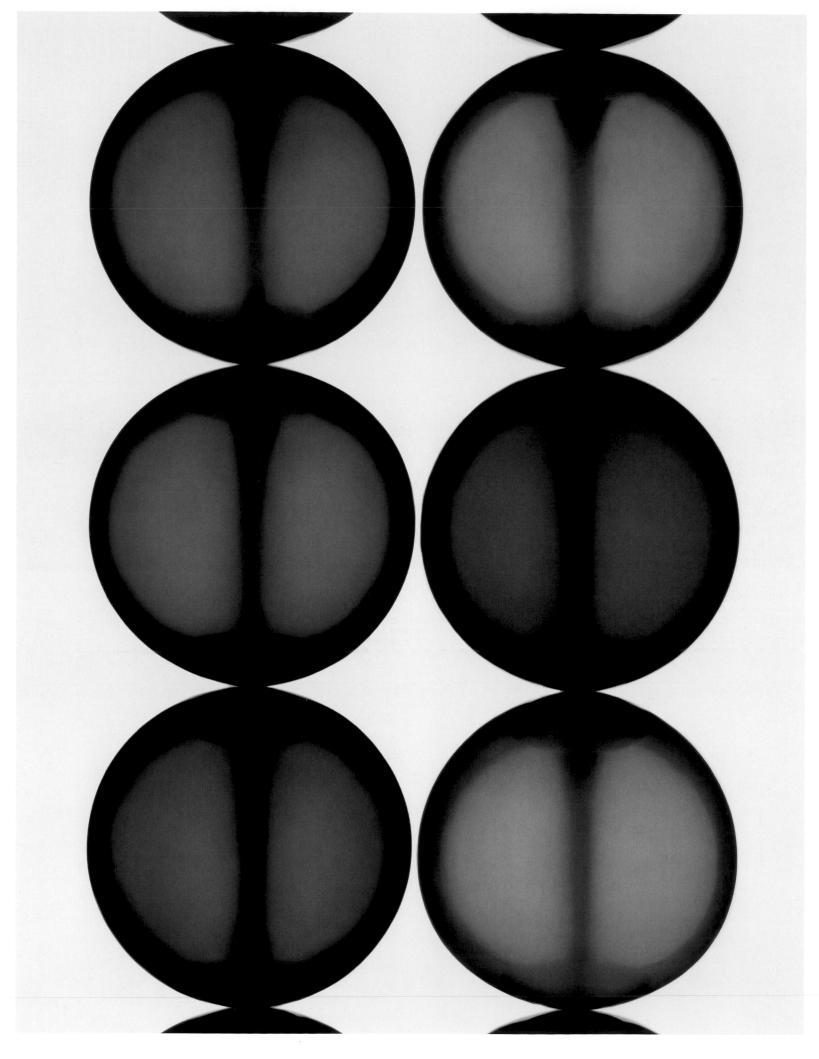

214 . guido mocafico . pearls, mikimoto necklace . numéro . 1999

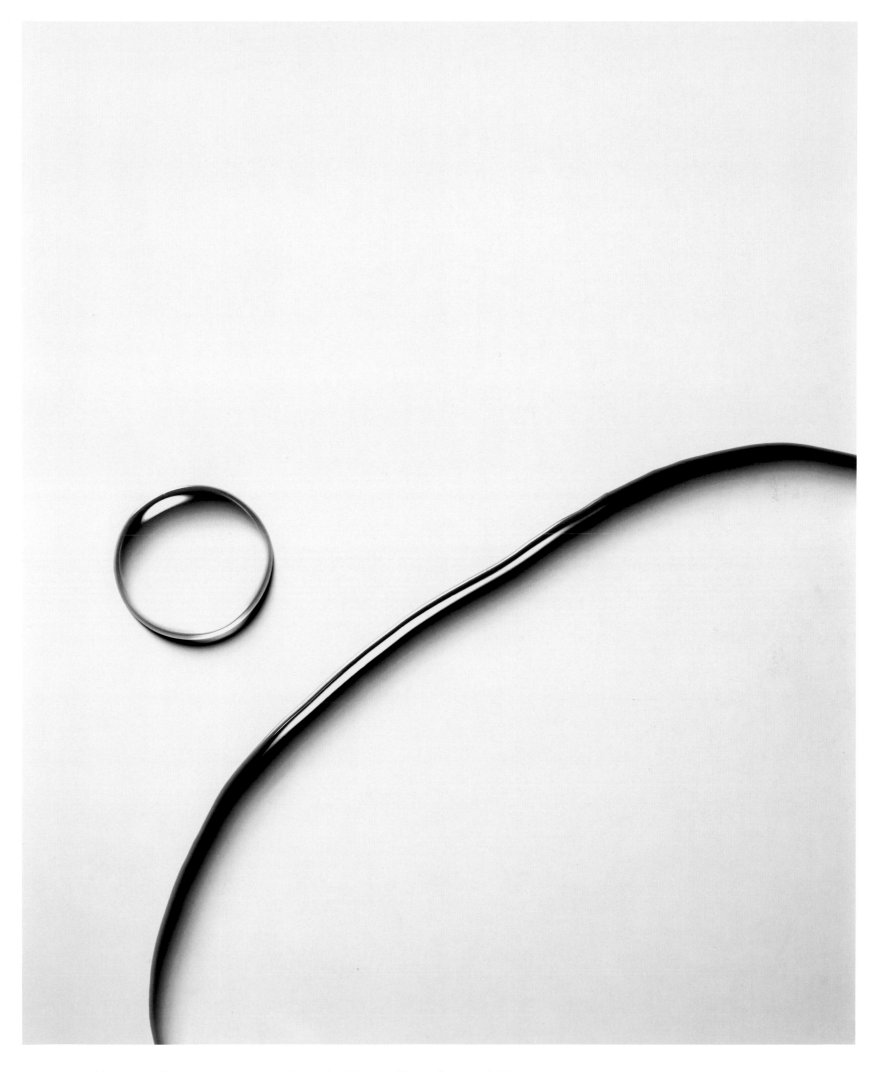

215 . guido mocafico . perfume, chanel n°5 . citizen k . 1999

endpoint All fashion photography is a mirrored surface. It mirrors our wishful images, and the four different force fields are four different mirrored surfaces, each of which is set at a different angle to the others and cast images, colours and silhouettes back and forth, waiting for feedback. The four mirror surfaces communicate repeatedly with one another according to their own respective motion. What links them is one and the same time code, a kind of imaginary dating of the picture, legible by all those who know the signs of the time. Visual culture then becomes a trap for it is a narcissistic culture if one's own desired images are no longer fractured and advanced, but are simply depicted unashamedly. Poetry is meant to avert the bane of self-bondage by the mirrored surfaces. Fashion photography has forfeited these opulently.

The desired images have become foils for the real mirror as is to be encountered in ever larger dimensions in contemporary living rooms, bathrooms and bedrooms. The foils of the real mirrors become instructions for mimicry en route to the quest for self-image. The foil judges the state of your efforts down the path to becoming your own desired image. Progress, regress, standstill are all noted by checking things with a glance in the mirror. It is no longer the actual state that is to be discovered on the foils, but the look desired. Fashion photography produces these foils. It produces dreams, wishes and hopes – and as with all dreams, it spawns the terror and the horror that go hand in hand with their realization. *Protect me from what I want*. Jenny Holzer's phrase has lost none of its appositeness. How robbed of protection we are when faced by our dreams is evident from the careers of the dream makers. The care we devote to nourishing our hopes is now exceeded by the fear of having deceived ourselves. Seen like this, fashion photography is also the poison cabinet – the right dosage is invaluable, but an overdose is lethal.

biographies

the 1999 art directors club award, new york **sean ellis** lives and

works in london early work concentrating on still life works for maga-

zines like i-d, the face, arena, visionaire, numéro, american vogue, big ...

active also as video director **jerome esch** born 1967 in tillburg, the

netherlands lives on malta, works mainly in europe for international

fashion magazines advertising campaigns for fendi, kenzo, cacharel,

yves saint laurent couture ... **andrea giacobbe** born 1968 in flo-

rence, italy studies at college of art and design, bournemouth 1992

moves to paris works for international press advertising films and

video clips **nathaniel goldberg** born 1970 in paris lives in new

york and paris 1996 prize for the best young photographer at the festi-

val des arts de la mode in hyères works for international fashion maga-

zines like harper's bazaar usa, w magazine, the face, french vogue,

mixt(e), numéro ... **alexei hay** born 1973 into a persian family in

miami, florida lives and works in new york 1995 completes studies at

brown university, providence, rhode island assistant to photographers

like michael benabib, jason schmidt and philip-lorca dicorcia pub-

lished in the new york times, scientific american magazine, dutch, i-d,

harper's bazaar ... advertising campaign for gucci, armani exchange,

kate spade, mtv **steve hiett** born 1940 in oxford, england lives in

paris and new york studies at the college of art, brighton, and graphic

design at the royal college of art, london works since the beginning of

the 1970s as a fashion photographer published regularly in interna-

tional fashion magazines **dominique issermann** born 1947 in paris,

where she lives and works 1974 beginnings of a regular cooperation

with the agency sygma, paris, and starts as fashion photographer

works for international fashion magazines many advertising cam-

paigns for sonia rykiel, maud frizon, christian dior haute couture, nina

ricci, yves saint laurent, emporio armani ... **seb janiak** born 1966 in

versailles, france lives and works in paris published by magazines

like harper's bazaar, french vogue, jalouse ... makes video clips and

advertising films **jean-pierre khazem** born 1968 in paris pub-
lished in magazines like the face, arena homme plus, numéro, taste,
details advertising campaigns for dockers, big issue, mustang, diesel,

canal +, heineken, mcdonald's **steven klein** is traditionally trained in
fine arts and carries a degree in painting currently lives and works in
new york city contributes to w magazine, l'uomo vogue, french, italian
and american vogue, the face, pop magazine, v magazine, visionaire
exhibitions in new york, london, milan, lausanne, berlin, seoul, tokyo

nick knight born 1958 in london, where he lives and works many
awards for his publications in vogue, dazed & confused, i-d, the face,
visionaire and for his work in fashion and advertising for alexander
mcqueen, calvin klein, christian dior, levi strauss, yohji yamamoto, yves

saint laurent ... **david lachapelle** born 1968 in north carolina
moves to new york at the age of 19, where he meets andy warhol
1995 awarded best new photographer of the year by both french photo
magazine and american photo magazine 1996 vh-1 fashion award as
photographer of the year 1997 the international center of photogra-
phy's applied photography award many publications in fashion, music
and entertainment magazines like i-d, arena, the new york times maga-
zine, rolling stone, vogue, the face, vanity fair ... works for jean-paul

gaultier, mtv, pepsi, levi's, lavazza ... **inez van lamsweerde &**
vinoodh matadin working since 1993 for fashion magazines like the
face and vogue artistic cooperation with the fashion designer yohji

yamamoto **felix larher** born 1971 lives and works in paris and
london photographs for the magazines wad, vogue, jalouse, perso,

spoon, têtu ... **mark lebon** born 1957 in london describes himself
as: not french, despite his name, born and lives in london, but from
russian stock, working mainly in london for i-d magazine, in semi
retirement looking after a young child, creating art inspite of himself

like harper's bazaar, french vogue, jalouse ... makes video clips and

advertising films **jean-pierre khazem** born 1968 in paris pub-

lished in magazines like the face, arena homme plus, numéro, taste,

details advertising campaigns for dockers, big issue, mustang, diesel,

canal +, heineken, mcdonald's **steven klein** is traditionally trained in

fine arts and carries a degree in painting currently lives and works in

new york city contributes to w magazine, l'uomo vogue, french, italian

and american vogue, the face, pop magazine, v magazine, visionaire

exhibitions in new york, london, milan, lausanne, berlin, seoul, tokyo

nick knight born 1958 in london, where he lives and works many

awards for his publications in vogue, dazed & confused, i-d, the face,

visionaire and for his work in fashion and advertising for alexander

mcqueen, calvin klein, christian dior, levi strauss, yohji yamamoto, yves

saint laurent ... **david lachapelle** born 1968 in north carolina

moves to new york at the age of 19, where he meets andy warhol

1995 awarded best new photographer of the year by both french photo

magazine and american photo magazine 1996 vh-1 fashion award as

photographer of the year 1997 the international center of photogra-

phy's applied photography award many publications in fashion, music

and entertainment magazines like i-d, arena, the new york times maga-

zine, rolling stone, vogue, the face, vanity fair ... works for jean-paul

gaultier, mtv, pepsi, levi's, lavazza ... **inez van lamsweerde &**

vinoodh matadin working since 1993 for fashion magazines like the

face and vogue artistic cooperation with the fashion designer yohji

yamamoto **felix larher** born 1971 lives and works in paris and

london photographs for the magazines wad, vogue, jalouse, perso,

spoon, têtu ... **mark lebon** born 1957 in london describes himself

as: not french, despite his name, born and lives in london, but from

russian stock, working mainly in london for i-d magazine, in semi

retirement looking after a young child, creating art inspite of himself

dior, armani, hermès, among others, and for magazines like the face, dazed & confused, citizen k, harper's bazaar, big and vogue **jean-** **baptiste mondino** born 1949 in aubervilliers, france, italian parent-age designs record covers at first makes video clips for artists like björk, neneh cherry, missy elliott, u2, rem, garbage, alanis morisette and madonna works for international fashion magazines and for fashion designers like yves saint laurent, jean-paul gaultier, kenzo advertising campaign for dior parfums, kodak, schweppes ... **sarah moon** born 1941 in england of french stock film director since 1970 published in elle, the magazine of the frankfurter allgemeine zeitung, graphis, harp- er's bazaar, marie-claire, nova, photo, zoom, time-life, vogue ... **jamie** **morgan** lives and works in london became known with buffalo, inventor of street fashion published much during the 1980s in the face and arena **marcus piggott & mert alas** live in london, and work in london, paris and new york 1997 they start working together for the face, visionaire, v magazine, i-d and numéro international advertising campaigns for missoni, gucci, sergio rossi, levi's, hugo boss, yves saint laurent ... **bettina rheims** born 1952 in paris, where she lives and works worked as model, journalist, gallery owner, and finally photogra-pher her photographic work became known through a nude series of striptease dancers, published in photo and égoïste makes portraits of actresses and other personalities for international magazines exhibi- tions of her work in many art galleries **terry richardson** born in new york first reportage sequences in the 1990s much discussed adver-tising campaigns in europe and asia responsible too for campaigns of costume national, levi's, sisley and atsuro tayama published in w mag-azine, harper's bazaar, english and russian vogue, the face, arena, arena homme plus, allure, vogue hommes international, i-d, purple prose and self service **herb ritts** born 1952 in los angeles lives and works in hollywood studies at bard college, new york known for his portraits

of VIPs and top models works regularly for condé nast, fashion designers and the music industry **paolo roversi** born 1947 in raven- na, italy lives and works in paris start of a photographic career at the age of 20 as a reporter moves to paris in 1973, where his interest is awakened in fashion photography published in many international fashion magazines like the italian and english vogue, l'uomo vogue, harper's bazaar usa, interview, arena, i-d, w magazine, marie-claire ... advertising campaigns for giorgio armani, cerruti 1881, comme des garçons, christian dior, alberta ferretti, romeo gigli, givenchy, krizia, valentino, yves saint laurent, yohji yamamoto adverts for dim, evian, kenzo and woolmark **laurence sackman** born 1948 in london ten-page publication at the age of 18 in nova magazine, london works for the times as well 1972 lives in paris and works for magazines like marie-claire, vogue hommes and harper's bazaar advertising cam- paigns until the end of the 1980s no longer active as a photographer, dedicates himself to writing **norbert schoerner** born 1966 in germany at the age of 21 starts to make photographs 1989 land- scape photographs on a trip through north and south america works for vogue, details, the face, arena and new york times ... advertising campaigns for levi's, jigsaw, nike, prada ... **stéphane sednaoui** born 1963 in paris 1986 starts his career as a photographer lives in new york since 1991 since 1991 director for music videos known mainly as a fashion photographer and for portraits of personalities in the public eye, active too as photo-journalist, capturing the revolution in romania in 1991 and the destruction by terrorists of the world trade center in new york in 2001 **david seidner** 1957–1999, born in los angeles started to take photographs at the age of 14 first title photo at the age of 19 first exhibition at the age of 20, many exhibi- tions followed worked under an exclusive two-year contract for yves saint laurent photographed for international fashion magazines

marion de beaupré born in germany studied photography at the folk-wang academy under otto steinert has lived in paris since 1968 agent for photographers: jeanloup sieff, peter lindbergh, paolo roversi, ellen von unwerth, thierry le gouès ... in 1997 she opened galerie 213 for contemporary photography

stéphane baumet born 1971 in france studied art history 1993–1997 collaborated on the festival de la photographie in arles 1997 head of the salon paris photo, carrousel du louvre has worked as a freelance curator since 2000 as well as a gallery organizer in collaboration with marion de beaupré

ulf poschardt born 1967 in germany / lives in berlin 1996 through 2000 editor-in-chief of the supplement of süddeutsche zeitung since 2001 creative director of the welt am sonntag newspaper teaches art theory as a visiting lecturer at the berlin academy of the arts author of the books dj culture (1995), anpassen (1998), cool (2000), über sportwagen (2002)

acknowledgments we would like in particular to thank **erich von endt**
1971 to 1998 professor for photography at essen's folkwang university
and a freelancer who worked for both the cultural and business worlds
we would like to thank them all for the trust they showed in us for their
kind support we thank art & commerce – vincent simonet art depart-
ment – patrick o'leary katy bagott katy baker agency antoine de
beaupré blanpied-rubini angela de bona thomas bonouvrier samuel
bourdin laurent bosque box ltd – jennifer steffencin laurent buttazzoni
jean-paul claverie crapule – patrick couratin clm – nick bryning béa-
trice dallot patrick demarchelier inc. – wendell maruyama benjamin
durand michele filomeno – susan oubari renate gallois – montbrun
pace-mac gill gallery – alissa schoenfeld susan günter astrid harel de
jong nk image ltd – philippa oakley-hill janvier vernon jolly sara
kendall steven klein – mark mayer mark kriendler-nelson – herbert e.
nass david lachapelle studio – sandy arrowsmith inez van lamsweerde
– vinoodh matadin ltd – jasper bode patrice lerat-nagel lighthouse –
tiziana trischitta peter lindbergh studio – anne srack camilla lowther
mitzi lorenz studio luce – anna hagglund maison européenne de la
photographie m.a.p. – julie brown the robert mapplethorpe foundation
– michael stout – launa beuhler frédérique monfort mother – héléna de
signori yannick morisot kasumiko murakami ninette murk pascal
narboni l'office dominique issermann – pascale perez the office – kate
ellis ninety one – sabrina hamida watch out – lecerf – maud hasard
emmanuel perrotin louise des pointes claire powell herb ritts studio –
griffin r. lauerman remi sackman marco santucci walter schupfer
management – barbara schlager – theresa farrell david sims photogra-
phy ltd – steve smith smile managment – kim sion francesca sorrenti
susan sone solar sreeters – beverly sreeter peter sterling tagad-
aboomboom juergen teller ltd – amanda handbury torch gallery
amsterdam – adrian van der have max vadukul inc – damian vincent

362

edited by **marion de beaupré** **stéphane baumet** **ulf poschardt**

art direction & design : **philippe de beaupré** **olivier bolla sina**

Translated from the German by Jeremy Gaines

Cover illustration: Camille Vivier, Untitled, 1999

First published in the United States of America in 2002 by

Rizzoli International Publications, Inc.

300 Park Avenue South

New York, NY 10010

Authorized edition, with the kind permission of

Marion de Beaupré Productions SARL, Paris

All photographs © 2002 the photographers

Text © 2002 Ulf Poschardt

English language edition © 2002 Rizzoli International Publications, Inc., New York

and Schirmer/Mosel Verlag GmbH, Munich

ISBN 0-8478-2512-4

2002 2003 2004 2005 / 10 9 8 7 6 5 4 3 2 1

Printed and bound in Italy

A Schirmer/Mosel Production